D0841940

ART IN LATIN AMERICA

Iria Candela
Translated by Chris Miller

ART IN
LATIN
AMERICA
1990 – 2010

Tate Publishing

First published 2013 by order of
the Tate Trustees by Tate Publishing,
a division of Tate Enterprises Ltd,
Millbank, London SW1P 4RG
www.tate.org.uk/publishing

A catalogue record for this book is
available from the British Library
ISBN 978-1-84976-070-6
Distributed in the United States and
Canada by ABRAMS, New York
Library of Congress Control Number
applied for

Designed by Adam Brown 01-02
Colour reproduction by DL Imaging Ltd, London
Printed in China by Toppan Leefung Printing Ltd

Front cover: Gabriel Orozco, *Cuatro bicicletas
(siempre hay una dirección)* 1994 *Four Bicycles
(There is Always One Direction)*
(detail of fig.13)
Frontispiece: Narda Alvarado,
Olive Green 2003 (fig.50)

Measurements of artworks are given in
centimetres, height before width

Contents

Introduction

Contrapositions

Over the last twenty years, the visual arts in Latin America have witnessed a boom like that experienced by Hispano-American literature during the 1960s and 1970s, when novelists such as Julio Cortázar, Gabriel García Márquez and Carlos Fuentes burst onto the international scene. Today a brilliant constellation of artists has emerged; like that generation of writers, they have set about renewing the disciplines of their art with fearless imagination and originality. This goal is present in each of the twenty artists featured in this book. Most of them were born between 1955 and 1975 and are therefore, at the time of writing, between thirty-five and fifty-five years old; they work principally in the areas of sculpture, installation, video art, performance and public art. Their origins or adopted places of residence range across the full extent of the Latin American continent and they envision their artistic practice as a means of intervening in the public sphere in critical and anti-conventional ways. The artists included in this book are, 'in order of appearance' here, Ernesto Neto, Gabriel Orozco, Carlos Garaicoa, María Fernanda Cardoso, Rivane Neuenschwander, Héctor Zamora, Miguel Ángel Ríos, Donna Conlon, David Zink Yi, Ingrid Wildi Merino, Tomás Ochoa, Jorge Macchi, Narda Alvarado, Francis Alÿs, Santiago Sierra, Jennifer Allora, Guillermo Calzadilla, Doris Salcedo, Javier Téllez and Regina José Galindo.

But the world has changed over the past forty years and this type of artistic boom is clearly different. In chronological terms, it developed at the dawn of the twenty-first century and after the close of the 'short twentieth century' marked by the fall of the Berlin Wall in 1989. In spatial terms, the visual arts today travel more quickly than literature since they need no translation; given the hyper-development of new technologies and the digital revolution, the context in which images arise today is already thoroughly globalised. The artists themselves constantly cross borders; just as there are Latin Americans working in Europe, the United States and Australia, so there are others, supposedly foreign, who have come to Latin America from a virtual 'abroad'. Moreover, unlike the literary movement, this is not an essentially masculine phenomenon: female artists – from Cardoso and Galindo to Neuenschwander and Wildi Merino – are pre-eminent. Also prominent are artists born in countries whose contemporary art was until recently considered of secondary significance, such as Peru, Ecuador, Bolivia or Guatemala.

Obviously, the artists featured in this book for the most part work in Latin America. But there are those who live elsewhere: the Colombian María Fernanda Cardoso lives in Sydney; the Peruvian David Zink Yi in Berlin; the Ecuadorian Tomás Ochoa between Zurich and Madrid. Some of the artists most representative of the contemporary art scene in Latin America are not in fact Latin Americans; consider the Belgian Francis Alÿs and the Spaniard Santiago Sierra, both of them resident in Mexico City, or Donna Conlon, a citizen of the

United States, who lives and works in Panama. This generation cannot, then, be easily pinned down to specific locations; its members are constantly moving from place to place and will continue to do so as long as their activities elicit the international interest they are receiving today.

This book studies a particular kind of contemporary artistic practice that must, first and foremost, be understood in the current socio-economic context of Latin America. Despite the increasing democratisation that followed the long era of dictatorships, the Latin American continent continues to show the highest indices of social inequality in the world. According to data published in 2009 by the Comisión Económica para América Latina (CEPAL), one in three Latin Americans lives in poverty – that is, a total of 190 million people – and 13.4 per cent (some 76 million people) in conditions of 'extreme poverty'. In 2006, there were 20 million people living in poverty in Mexico and 40 million in Brazil.[1] At the same time, Mexico City and São Paulo are among the ten cities highest ranked in the world in terms of GDP and number of multimillionaires.[2] The dissident character of many works discussed in this volume should be understood within this context of poverty and social inequality.

At the same time, the twenty artists included here share the idea that the public sphere is the proper place to debate questions of collective interest. A basic premise lies at the foundation of their works: that ideas of social consensus are meaningless if they fail to take account of difference, or, to put it another way, that 'the ideal public space is one of continuous conflict'.[3] To that extent, their disruptive and at times polemical expression is intended to confront the mainstream discourse that propagates and perpetuates the ideologies of late capitalism. By positioning itself in opposition to the hegemonic power, their art cannot help but put in question the very formats with which they work. That would explain why some of the works show a clear intention to transcend the spatial limits of the gallery and museum and to function in hybrid or provisional places, thus contesting the traditional contexts of artistic production and exhibition and challenging the uses often assigned to art by the institution.

For the most part, these artists rely on installations, videos or performative actions to articulate a set of social frictions and so denounce the way in which these frictions have been elided or misrepresented in the public sphere through strategies of distraction or false reconciliation. This, as we shall see, is the case with the installations *Noviembre 6 y 7* 2002 (*November 6 and 7*, figs.55–6) by Doris Salcedo and *Delirio atópico* 2009 (*Atopic Delirium*, fig.29) by Héctor Zamora, both realised in Bogotá; with the video *Olive Green* (figs.50–1) created by Narda Alvarado in La Paz in 2003; and with the urban actions *Obstrucción de una vía con un contenedor de carga* 1998 (*Obstruction of a Freeway with a Truck's Trailer*, fig.59) by Santiago Sierra in Mexico City and *¿Quién puede borrar las huellas?* 2003 (*Who Can Erase the Traces?*, fig.66) by Regina José Galindo in Guatemala. Each in its

own way, these works intervened in the daily activity of a city, and by doing so reactivated debates about economic, legal or military processes that were undeniably problematic – to say the least.

The way in which the works discussed in this book incite public debate and individual participation sets them radically apart from the consumerist models of post-Fordism, as typified by the agendas of the major media corporations and the conventional artistic production of decorative and post-utopian art.[4] But it also sets them apart from obsolescent models of commitment and militancy associated with parties that defended a single party line defined by leaders of sometimes dubious democratic legitimacy. Today, contrapositional art is produced in more fragmentary and at times ephemeral ways; it does not subscribe to orthodox programmes and tends to integrate social content into specifically aesthetic forms. These artists often use artistic objects and spaces to generate a non-instrumentalised artistic experience rather than placing themselves in a position of authority.[5]

A considerable number of these artworks acquire their political character through a complex formal configuration. Their critical discourse is at times articulated in the street, in direct contact with the problems affecting common citizens, but may also be the result of a solitary, studio-based experimentation with different forms and materials – ranging from paper, wax and celluloid to blood, chairs, spinning tops, second-hand vehicles and desiccated amphibians. For example, Gabriel Orozco redesigns a standardised industrial object, adjusting it to the scale of his own body in *Elevador* 1994 (*Elevator*, fig.12); Ernesto Neto uses lycra weights and counterweights to conduct a phantasmagorical invasion of the nineteenth-century architecture of the Panthéon in Paris in his *Léviathan Thot* 2006; and Miguel Ángel Ríos records a series of jousting spinning tops to reflect upon the violence of ethnic and national conflicts in his video *Aquí* 2007 (*Here*, fig.35). A counter-discursive tendency in Latin American art can thus be seen to breathe new life into an idea long since formulated by Theodor W. Adorno: the political content of the work of art that consciously opposes a one-dimensional and reified society paradoxically resides in its form.[6]

In the first chapter of the book, I examine works that are more abstract, in which the thinking of the artists unfolds through autonomous forms; these are for the most part sculptures and installations exhibited in museums and galleries. These are objects proposing enigmas that have to be interpreted; coded questions rather than overt statements; works that refuse to convey direct messages but nevertheless embody a narrative imagination that runs counter to the administered reality.[7] In the second and third chapters, the historical and urban context is more evidently present and the pieces discussed – videos and performance art – are more overtly political in their purposes. But the proposed division in chapters is by no means rigid: works like Zamora's *Atopic Delirium*

1 **Tuca Vieira**
São Paulo, Brazil
2005
Photograph
The Paraisópolis favela
borders the affluent district
of Morumbi in São Paulo

or Alvarado's *Olive Green* cleverly combine several disciplines (installation and public art, urban actions and video) and clearly demonstrate that the differing formats of the works studied in this volume are less important than their common political and aesthetic preoccupations.

The revision of identity and the continental project

Several studies on Latin American art published over the last few years have made use of the categories of multiculturalism and *mestizaje* ('racial mixing', 'cultural cross-fertilisation') to comprehend the multiple realities of a region constituted by more than twenty countries with very different cultural traditions and historic legacies. The Latin American continent is a plurinational, pluriethnic, pluricultural and plurilinguistic entity which embraces almost 570 million inhabitants. Any attempt to understand its contemporary artistic manifestations must encompass such multidimensional diversity of experiences if it is not to succumb to the old exoticist and essentialist model based on the mistaken premise of Latin American unity and 'authenticity'. As Patrick Frank has pointed out, the continent is too complex to be subsumed under a single identity: 'Each region has its own set of relations with its native past, the Conquest, its neighbours, and the rest of the world, and each country creates its own modernity out of this web of relationships'.[8]

Continuous revision of the notion of 'Latin America' has been the defining feature of a great many of the texts written on the continent's art over the last two decades. In contrast to a fixed definition of pure and uncontaminated identity – generally imposed or imported by force – the tendency today is to interpret artistic practice from an open, plural perspective that is 'in transit'.[9] Today, concepts created over the course of the twentieth century are continually being recovered and revised – from Oswald de Andrade's 'antropofagia' and Fernando Ortiz's 'transculturation' to Néstor García Canclini's 'hybridisation' – in order to avoid new clichés that, instead of explaining and broadening the reality of Latin America, reduce and reify it. For this reason, terms such as the 'fantastic' and the 'baroque' have given way to new concepts (such as the 'post-fantastic' and 'ultra-baroque') in an effort towards reinterpretation that attains maximal expression in the newly minted adjective 'post-Latin American'.[10]

The present text is inscribed in this new context of inventive reinterpretation of Latin American art and seeks to adopt perspectives similar to those recently expressed by a number of curators and art critics. Rina Carvajal, for instance, has observed that:

the multiple tension of forces and narratives pertaining to the notably distinct cultures and societies of Latin America, and the dislocation caused by the migrations and nomadism of this particular historical moment require that notions of identity, appropriation and cultural frontiers be rethought in much more open and dynamic fashion. One possible

way of approaching this [artistic] production would be to see it in the light of a labyrinthine practice inevitably fragmented, unfinished and constantly reformulated.[11]

Eugenio Valdés Figueroa, critiquing the ways in which people have sought to unify 'top down' a culture metamorphosing and transforming at its roots, has called for the recognition of 'an alternative order at the same time as accepting its own internal "disorder"'. This should, he says, lead to a 'reformulation of what it means to be Latin-American, understanding it as a socio-cultural relation at the frontier rather than as a stable, unitary identity within a precisely demarcated field'.[12]

In this study, I have incorporated these critiques of a misleadingly totalising perspective on Latin American art and argued for an open, unfinished and flexible vision capable of encompassing that art in all its complexity. But I have also taken into account the need to transcend the debate about 'identity' in Latin America. Many of the arguments advanced in this book go well beyond such debate, which has begun to seem obsolete. In this respect, I would draw attention to a declaration made by the artist Gabriel Orozco in 1998:

Everyone is talking about nationalism, about being Mexican or being international. I refuse to talk about this, [because] the interesting thing today is the way in which an artist behaves in the world, how he or she lives, and what political position he or she takes.[13]

The very fetishisation of 'hybridisation' can disable the social character of a work of art and cause what the Cuban curator Gerardo Mosquera, speaking of contemporary Latin American arts in general, defined as 'identity neurosis'.[14] If we become obsessed with seeking in Latin American artistic practices a component of *mestizaje* or post-Latin-American-ness, we may lose sight of the basic objective of art criticism, that of explaining why a work of art is valuable to society and to what extent it constructs an imaginary notion of collective emancipation. On the other hand, our labyrinthine and fragmented perspective should not reduce our focus on what has, in another context, been called 'a continental project'.[15] That is, attention to the detail of certain diversified and atomised practices should not occlude the interpretation of common historical and political preoccupations, constantly shared and reactivated in the multiple contexts of the continent.

The historic present

The works of art considered in this volume are a product of the complex historical moment from which they arose. During the 1990s and 2000s, simultaneous periods of intense democratisation and de-democratisation coexisted in the region. As the political scientist Charles Tilly has noted, 'democratisation is a dynamic process that always remains incomplete and perpetually runs the risk of reversal – of de-democratisation'.[16] Both processes have occurred in parallel in the Latin American continent. On the one hand, the neoliberal policies propelled by

financial elites and national and local economies – and supported by successive governments in the United States – have concentrated wealth, increased public deficits and all too often expropriated the fundamental rights of the majority, notably in respect of employment, education and housing. As Tony Wood so graphically puts it, Latin America continues to be:

A region historically marked by profound inequalities [that] has witnessed their entrenchment in quantitative terms, and their amplification in the realm of social experience. The super-rich commut[e] in helicopters from fortified compounds to skyscrapers, while on the ground the poor scramble to earn a precarious living, and in their midst a thin layer seeks to emulate the consumption patterns of the US or European middle classes.[17]

On the other hand, since the Zapatista rebellion in Chiapas broke out in January 1994, social movements have acquired a prominence unparalleled in any other part of the world. The struggle of indigenous organisations in Bolivia and Ecuador, of the Movement of Rural Workers without Land (the 'Sem Terras') of Brazil, and of the *piqueteros* and unemployed activists in Argentina, were representative of the strong anti-system movement that arose over the course of the 1990s and attained unprecedented international exposure in January 2001 with the celebration of the first World Social Forum in Porto Alegre. Such social demands have also been expressed by voters. Since the election of Hugo Chávez as president of Venezuela in December 1998, there has been a series of electoral victories for parties at least nominally of the left or centre-left. I refer to the governments of Lula da Silva in Brazil and Néstor Kirchner in Argentina in 2003; of Tabaré Vázquez in Uruguay in 2004; of Evo Morales in Bolivia and Michelle Bachelet in Chile in 2006; of Rafael Caldera in Ecuador and Daniel Ortega in Nicaragua in 2007; and of Fernando de Lugo in Paraguay in 2008. Their political agendas are various but almost all are in striking contrast with the neoliberal projects of the previous decade, represented by leaders such as Carlos Salinas de Gortari, Carlos Menem, Fernando Henrique Cardoso and Alberto Fujimori – against whom they were reacting. Indeed, as the Brazilian sociologist Emir Sader has suggested:

the three largest Latin American economies were the theatre for the most dramatic crises: Mexico in 1994, Brazil in 1999 and Argentina in 2002... It was neoliberalism's poor performance in Latin America that in many instances led to the defeat of the governments that pioneered it.[18]

The recent election of some of these leaders was enthusiastically received not only by the cultural and artistic communities of Latin America but by a broad swathe of intellectual opinion throughout the world. In 2006, the British Pakistani historian Tariq Ali remarked: 'South America is the continent where an essentially social-democratic alternative to neoliberal capitalism is rising from below and infecting politics everywhere'.[19]

But artists working in Latin America today cannot simply confirm that their continent has gone from being the 'privileged victim' of neoliberalism to its 'principal gravedigger'.[20] Far from it; they are aware of the unresolved tensions between the powerful local elites and the Obama administration's new Washington Consensus on the one hand, and on the other, the increasing strength of putatively left-wing governments (some of them excessively populist and authoritarian) and the more or less intermittent social movements working against neoliberal globalisation. Two recent events confirm this extreme divergence of political dynamics in Latin America: the bloody coup d'état engineered by Roberto Micheletti in Tegucigalpa, Honduras, in the summer of 2009 and the electoral victory of the former Tupamaro activist José Mujica in Montevideo in November of the same year.

It is in this context, full of contrasts and contradictions, where various political systems midway between the neoliberal model and Bolivarian socialism are simultaneously at work, that contemporary Latin American art has developed and is developing. In this respect it is important to re-emphasise that the make-up of the artistic subject has changed no less than that of the historical one. These artists, like many other actors in the new social movements, do not necessarily identify with the classic leftist tradition represented by the struggle of the working class and the trades unions, nor do they set themselves up as direct political activists.[21] Their work principally arises in opposition to a new world order imposed via privatisation, the protection of monopolies and the slashing of social budgets. In articulating their dissidence, no less important than the workers' demands is the necessarily polyphonic voice of student, feminist, indigenous and queer movements. My particular interest is to study those artists who, in this complex background, have established an artistic *praxis* whose inner form comprises a number of antagonistic elements, thus continuing a powerful tradition of social art in Latin America.

Reinventing tradition
It would be as inappropriate to deny what is new about the current disruptive practices in Latin American art as it would to ignore their more or less recent precedents, that is to say, the tradition of which they form part and that they in some measure both continue and revise. Counter-discursive artistic production has a strong tradition in Latin America, going from the Mexican Muralists and the earliest European-influenced avant-gardes to Cuban documentary film and the *latino art* of social protest in the United States. According to Shifra Goldman, in countries that are constantly destabilised or impoverished – and this was the case for the majority of Latin American states throughout most of the twentieth century – a political art orientated towards social change is frequently a way of rendering bearable lives otherwise submerged in violence and injustice.[22]

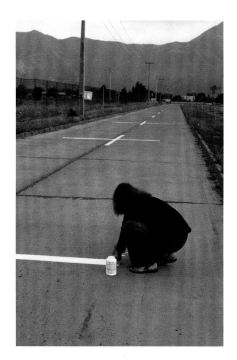

Nevertheless the preponderant influence on the artists selected in this book comes from works produced by the generation immediately before their own, which experienced in more or less direct fashion the appalling consequences of the dictatorships of the 1960s, 1970s and 1980s. In many of their pieces one detects, if not direct dialogue, at least the presence of significant ideas and forms produced by artists active during those decades, some of whom have since died (Hélio Oiticica, Lygia Clark, Ana Mendieta and Félix González-Torres), while others are still active (Waltercio Caldas, Artur Barrio, Cildo Meireles, Luis Camnitzer, Liliana Porter, David Lamelas, Eugenio Dittborn and Lotty Rosenfeld). Whether through their interest in Argentine conceptualism or in the Brazilian Tropicália movement, many of the artists currently working in Latin America have incorporated an important legacy from their predecessors, in particular as regards their overcoming the most traditional practices of art and configuring social content through new and complex formal challenges.

The coded political character of the works of that earlier generation is attributable not only to its enthusiasm for subverting aesthetic conventions but also to the difficult historical conditions – the censorship and repression – under which its art was produced. As Jacqueline Barnitz has said:

The events that occurred in Latin America in the 1970s and 1980s tested the ingenuity of artists, who were forced to find alternate means of communication under governments that monitored traditional circuits. On the other hand, the inventiveness of the art produced under these circumstances leads to the conclusion that many artists had the will to make art out of adversity without compromising their ideological principles. During the years of the military governments, art had lost its meaning as object, and artists sought other means of expression, particularly through conceptual art and street actions. [23]

The bandaged and 'bloodied' boxes of Camnitzer's installation *Sobras* 1970 (*Leftovers*); the altered tickets and Coca-Cola bottles of Meireles's *Inserções em circuitos ideológicos* 1970–5 (*Insertions into Ideological Circuits*, fig.3); the crosses created by Rosenfeld on one of the main thoroughfares of Santiago de Chile in the urban intervention *Una milla de cruces sobre el pavimento* 1979 (*A Mile of Crosses on the Pavement*, fig.2); or the folding, transportable 'airmail paintings' of Dittborn's *Sin rastros* 1983 (*No Tracks*) are among the idiosyncratic examples of contra-hegemonic art made in the context of the Latin American dictatorships.[24]

The historical context is different today but many artists have continued that generation's project of going beyond the parameters of the art institution and blurring the borders between artistic production and daily life. We might say of them what Mari Carmen Ramírez said about the extra-artistic dimension of the groups that managed to 'insert themselves and influence the social matrix of their respective countries' during the 1960s, 1970s and 1980s:

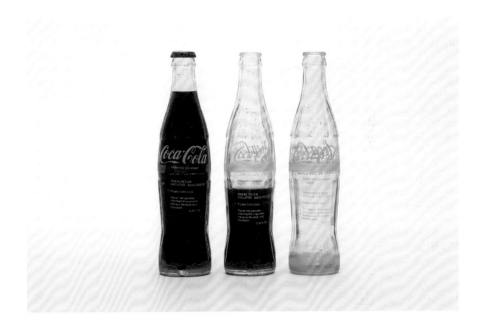

3　**Cildo Meireles**
Inserções em circuitos
ideológicos: Projeto
Coca-Cola 1970
Insertions into
Ideological Circuits:
Coca-Cola Project
Transfer text on glass
Each 25 × 6 × 6

In this regard, what makes the Latin American versions of the neo-avant-gardes so unique is not so much their radical artistic postulates but a non-aesthetic goal: the social function they were called upon to play with regard to the paradox of unstable societies and their status quo. Therein lies their innermost utopian dimension. The attempt to contest the institutional art world in order to bridge the gap that separated them from society led many of these manifestations to actively engage the public sphere – right there where the aesthetic specificity of their practice dissolved into broader fields, such as politics, sociology, ethnography, and anthropology ... The urban guerilla tactics of *El Techo de la Ballena*, the Mass Mediatic interventions of Brazilian and Argentinean Conceptualists, and the performative proposals of the Neo-Concrete artists exemplify the desire to overcome the strict parameters of art in favor of experiences more directly related to everyday life.[25]

At all events, I consider it necessary not to 'drown' the work of new artists in either the tradition of art history or the earlier artistic practices to which they themselves may on occasion refer. Orozco ironised about this danger in an interview with Robert Storr published in 1997, when asked about his piece *Caballos corriendo infinitamente* 1995 (*Horses Running Endlessly*). 'To the art world, chess is related to Duchamp', he replied. 'But chess is related with everything else. Duchamp is the least important thing about chess. Chess is a thing in itself.'[26] In similar spirit, in a recent article about Rivane Neuenschwander, Sam Thorne observed:

Much writing on Neuenschwander's work stresses a linear account of post-Tropicália Brazilian art – running from Hélio Oiticica through to Cildo Meireles – at the expense of

recognizing either a mutating scene of differentiated communities or an international influence. It is perhaps less important that Neuenschwander was born in Belo Horizonte, the same city as Lygia Clark, than the fact that she – along with Beatriz Milhazes, Ernesto Neto and Renata Lucas – belongs to the first wave of Brazilian artists who exhibited internationally at the same time as they started to show in Brazil.[27]

Art in Latin America, 1990–2010

The primary objective of the pages that follow has been to understand the works in and for themselves. For this reason I have paid special attention to the form in which they have been constructed and the explanations that their authors have given for what they have done (though at times following the famous advice of the artist Walter Sickert: 'Never believe what an artist says, only what he does'). My principal commitment has been to scrutinise what the pieces say and understand the way in which they say it through exclusively artistic means. I make no claim to study the complete trajectory of these artists but select a specific facet of their creative activity, which sometimes appears in a series of projects but on other occasions may be manifest in only one or two works.[28]

In the first part, I consider various sculptures and installations by Neto, Orozco, Garaicoa, Cardoso, Neuenschwander and Zamora. As we shall see, some of these were made in the solitude of the artist's studio, others in direct interaction with the community or space in which they came into being. In the second section, I turn my attention to a varied set of videos directed by Ríos, Conlon, Zink Yi, Wildi Merino, Ochoa, Macchi and Alvarado. The more abstract, even sculptural, character of the earlier pieces (the films by Ríos and Conlon) is followed by works that are politically more explicit and direct, such as the video realised on the basis of the original site-specific performance by Alvarado. That film leads directly to the third and final part of the book, which considers works of public art by Alÿs, Sierra, Allora and Calzadilla, Salcedo, Téllez and Galindo. These works were produced in situ and their clear ambition was to change the physiognomy of the space in which they intervened and promote aesthetic debate on problems recent or contemporary.

This book does not aim to rank or select the twenty, fifty or hundred best artists working in Latin America today, as some recent publications seem to have done, but to select works on the basis of common stylistic and thematic features that I consider particularly relevant to the theoretical and practical debates of altermodernity. Yet no attempt is made to domesticate through some reductive perspective the variety and richness of the very different propositions of the artists studied. On the contrary, I would like to put the reader in contact with a series of creative singularities and practices opposed to the self-congratulatory logic of discourses complicit with the global neoliberal system.[29] The main goal is to reflect on the meaning of this explosion of propositions made in Latin

America by artists who, their feet firmly on the ground, adapt their methods to their very different kinds of battleground but share the notion of constructing an imaginary world of collective emancipation in the context of a common continental project.

To undertake this analysis, I have taken up a transversal position midway between art history and curatorial practice. It is a speculative approximation that has no claim to be exhaustive and seeks to avoid arcane academic interpretations. I wanted to reclaim the role of the art critic who feels bound to justify the criteria he or she employs in the face of the multitudinous and unequal tendencies of contemporary art. To that extent, this is a synthetic continuation of two earlier projects: my book *Sombras de ciudad,* published in Madrid in 2007, which examined the trajectories of an alternative urban art made in New York between 1970 and 1990 by artists such as Gordon Matta-Clark, Hans Haacke, Martha Rosler, Tehching Hsieh and Krysztof Wodiczko, and the exhibition of emerging 'low key' artists curated the following year at the Villa Iris in Santander, in the catalogue for which I set out in brief some of the ideas to which I return in this book.[30]

This combination of art history and curatorial practice is intended to draw on the merits of either discipline and trigger the most stimulating dialogue between them. Far from setting their methodologies at odds, I hope that this combination – hybrid and transcultural like the works of art discussed on the pages that follow – will make both disciplines more attractive and useful not only to artists and curators currently working in the field of contemporary Latin American art but to students and academics who seek in these pages an interpretation of the art of contraposition.

From sculpture
to installation

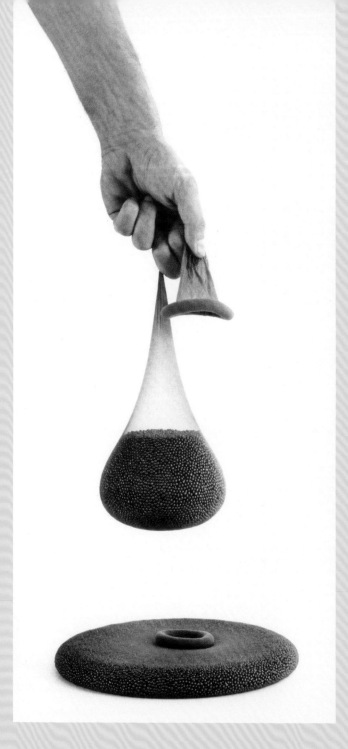

1

The exuberant organism

The work of the Brazilian artist Ernesto Neto (b. Río de Janeiro, 1964) has evolved from the basic elements of sculptural practice to the realisation of hybrid projects midway between installation, environment and architectonic intervention. His artistic trajectory has been marked by a succession of distinctive phases and new discoveries; the prevailing character of that evolution has been the desire to experiment with the physical principles of weight and gravity with a view to progressively transforming the artistic object into an ethereal and weightless entity.[1] His attempt to dematerialise sculpture has been predicated on undermining the physical solidity of the object. Since his first exhibition in 1989, Neto has produced hundreds of 'organisms': sculptures and installations that have acquired flexible and mutable forms, and whose dynamism is born of the confrontation generated between the forces of tension and the spaces of tranquility. His oeuvre is based on a modular system that has been gradually, one might almost say biologically, developing from tiny, cellular offerings to exuberant biomorphic manifestations that have invaded the architecture and transfigured the spaces of the artistic experience.

In a first series of works, Neto presented simple sculptural volumes, isolated objects with which he explored basic notions of gravity and elasticity. An early example, *Barra bola* 1988 (*Bar-Ball*), consisted of an iron beam whose weight squashed a little ball of orange rubber as it leaned against the wall, clearly referencing the post-minimalist sculpture of Richard Serra. The simple idea of contrasting a weighty, rigid volume with flexible material was repeated in *Peso de partículas* (*Weight of Particles*) made in the same year; here Neto first made use of a material essential to the development of his work, polyamide lycra. The photograph documenting this piece shows a hand holding up a piece of stretch nylon that contains within it 5 kilograms of lead pellets (fig. 4). The artist himself defined *Weight of Particles* as the seed of his later pieces and the work from which his entire corpus would grow.[2]

The following year, Neto placed on the ground a polyamide net full of tiny spheres of lead and entitled it *Partícula* (*Particle*). This indivisible sculptural unity could be exhibited on its own or accompanied by another unity with which it formed a duo; it could even be made to configure groups and *Colonias* 1989 (*Colonies*) that spread out across the exhibition space. It could also be raised to form a protuberance – the lycra now filled with lead and polystyrene foam – as demonstrated by *Pólipo* (*Polyp*), which in 1990 Neto placed on a rock by the seashore like some mysterious amoeba. In this way the particle was converted into a sculptural body that, like humans and animals, was contained within an integument, in this case a web of lycra defined as 'the sculpture's skin'.[3]

From that moment on, Neto's work, which by now he viewed as an organism, began to multiply: to 'reproduce itself' and occupy the space in which it was

4 **Ernesto Neto**
Peso de partículas 1988
Weight of Particles
Polyamide fabric and lead spheres
25 × 25 × 4.5 kg

presented in invasive fashion. Now there came *Grupólipo* 1990 (*Groupolyp*), a set of twenty-seven polyps each approximately a metre high that changed position according to the day of the week in the Galería Sérgio Porto in Rio de Janeiro. Or the *Lipzoides* 1996 (*Lipzoids*), in which the porosity of the lycra allowed the substance contained within it to ooze out, forming a circle of white on the floor of the Zola Liberman Gallery in Chicago. The porosity of polyamides allowed Neto to fill his pieces with new materials; instead of cold, industrial matter like leather or rubber, he began using living, organic substances such as pigments and spices (thus breathing new life into the pioneer experiments made with physical processes and organic materials by Italian *arte povera* in the late 1960s). His sculptures began to be dropped on the floor, contaminating it with different colours and scents: the ochre *Puff* 1996 (fig. 5), the black *Poff* 1996 or the *Jardims de lipzoides* 1996 (*Gardens of Lipzoids*), in which dozens of forms reciprocally engendered and multiplied, containing and exuding white lime, pepper, saffron, cloves, caraway, urucú...[4]

Thus, starting with an individual piece that situated the body of the sculpture (the weight of lead) within the skin that contained it (the lycra net), Neto went on to multiply that body, installing and moving it in space and generating multiple organisms; at a given point, he made use of the porosity of the nylon to challenge the interior/exterior scission of the sculptural volume and project colours and scents out of the organisms' bodies. The circular marks left on the ground by the onomatopoeic *Puff* and *Poff* demonstrate not only the effect of their impact when dropped on the ground but also the breathable quality of the skin container. This effect is connected with the metaphor of the 'permeable membrane', which, according to Guy Brett, began to appear in different parts of the world during the 1960s and especially in Brazil, where artists like Lygia Pape, Lygia Clark and Hélio Oiticica used penetrable structures as 'a means of both accentuating and crossing the boundary between the inside and the outside of the body'.[5]

But as of 1996, Neto felt it was no longer sufficient for his sculptures and installations to interact with space in this way alone. They began to rise into the air, defying the law of gravity, in a series of pieces that the artist named *céus* (*skies*), and to create inhabitable interiors that could be entered by the spectator, which Neto later termed *naves* (*vessels*). *Skies* and *vessels*, two new typologies within Neto's organic universe, developed towards the end of the 1990s and, like his previous sculptures, confronted 'an extremely geometric' and 'mechanised' world that persisted in understanding the body 'as a machine'.[6]

In order to realise a 'sky', the 'particles' had first to take their distance from the floor and ascend the walls of the gallery. A first attempt to 'elevate' sculpture could be seen in two pieces raised into the air with poles, string and fabrics: *Fluencia topológica sobre un campo estructural para un punto de alta intensidad, si!*

1992 (*Topological Flow over a Structural Field for a Point of High Intensity, Yes!*) and *Epoché* (Greek for 'suspension'), which was installed that same year at the Museu de Arte Moderno in São Paulo. Though these works generated expanded force fields, none of them raised the lycra particle wholly in the air. Only in 1997, with the work *Anatomia do prazer* (*Anatomy of Pleasure*), did Neto finally invade the ceiling, from which he hung a simple net holding a weight. Now his sculpture had freed itself of the floor: Neto had succeeded in converting the nylon nets into an organic, coloured, scented body entirely hanging from the 'sky'. In *Nós pescando o tempo* (*densidades e buracos de minhoca*) 1999 [*We Fishing the Time* (*Densities and Wormholes*), fig.6], some particles were still touching the ground but others did not; they gently caressed the floor or raised themselves a few centimetres above it.

Vértice Ogum Tempo (*Vertex Ogun Time*) and *Dropping Sky*, both also completed in 1999, were already forms of aerial sculpture thanks to their measured study of counterpoise. An ineffable unfolding of semi-organic hanging forms generated a strange choreography through the exhibition space, thus restoring it to a pre-architectonic state, like a natural cave with rounded stalactites. Neto observed that these are works 'at one with architecture', that they 'occupy the surface of the ceiling', 'proceed from the sky' and form 'a skin above us with drops falling from the room'.[7]

Perhaps the most famous of these skies is *É ô Bicho* (*It's the Bug*), made in 2001 for the forty-ninth Venice Biennale, whose title pays homage to Lygia

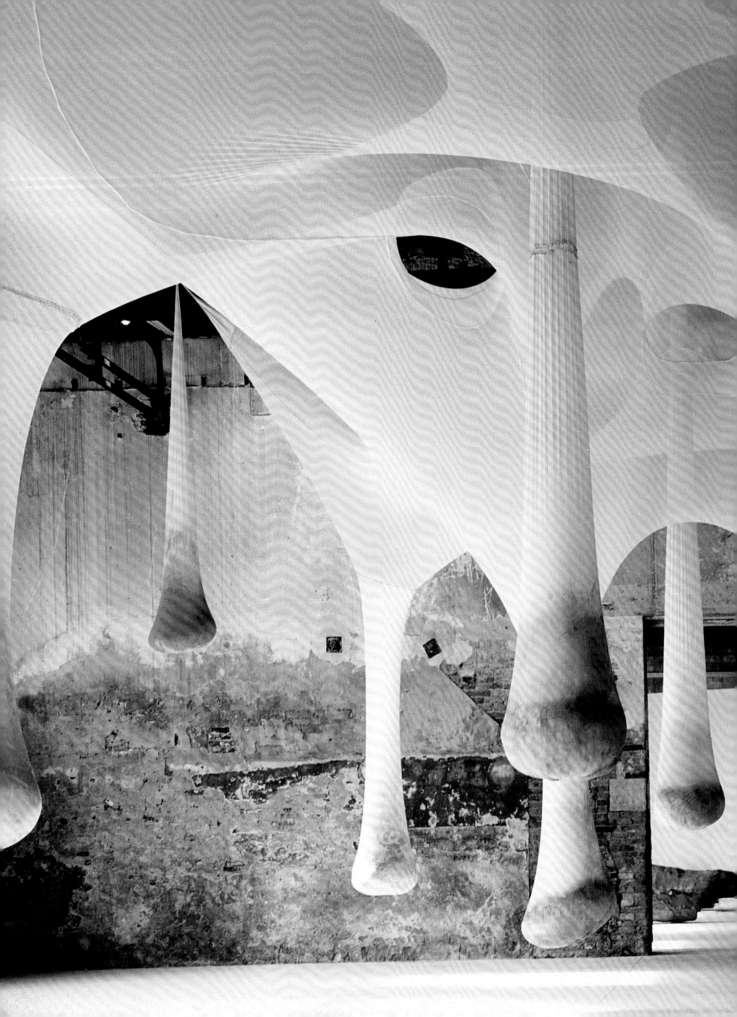

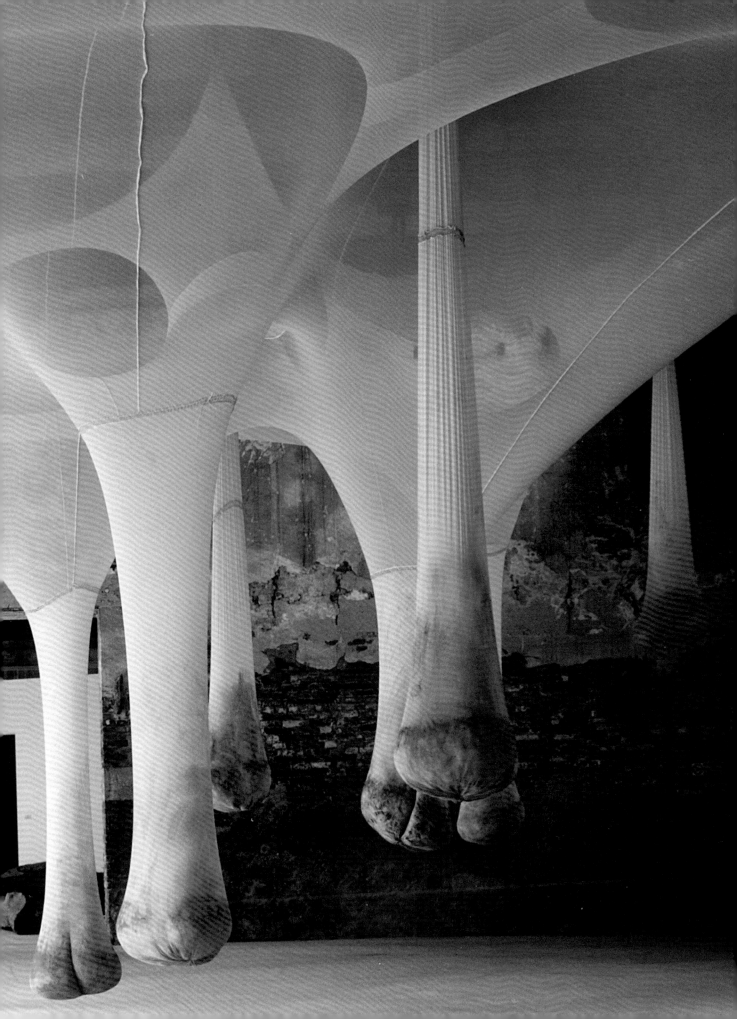

Clark and her series of *Bichos* (*Bugs*). In a large room with chipped plaster
walls in the Arsenale, a dozen 'weights' of brown, red and ochre descend in a
broad net of white lycra (fig.7). The aerial and pendant forms occupy the space
and the visitor walks around them to see (and smell) the organic substances
that permeate the skin of the 'bug'; that mysterious and disconcerting entity,
halfway between plant form, animal body and extraterrestrial presence, turns a
Cartesian and quadrangular interior into something curved and transformative.
By means of this space that seeps, secretes and excretes, Neto undermines the
imperturbability and solidity of the architecture by which it is surrounded,
while his work's reclamation of bodily functions critiques that architecture's
alienation from the body that inhabits it.

The interest that Neto takes in the sciences, especially biology, has always
gone hand in hand with his rejection of doctrines imposing a scientist logic
in all areas of life. He once humorously pointed out that his installations were
a mixture of mathematics 'and sensibility'.[8] The emphasis he places on curved
and organic forms, smooth and porous materials and on folds – he once declared
that he hated screws and adored knots – implies a challenge to the excessive
geometrical mechanisation imposed by technological hyper-development and
instrumental reason. In a recent conversation, he declared:

There is that entire Platonic story that the soul, or spirit, is much stronger than the body.
The body is a terrible thing that we need to carry around, and this is the structure on
which all our intellectual reality was built, and of which I am very critical, obviously.[9]

Thus the elevation of the sculptural organism or body in Neto's work should
also be understood as transcending the Platonic dichotomy, according to which
the (mortal) body weighs us down and the (immortal) soul takes flight. His
approach to this issue is not religious but philosophical and aesthetic: it seeks
to transcend the division between spirit and matter and relates to the desire to
make things float that Neto discovered in Egyptian and Greek sculpture in the
late 1990s. 'What I understood about Egyptian sculpture is that it aspired to be
gas,' Neto remarked: 'The stone wanted to stop being stone.'[10] Desacralising both
traditions, Neto felt that this aspiration could be realised without condemning
the organism, precisely because he has always conceived the spiritual as 'linked
to the body'.[11]

Working towards this notion of the aerial body, the artist set about
materialising his most monumental and complex skies, first with his gigantic
intervention *Léviathan Thot* 2006 conceived for the Panthéon in Paris, and
subsequently with the installation entitled *A culpa civilizada* 2009 (*Civilised
Guilt*) in the Fine Arts Museum at Nantes, France. In the Parisian work, the
sky presented itself as a kind of 'counter-installation',[12] disfiguring as it did
the eighteenth-century architectonic authoritarianism of the Panthéon and

its triumphant rationalism. Neto challenged the immaculate interior of the building with an arrangement of white ramifications that descended from the cupola to the floor in the form of a titanic mucous membrane or Mesozoic lichen. In a manner reminiscent of the technique by which Christo and Jeanne-Claude from the 1960s on wrapped entire buildings with huge fabrics, Neto filled the imposing classical architecture of the interior with amorphous, mutating bulbs. Foucault's famous pendulum, which measured the rotation of the Earth from the same dome, was now accompanied by an enormous animal body whose exuberance disarmed the domineering tendencies of the exact sciences and opened up perception of the space to the universe of sensory experiences.

At this artistic stage, as we have seen, the sky lived in harmony with the vessel. But 'soon, with the increase in size,' Neto observed, 'my works began to acquire the status of bodies that could be folded in on themselves and I realised that immersion within the body allowed me to appreciate the other side of the skin'.[13] The vessel is a habitation, an organic cavity whose floor, ceiling and walls are composed of webs of lycra or cotton. It is a space that the visitor can occupy or inhabit: a 'house-body' or 'visceral architecture', in Juan Antonio Ramírez's words, and a 'complete environment-object that requires the spectator effectively to penetrate into the space of the creation'.[14] Neto discovered it in 1998 and

8 **Ernesto Neto**
Nave Novia, Blop 1998
Fiancée Vessel, Blop
Lycra tulle, polyamide fabric,
tulle, polyester and rice
Installation, 11th Biennial
of Sydney, 1998

that year he produced variations throughout the world: after the *Nave óvulo* (*Ovule Vessel*) in Brasília came the *Nave denga* (*Denga Vessel*) in New York; after the *Nave Noiva, Blop* (*Fiancée Vessel, Blop*, fig.8) in Sydney came the *Nave deusa* (*Goddess Vessel*) in São Paulo; after the *Nave casa* 1999 (*House Vessel*) in Miami, the *Globiobabel nudelione landmoonaia* 2000 in London...

While the particles, polyps, lipzoids or skies were (positive) volumes in the form of sculpture or installation, the vessels presented themselves as curved and shaped spaces with (negative) interiors to which access was gained by narrow openings. Within them, the body and skin of the archi-sculpture ceased to be 'models of representation' to become, in Neto's own words, 'experience-dwelling' places.[15] The vessel offers its membranes, pillows and mattresses – in the form of organs, intestines, sinews, vaginas or testicles – as sites for relaxation, conversation, sharing, seduction and procreation. Or it may produce sensations of dynamic movement by means of colour, recalling the aesthetic of the cinechromatic *aparelhos* (apparatuses) of Abraham Palatnik or Carlos Cruz-Diez's *Cromosaturación* 1965 (*Chromosaturation*). *Útero capela* (*Uterus Chapel*), installed in the Museum of Modern Art in Rio de Janeiro in 2000, was used for an artistic ceremony, the marriage between the artist and his wife (who was eight-months pregnant), in a performance entitled *O Casamento: Lili, Neto, Lito e os loucos* (*The Wedding: Lili, Neto, Lito and the Mad*). The vessel thus becomes 'a sculpture to penetrate',[16] equipped with protuberances that can be touched or embraced and where the visitor, having been invited to take his or her shoes off, takes part in a communitarian experience.

Neto thus proposes a kind of immersive installation that is completed when the viewer physically enters it; the spectator's participation, physical and psychological, is an integral part of the work. A sensual and enveloping, almost oneiric, space generates a wide range of sensory experiences that stimulate different kinds of psychological exploration. Consequently Neto's work has been connected with Merleau-Ponty's paradigm of the phenomenology of perception; that paradigm had already exercised an influence both on the art of installation in Brazil during the 1960s and in artistic experiment with ambient and sensory situations directly involving the viewer.[17]

The notion of fusion and mixture plays a primary role in Neto's imagination, as evidenced by the name of his son Lito – a combination of the first syllable of his mother's first name and the second of his father's family name – and the invented words used to name his vessels (globiobabel, nudelione, landmoonaia). Here syllables are fused, as fluids are mixed in the sexual act:

The artist is very conscious of the erotic implications of his works, as is shown by certain of his declarations: 'I want art that unites people and helps us to interact with others, that shows us the limit'. Similarly: 'Forgive me, world, but only libido

9　**Ernesto Neto**
Humanóides 2001
Humanoids
Lycra tulle and styrofoam
balls
Installation, Kölnischer
Kunstverein, Cologne, 2001

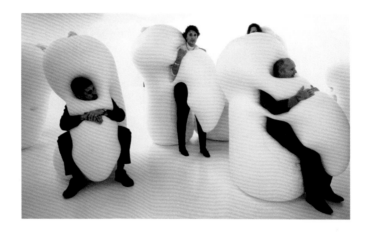

can save us. Libido alone knows the truth'. To enter such works and live momentarily within them is a metaphorical act alluding to physical and spiritual elevation: a promise of happiness.[18]

Indeed, the 'therapeutic potential' of Neto's art has frequently been mentioned, as has the way in which his work reflects the 'desire to attain equilibrium between society and the environment'.[19] To the extent that they function like 'promises of social cure', his works remind us of the experiments with art therapy that Lygia Clark undertook in the last few years of her life.[20] On the other hand, to the extent that they address the field of human interaction and the creation of social space (rather than the attempt to establish a symbolic and independent private space), they also represent aspects of the so-called 'relational aesthetic' that spread through international artistic practice during the 1990s.[21] This is why the *Ovaloides* 1998 (*Ovaloids*) and *Humanóides* 2001 (*Humanoids*, fig.9), two sets of works in which Neto restores and amplifies the idea of the individualised volume (polyp or lipzoid), ultimately become useful, ergonomic, curative objects in which to relax and embrace.

But the universe installed by his sculptures and installations with their promises of antidote, recovery and reconciliation is by no means 'free of tension'.[22] From the outset, Neto has incorporated counterpoised force fields as structural and constitutive elements of all his projects; without weight and counterweight, they could not exist. It would be as foolish to deny the artist's desire to generate a space of relaxation and well-being as it would to overlook the tension that underlies such conditions. 'I am interested in pleasure, but not pleasure in the sense of distraction', Neto has said. 'Happiness lives alongside pleasure and pleasure alongside peril.'[23] The substance that oozes through the porous web reminds us of the body that bleeds; the lycra with which his artistic organisms are constructed can break; the pulsing organ can malfunction and come to a halt. Neto's dialectical approach to art and life suggests that there can be no elevation of the sculpture without the resistance of gravity and that no pleasure can exist without pain. The spiritual is always the body – the body that aspires to evanesce, 'become gas' and disappear.

Imaginary vehicles

In the autumn of 1993, the Mexican artist Gabriel Orozco (b. Xalapa, 1962) was walking the streets of Paris in search of inspiration for his first solo exhibition in the Chantal Crousel Gallery when he came across an old Citroën DS in a scrap yard. Fascinated equally by its aerodynamic design and significance as a national symbol of France, the artist decided to buy and make a sculpture of it. Over the course of the following month, he set about the laborious process of transforming the vehicle. First he dissected it longitudinally into three equal parts, then he removed the central part and finally fused the two side parts –

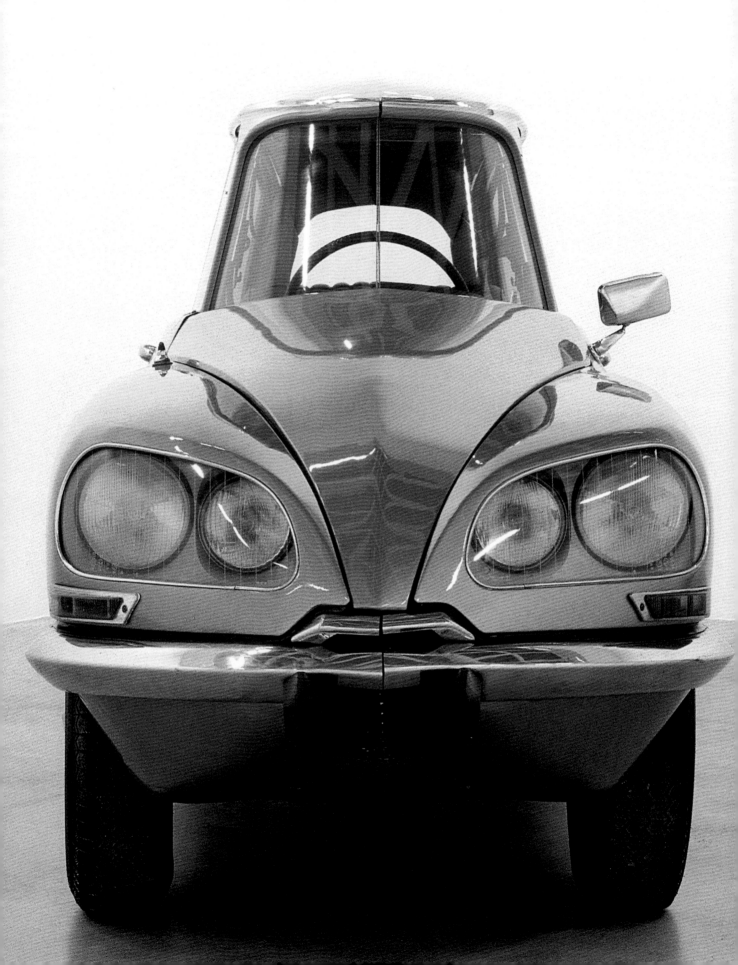

thus creating a new car with a single seat and no motor. In early December, Orozco exhibited it in the Parisian gallery under the title *La DS* (fig.10); he was, of course, aware that the pronunciation of these two initials is identical with the word *déesse*, the French for goddess. The result was an immediate critical and popular success. In March 1994, the Italian curator Francesco Bonami described the work in the magazine *Flash Art* as 'a surgical operation, a feat, a technical hallucination'.[24]

Orozco's *La DS* is an imaginary vehicle that has lost its utilitarian purpose as a locomotive object through a beautifully precise technical transfiguration that has endowed it with a new function. On the one hand, it revises the iconic image of the Citroën as a symbol of the modernisation of post-war France, when the latter sought to publicise its renewed cultural and industrial grandeur (thus the piece has been interpreted as 'a critical meditation on modernism's utopian dream of technological progress and the failures of the accompanying culture of rapidity').[25] On the other, the sculpture generates in the viewer a spatial experience, one not confined to the way in which the sectioning and subsequent rewelding redesign an industrial object that now finds its place in an art gallery. Orozco allows the visitor to enter the car and discover that *La DS* is also a work about the space that has been removed from its interior. The immobility of the car produces a sensation of imprisonment, revealing that the supposed vehicle is at one and the same time a coffin.[26]

In this seminal project, Orozco brought back to life the technical resources of cutting and slicing that had in the past been practised in the form of Dadaist collages and assemblages by, for example, John Heartfield and Raoul Hausman, or in the famous sequence from Luis Buñuel's 1929 surrealist film *Un Chien Andalou*. Later in the twentieth century other artists would apply such cuts in various disciplines, such as painting (Lucio Fontana cutting the canvas), architecture (the sliced house by Gordon Matta-Clark) and literature (William Burroughs' cut-ups). Orozco, however, combines the transgressive cut with another artistic tradition, that of Constructivism. As he pointed out, 'it is not sufficient to cut a car in half. You have to reconstruct it. [It isn't] an issue of discarding but also of reconstructing, reconfiguring, recreating a geometry.'[27] His own adaptation of the constructivist strategy is thus combined with that of the *objet trouvé*, creating a sculptural work that reflects some of the principal preoccupations about the object that have defined twentieth-century sculpture, notably including the Pop art critique of the dichotomy between high and low culture.

A few years earlier in Mexico City, Orozco had made another work that reconfigured an industrial object for artistic ends. For *Naturaleza recuperada* 1990 (*Recaptured Nature*, fig.11), he transformed two lorry tyres into a voluptuous sphere of inflatable rubber. In metonymic fashion, this sphere could also be considered a 'vehicle'[28] in that it maintained the rotative capacity of wheels. The

10 **Gabriel Orozco**
La DS 1993
Modified Citroën DS
140.1 × 482.5 × 115.1
Fonds national d'art
contemporain (Cnap), Paris

process of creation was similar to that of *La DS*, though this time, after he cut the two air chambers in half to form a new work, the size of the tyre did not diminish but increased relative to the original object.[29]

The year after his deconstruction and reconstruction of the Citroën, Orozco fabricated a further imaginary vehicle for the Museum of Contemporary Art in Chicago: *Elevator* (fig.12), a lift that was also cut and structurally modified. A year later, recalling its process of production, Orozco said:

The story about the elevator is a curious one. I thought it would be very easy to obtain a used elevator to cut it up; however, I spent a whole year finding it, because there is no such thing as a second-hand elevator. Elevators are made to order for each building, and when the building is destroyed, the elevators are destroyed. The Museum of Contemporary Art of Chicago, for which I made the piece, was looking for buildings in demolition until it found one with the elevator I had pointed out and asked them to please not destroy it. *Not* to destroy what was precisely in the centre of a building turned out to be a lot of work. It was memorable to finally see the demolished building, the level ground and wasted land, with an elevator in the middle, just like what we see now, because I didn't change it much: all I did was cut it and assemble it to my height.[30]

Indeed, Orozco cut the lift into three parts and again discarded the central part, so that its height exactly matched his own. As with *La DS*, he allowed visitors to the museum to enter the work and experience for themselves the new space

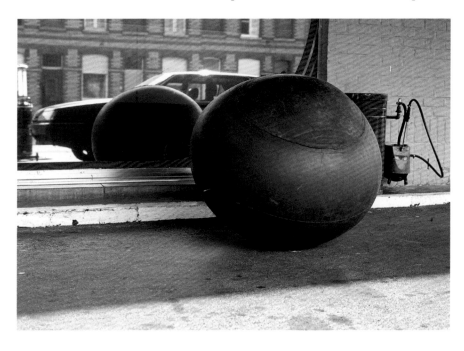

11 **Gabriel Orozco**
Naturaleza recuperada
1990
Recaptured Nature
Vulcanized rubber
Approx. 75 × 105 × 85
Alma Colectiva, Guadalajara

12 **Gabriel Orozco**
Elevador 1994
Elevator
Modified elevator cabin
243.8 × 243.8 × 152.4
The Dakis Joannou Collection

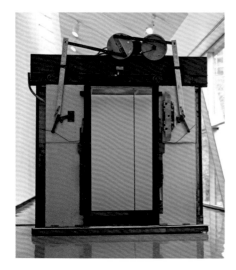

generated within the lift. Despite removing it from its context and altering its functionality, Orozco insisted that the lift still maintained a certain utility:

The elevator and the Citroën car also continue to be what they are after being cut up and reassembled; they keep on elevating and in some way transporting. They continue to function, we can live in their new configuration, we can get into them … They continue to be means of transport, they continue to be vehicles for a body.[31]

Rather than simply extracting an object from the world in order to bring it into the art space, Orozco seeks to make the individual aware of the materiality of his or her environment. As Jessica Morgan has suggested, 'this sculpture creates a dialogue that extends to the spectators through their real or projected participation, one that will take place only at the initiative of the spectator'.[32] In a way reminiscent both of the Situationist strategy of *détournement* (subversion) and of the Brazilian theory of the *não-objeto* (non-object)[33], Orozco intervenes an object to extract its centre, sabotage its nucleus and reassemble its elements in a new configuration. The result is an ironic metaphor about the centre/periphery dichotomy with unavoidable geopolitical resonance, since it presents a structure of alterity that is both sustainable and functional, composed of lateral and peripheral elements independent of a coherent and unifying centre.

More specifically, *Elevator* presents a 'static mobility'[34] of a vertical rather than a horizontal kind, emphasising the equivocal perception in any case produced by lifts when it is unclear whether they are going up or down. Moreover, by extracting it from the building, Orozco has stripped the object bare, transforming what existed exclusively as an interior space into an external space, thus undoing the hierarchy of reverse and obverse – curiously enough, the artist himself has observed that, in ordinary use, the interior of a lift is in fact its exterior.[35] This way of 'turning things inside out' and subverting the conventional order suggests precisely the kind of dialectical proceeding by which the work of art is defined.

The fact that the lift's dimensions were reassembled to fit the body of the artist himself shows to what extent the cutting and reassembling function is a way of bringing the industrial object back within a human, individual and non-standardised scale. Orozco had already materialised his body in *La piedra que cede* 1992 (*Yielding Stone*), a Plasticine ball of his own weight that he shaped by rolling it through the streets of New York (and before that of Monterrey); over the course of its itinerary, urban detritus stuck to its surface and it was imprinted with the relief of pavement and tarmac. In this action, Orozco was attempting dynamics of intervention in the public space similar to those with which the artist David Hammons was experimenting during those same years at New York, with a view to motivating new relationships with the most immediate and insignificant elements of the street.

The sculptural volumes of *Yielding Stone, La DS* and *Elevator* are conceived in proportion to the human body – both the body that they shelter and the body that they 'displace'. Anthropologically speaking, vehicles are based on the invention of instruments that increase the user's motor capacities. In Orozco's works, physical forces combine with geometrical exactitude and the organic body with mechanical beauty.[36] When the industrial object is subjected to the power of *physis*, its vulnerability is enhanced. This notion of vulnerability defines Orozco's aesthetic in ways that may be related to the destructive Mexico City earthquake of 1985, of which he was himself a witness. Yet, in Orozco's perspective, this vulnerability does not weaken the work of art, it strengthens it:

Yielding Stone is vulnerable, it always will be, the knocks it has received have become part of it and given it its form. But that is what makes it indestructible. Instead of making it from bronze or steel, which would theoretically make it invulnerable, I made it from a soft material which makes it vulnerable, and that vulnerability gives it a constant form and a permanent state of change which makes it indestructible.[37]

Orozco's imaginary vehicle is a reflection on the transport-object as a metaphor of the itinerant condition of the contemporary subject; this is exemplified by his own biography, which straddles Mexico, the United States and Europe. It is also a metaphor of ephemerality and this too is a definitive aspect of his work. The sense of voyaging and displacement is a constant in his trajectory and is used to evoke a transnational movement that traverses geographies now lacking any fulcrum, any centre of reference. In 1994, for instance, Orozco travelled to the Netherlands to take part in a group in the Witte de With Centre in Rotterdam. On his arrival he observed that a large part of the population used bicycles to get around, as he himself did during his stay in the city.

This was Orozco's inspiration for assembling four bicycles into a single structure, without any welding, merely discarding the handlebars and the seats in order to slot them one into another. *Cuatro bicicletas (siempre hay una dirección)* 1994 [*Four Bicycles (There is Always One Direction)*, fig.13] again worked metaphorically at various levels. At the most immediate, it was playing with the symbolic value of a national vehicle, in this case the Dutch bicycle, just as he had with the French Citroën in *La DS* and was later to do with the Italian Vespa in *Habemus Vespam* 1995. Furthermore, it presented a complex structure in natural equilibrium – Orozco once remarked that welding the bicycles 'would be cheating'[38] – an assemblage of frames and wheels that, though it seemed on the point of collapse, miraculously remained upright. Again vulnerability – the possibility of the composition's collapse – formed an integral component of the work of art. The piece thus presents its *promesse de bonheur* or, paraphrasing Adorno, makes 'the impossible possible'.[39] This proposition is reinforced by the subtitle of the work; the four bicycles always indicate

13 **Gabriel Orozco**
*Cuatro bicicletas (siempre
hay una dirección)* 1994
*Four Bicycles (There is
Always One Direction)*
Bicycles
198.1 × 223.5 × 223.5
Carlos and Rosa
de la Cruz Collection

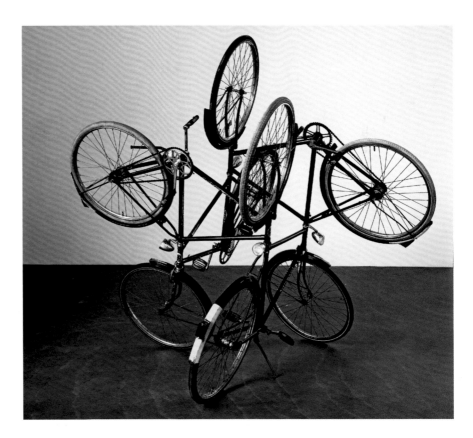

a direction rather like a weathervane that indicates all the cardinal points.

Orozco uses the vehicle as sculpture and sculpture as a vehicle of experience. Echoing the inherent mobility of the vehicle, he has said: 'I want to make site-specific projects but I also want the work to travel, to transcend space. It is important that the work should move and be exposed to the erosion of other places.'[40] In this respect the goal of his art, over and beyond the format in which it is materialised, is to 'create an experience':

[Viewers] are having an experience. They are not reading a document of someone else's experience ... What I am trying to do is to recover the word 'experience' in its full sense, from beginning to end. And in that sense, an object or a photograph or a drawing or a painting can be useful in the same way. The digital and the technological can be quite useful if they are capable of generating this experience and not just fakery or an illusion of something.[41]

Orozco's interest in generating a new living space, an aspiration already present in his imaginary vehicles, was subsequently developed through a series of

sculptures made on the basis of the concept of play: *Horses Running Endlessly* 1995, a chessboard where there are only knights; *Carambola con péndulo* 1996 (*Carambole with Pendulum*), an oval Spanish pool table whose red ball hangs from the ceiling, hovering over the baize; and *Ping-Pond Table* 1998, a four-way ping-pong table in which the non-space where the net should be has been replaced by a pond. These three works invite the viewer to participate and produce situations in which new rules evolve. The estranged object now fulfils a similarly estranged function, not only broadening the field of action to include the surroundings and its objects but multiplying its uses in order to revise a given system of organisation. It is precisely here that we find the liberating potential of his work: what Benjamin Buchloh has defined as a 'de-fetishising practice'.[42]

Orozco has stated that, in his view, rules have a strategic rather than a repressive meaning:

When things are dispersed, when you can't understand the way they are, you can invent a rule of behaviour that has its own logic. To begin with, love is like that: a series of rules that you invent at a given moment with somebody and which mean that everything else is relativised. They are, moreover, rules that you invent as you go along. I'm also thinking about the rules children invent when they play: to take a little car and instead of running it along the table, put it in the soup plate, just to see what happens, over and over again. The idea is to generate new rules on the basis of a known situation. On the other hand, it's interesting to see how the geometry that generates these rules of behaviour, even for oneself, can be reversed or inverted. The game in art is this: to rejuvenate this geometry, to turn it inside out.[43]

To turn the geometry of the world inside out means infringing the logic by which it is configured. It is a contraposition: an alteration in the order of things. That strategy may in some cases imply the dissolution of the artistic object itself in a specific and ephemeral social situation. In 1995, during his residence in Berlin on a DAAD grant, Orozco returned to the idea of working with a vehicle that was a national symbol, in this case with the kind of yellow Schwalbe motorbike that the former German Democratic Republic had mass-produced during the 1960s. However, unlike his interventions with cars, lifts or bicycles, *Hasta que encuentras otra Schwalbe amarilla* 1995 (*Until You Find Another Yellow Schwalbe*) did not present a sculptural object but documented an urban action.

The artist decided to ride his motorbike through the streets of Berlin until he came across another exactly like it. When this occurred, he got off his bike, photographed both bikes parked side by side, and continued his wanderings. By following this procedure, Orozco created an archive of unexpected encounters (fig.14). The project further included contacting the owners of all these Schwalbes to invite them to attend an artistic gathering in which they could exhibit all their motorbikes together, not as a melancholy commemoration of a vehicle from the past but as a celebration of a means of transport still in use.[44]

14 **Gabriel Orozco**
Hasta que encuentras otra
Schwalbe amarilla 1995 (detail)
Until You Find Another
Yellow Schwalbe
Forty chromogenic colour prints
Each 31.6 × 47.3
Tate. Presented by George
and Angie Loudon 1999

He organised the event for 3 October, the date on which the fifth anniversary
of German reunification was being celebrated. The fact that only two people
attended the encounter was perhaps indicative of some degree of failure in the
forced annexation of the two Germanies.

That same year, Orozco realised a further urban action, this time in Antwerp
for the Micheline Szwajcer Gallery. Observing the lack of public parking in
the zone where the gallery was situated and exploiting the direct access to the
streets from the gallery, he decided to convert the space into a covered car park.
Aparcamiento 1995 (*Parking Lot*, fig.15) thus transformed the private exhibition
space into a social space available without charge to the user. With marked
parking bays, external signage ('P' for parking) and the conversion of the gallery's
reception counter into a parking attendant's kiosk, the work implied a further
step in the process of making the individual participate in the production of the

15 **Gabriel Orozco**
Aparcamiento 1995
Parking Lot
Installation, Galerie Micheline
Szwajcer, Antwerp

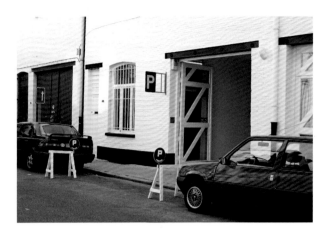

work of art and contributed to blur the frontier between art and life.[45] The British art critic Guy Brett said about this work that it

perpetrated a joke far funnier and more pointed than any satirist of the absurdity or the 'emptiness' of modern art has managed to produce. It was encapsulated in the idea that an anonymous passer-by, in the act of blithely solving a banal problem of everyday urban life, could unconsciously contribute to the elucidation of a crisis in the direction of contemporary art ... the anonymous motorist and his symbolic car slip into the role of protagonist by crossing a threshold between one context and another.[46]

Indeed, throughout the 1990s, the work of Gabriel Orozco contributed to blur the distinction between merchandise and sculpture, the public and private spheres, and between artistic practice and quotidian experience. The strategy was not invariably welcome and has generated its share of misunderstandings. Far from avoiding intellectual confrontation and faced with the kind of disagreements provoked by works such as *Until You Find Another Yellow Schwalbe*, the artist declared: 'The object is not to entertain the spectator ... People tend to forget that what I want to do is to disappoint them. I use this word deliberately. I want to disappoint the spectator who hopes to be surprised'.[47]

The architecture of dream

The installations that the Cuban artist Carlos Garaicoa (b. Havana, 1967) has developed since the early 1990s constitute a reflection on the processes of architectonic and urbanistic construction in great cities. Garaicoa initially focused on the idiosyncratic urban condition of certain quarters of his native Havana: a great many of these were constructed in the 1950s and 1960s and subsequently abandoned because of the historical events that marked post-Revolutionary Cuba, among them the US embargo imposed in 1962, Cuba's consequent economic dependence on the Soviet Union and the collapse of the latter along with the other Communist regimes in Eastern Europe in 1989. Garaicoa's earliest works consisted of drawings and maquettes for the projected reconstruction of neglected buildings and districts of Havana, showing the influence of Constructivist aesthetic principles. The Cuban capital appeared in these works as a 'ruin with utopian potential'[48] and the artist as the imaginary architect of the sempiternal ideal city once hypothesised by Fourier, Owen and other scientific socialists.

In 2002, Garaicoa exhibited *Continuidad de una arquitectura ajena* (*Continuity of Somebody Else's Architecture*) at the Kassel Documenta. The installation comprised maquettes, sketches and photographs presenting proposals for the completion of unfinished buildings in Havana (fig.16). In this urban intervention project, the artist designed spaces and structures on the basis of the original plans for these buildings, which had for the most part been initiated years before by the so-called *microbrigadas*. These were cooperatives of volunteers who, motivated by

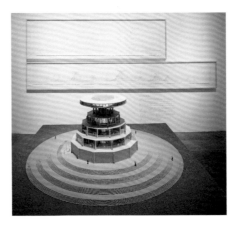

the need for housing in Cuba, began during the 1970s, in collaboration with state architects, to construct buildings for the use of their members. Garaicoa created new plans intended to ensure 'continuity' with this architecture that history had aborted. These plans included estimates of production costs to demonstrate the viability of the project and, should funds be obtained, to carry it out.[49] Thus Garaicoa attempted to renew the profile of the interdisciplinary artist situated midway between art, architecture and urban planning.

The Kassel installation could be interpreted as an implicit criticism of the inefficiency of the Cuban government or of the failure of the *microbrigadas*. It was, nonetheless, a broader reflection about the incomplete project of modernity and the way in which collective ideals could be reconstructed after the fall of the European socialist regimes. This is a topic on which Garaicoa has expressed himself very clearly:

For me, there was something frustrating about the fact that [most critics] interpreted *Continuity of Somebody Else's Architecture* as just one more debate about Utopia and the ideal city. [In] the work, I made it very clear that it was not a utopian product. On the contrary, I am discussing a specific social problem and my proposal is focused on the real constructive potential that the buildings possess. These are not mere mental constructions or debates about the possibility of transforming a city but current proposals concerning real sites.[50]

The fact is that Garaicoa's piece presented architectonic and town-planning designs as social activities that aspire to satisfy basic needs, those of housing and public space. It occupied a position in relation to the conflict concerning the lack of housing that afflicted and continues to afflict broad swathes of the population not only of Latin America but of the world as a whole – a lack that the artist has described as 'the failure of reality'.[51]

During this early stage, Garaicoa's art seemed rooted in specifically Cuban conditions. But as his career advanced, so his horizons broadened. In conversation in 2002 he observed:

For over five years my work has been focusing on phenomena pertaining to a Cuban context, its cities and social expectations. But at the same time it also attempts to trace broad paths, so my thoughts are able to circulate and encounter the ideal spectator, the global spectator. I'm afraid of works that address local or national problems that can be of no interest to anyone outside that realm.[52]

Thereafter Garaicoa made a new series of installations whose revision of the concept of 'Utopia' went well beyond the context of Cuban socialism. His intention was to revive the true meaning of 'Utopia', a notion that had, in his view, been 'excessively used'; this use had converted it into an 'empty word' of a 'pejorative' kind, 'thus invalidating the earlier intellectual, conceptual, historic debates concerning any art object'.[53]

At the same time, he was unwilling to allow the initially utilitarian vocation of his work to sideline its poetic scope. On the contrary, in his view the failure of reality had occurred not for lack of pragmatism but for lack of imagination. It is possible that the evocation of night in some of his works derives precisely from this need to relate architectonic construction to the exercise of oneiric fantasy. A series of five installations entitled *Nuevas arquitecturas o una rara insistencia para entender la noche* 1999–2003 (*New Architectures or a Rare Insistence on Understanding the Night*) presents maquettes of imaginary cities, some of them hanging, in which the buildings are made with Japanese paper lanterns and spread out across the darkness of the exhibition space (fig.17). These installations call to mind the city's nocturnal illumination, while the delicacy of their paper and wire construction connects architecture with the fragility of the creative mind.

One of the most complex 'nocturnal' works of this kind was *Ahora juguemos a desaparecer I* 2001 (*Now Let's Play to Disappear I*). With this work, Garaicoa moved from interrogating the dream of architecture (what would the ideal city be like?) to reflecting on the architecture of dream (how is any fantasy constructed?). If the solution to society's failure could be found only through the human imagination, the object of study was no longer Utopia but the mind that had been capable of creating it time and again, incessantly designing an ideal world of justice and liberty. For Garaicoa, any such study should nevertheless avoid any one-dimensional or Manichean vision, for the fantasy of a perfect system could also become a nightmare. The plan of this particular work should therefore include its own destruction.

Now Let's Play to Disappear I was made up of candles that slowly burned away (fig.18). Garaicoa made this ephemeral work as part of a collective project of public art curated by Jan Hoet in Arnhem.[54] The artist, on learning that the Dutch city had been bombed during the Second World War, constructed a maquette of the city in wax with miniature replicas of the buildings destroyed during the conflict; it was installed on a cross-shaped iron table in Arnhem's Cathedral, the Eusebiuskerk or Church of St Eusebius, which was destroyed in 1944 and reconstructed during the 1960s.

On the first day of its presentation to the public, Garaicoa lit all the candles of the scale reproductions and, as the flames consumed the wax, the maquette of the city gradually melted away until it disappeared. Placing the work in a church bestowed an almost liturgical halo on the process. The installation was specific to the place and ephemeral in time. The reception in Holland was very positive, in part because it combined 'pure sculpture' with 'a precise and tangible historical study' of the former plan of the city, thus generating a meeting place 'between the real and the fictional world'.[55] The work nevertheless utterly refused to elevate itself to the status of a

17 **Carlos Garaicoa**
Nuevas arquitecturas o una rara insistencia para entender la noche
2000 *New Architectures or a Rare Insistence on Understanding the Night*
Wood table, wire and rice paper lamps
Installation, Collection Museo Nacional Centro de Arte Reina Sofía, Madrid

18 **Carlos Garaicoa**
Ahora juguemos a
desaparecer I 2001
Now Let's Play to Disappear I
Metal table and candles
Installation, 9th Sonsbeek
Public Art Exhibition, Arnheim

19 **Carlos Garaicoa**
*Ahora juguemos a
desaparecer II* 2002
Now Let's Play to Disappear II
Metal table, candles, wire
and closed circuit projection
Installation, Galleria Continua,
San Gimignano

memorial monument. Garaicoa had become aware that commemoration of the bombardment of Arnhem underpinned the tourist strategy of the municipality. By incorporating its own extinction into the creative genesis of the work, he not only destroyed the art object but added into it a veiled critique of the commercialisation of historical memory.

A second version of the work, *Now Let's Play to Disappear II* 2002, was made and exhibited the following year and similarly destroyed by fire. But this time the artist adapted the installation to a global context by including in his imaginary city buildings and monuments of international reputation, such as the Twin Towers of Kuala Lumpur, the Basilica of St Peter in Rome, the Eiffel Tower and the Statue of Liberty. Garaicoa also installed a number of video cameras and recorded the gradual disappearance of the wax buildings from various points of view, projecting this record in real time onto a screen alongside the maquette (fig.19). The study of the architecture of dream thus metamorphosed into a (video) analysis of a nightmare vision. The retransmission by closed-circuit evoked a control-and-surveillance state within the city while recording the catastrophic corrosion of its physiognomy. This was no commemoration of a past tragic event, such as we saw in the first version of *Now Let's Play to Disappear*, but a premonitory vision of future chaos. To the extent that the installation was destroying emblematic buildings that have come to symbolise the progress and wealth of different civilisations, the work established itself as a counter-monument, a vision in which the false permanence of empires was exposed. It was, ultimately, an adaptation of the Babel myth. Garaicoa himself used the phrase 'ruins of the future' to explain this work. He noted that in today's world,

Unfinished buildings abound, neglected and in a sort of momentary oblivion. The encounter with these buildings produces a strange sensation; the issue is not the ruin of a luminous past but a present of incapacity. We face a never-consummated architecture, impoverished in its lack of conclusion, where ruins are proclaimed before they even get to exist. I call these the Ruins of the Future.[56]

The frog and the steamroller

To mark the solo exhibition of the Colombian artist María Fernanda Cardoso (b. Bogotá, 1963) organised in 2004 by the Biblioteca Luis Ángel Arango in her native city, a catalogue was published that rejected the customary chronological presentation of the artist's work. Instead it opted to categorise her oeuvre according to the different materials that the artist had employed over the course of her career. The list of these materials was long and therein lies a part of Cardoso's originality; it included caramel, soap, gold, maize and gourds. Other works were made with crickets, vipers, lizards, butterflies, seahorses, sand, cement, bones and wool. Prefacing the catalogue, the curator

Carolina Ponce de León related this variety of materials in Cardoso to the modern era's aspiration to apprehend the world scientifically:

An itemized list [of these materials] calls to mind the inventory of a 'cabinet of curiosities', those private collections of *exotica* that proliferated throughout 17th-Century Europe. Also known as *Wunderkammern*, or cabinets of wonders, they included a variety of cultural trophies and rare objects of historic, scientific and artistic interest; from starfish, 'unicorn' horns and crocodile teeth to ethnographic artifacts, historical documents and artworks.[57]

And it is true that the influence of science, and in particular of taxidermy, is essential to Cardoso's work. Since the early 1990s, she has, moreover, combined many aesthetic elements deriving from fields as diverse as floriculture, pre-Columbian art and the circus.

Her sculpture *Ranas bailando en la pared* 1990 (*Dancing Frogs on Wall*) is perhaps the piece that best condenses the multiple ingredients with which she has constructed her sculptures and installations. From a distance, the first thing one sees is an attractive circular metal sculpture of considerable size (almost 2 metres in diameter) inhabited by figurines adapted to the wall and apparently weightless (fig.20). As the spectator moves closer to the work, he sees that these figures are in fact some one hundred frogs lined up in identical posture. Moving even closer, one discovers that they are authentic frogs, desiccated, squashed flat, violently pierced by the metal circle and organised as if they were uniform, mass-produced parts of an army or were concentrating on a macabre dance. The process by which the work is perceived thus contains an element of surprise – if not indeed amazement – produced by the different stages of meaning; as the viewer focuses in on the work, they range from the monumentality of the circle to the minutiae of the amphibians' gestures.

Cardoso began working with desiccated animals early in the 1990s on the grounds that they allowed her to 'conserve an instant, a moment'.[58] For the artist it was very important that these should be real animals and not recreated in the studio with synthetic materials: 'The animals with which I work', she once remarked, 'are beings that were alive, that once existed.'[59] Seen from close up, *Dancing Frogs on Wall* does indeed give the viewer the sense of seeing a real physical body that has been mummified and preserved forever. However, Cardoso eschews what taxidermy does, that is, attempt to present the living movements of an animal. On the contrary, these desiccated animals do not so much embalm life as eternalise death. In a conversation with the curator Hans-Michael Herzog in June 2004, Cardoso declared that her work was not 'beautiful':

The toads are dead and look like mummies. They don't aspire to be attractive like they do in taxidermy, where they pretend to be alive with the beauty of color and life. No, here they looked drawn, wrinkled. What I did was to stretch them a little bit, place them in

a geometrical position and take away the corpse's narrative and turn them into art. But it was a minimal gesture.[60]

The original idea for this work came from a joke that Cardoso heard when she was a child, featuring a frog run over by a steamroller. Thus she recreates the world of her childhood, while reflecting on death from the perspective of the aesthetic paradigms of her own *sui generis* minimalism. Moreover, in the way that it sets up a dialogue with *Wunderkammern* and taxidermic collections, *Dancing Frogs on Wall* offers a reflection on humanity's determination, as expressed in art and science, to control nature. What those extravagant scientific collections of the late seventeenth century began to signify was the aspiration to classify and dominate nature, one that was to characterise the Enlightenment over the course of the following century. That tendency, as Adorno and Horkheimer diagnosed in their *Dialectic of Enlightenment* (1947), made the Enlightenment its own victim; in its attempt to emancipate itself from mythical thinking, it fell prey to the authoritarian myth of total domination.[61] Though Cardoso's attempt to 'understand and control nature [in] search of perfection' is undoubtedly a response to this enlightened impulse, the impulse is subjected to its own critique in the final meaning of the work.[62]

A number of curators have mentioned the relation of Cardoso's work to the European avant-garde of the early twentieth century and its concern with generating pure geometric forms and expressing movement through the artistic object. Irma Arestizábal, in the catalogue of the fiftieth Venice Biennale, pointed out that Cardoso followed in the wake of this European tradition by attempting to 'wrest the organic form into geometrical abstraction', while José Roca noted that 'in her work with frogs, snakes, crickets, flies and lizards, the animals are subjected to precise geometric placement, in circles, spheres or ellipses, resulting in sculptures that bring to mind Modernist formalism'.[63] In *Dancing Frogs on Wall*, the geometrisation is shown not only in the metal circle but in the arms and legs of the frogs, which, after crushing, are arranged at perfect right angles. But can we reduce this search for movement through mass-produced repetition of animal figures – or indeed Cardoso's desire to geometrise the natural world – to anything as simple as a revision of Bauhaus, de Stijl or Constructivist theories? The artist replies:

[In *Dancing Frogs on Wall*] there is a reference to animation, when you repeat and create the illusion of movement. If you repeat the animals, they seem to start dancing or jumping about. [But] in these works, there is also the reference to pre-Columbian culture. Some pre-Columbian necklaces are made from many frogs: so I stylized them and put their paws or feet at a right angle, as if referring to indigenous art and design, which turns nature into geometry.[64]

21 María Fernanda Cardoso
Corona para una princesa
Chibcha 1990/2002
Crown for a Chibcha Princess
Preserved lizards and metal
Approx. 216 × 90 × 24
Daros Latinamerica Collection,
Zurich

Thus the influence seems to come not only from modern but from pre-Columbian art, which Cardoso studied in depth while growing up in Bogotá. During her education, the artist only had access to European art through books and magazines, and her principal influences were indigenous primitive art and the religious arts that the Spanish Catholic colonialists brought to Colombia: 'I always found it funny that the modernists looked at the "primitive" cultures for inspiration, and then we (the margins-the primitives) looked at them for "models".'[65]

The relationship with pre-Columbian art in *Dancing Frogs on Wall* is not confined to the geometrisation of the animal or the aspiration to reproduce its movement. Cardoso has brought into play the ancient aspiration to create in the artistic object an allegory of life and death represented in the form of dance. Though the cult purposes of pre-Columbian art are here secularised, the invocation of the world of the dead through the dance of the living has survived intact. This ritual character of the work also derives from the 'strong influence' of religious art: 'The Catholic religion with its churches, Christ on the Cross, the idea that you die and are redeemed; the belief that they torture you, you suffer and then you will be saved. That is very strong and visual. That is the clearest influence', Cardoso has said.[66] This no doubt accounts for the work's analogy with the theme of *memento mori* and the still lifes that conveyed the ephemerality of life and the feeling of *vanitas* so characteristic of baroque art.

Corona para una princesa Chibcha (*Crown for a Chibcha Princess*), a work that

Cardoso first made in 1990 and remade in 2002, is a slender structure of metal
from which the artist delicately hangs a crown of lizards. The legacy of the
Chibcha civilisation, which was known for its architecture and gold work, is in
this work fused with Catholic tradition, in which the crown of thorns symbolises
the suffering and sacrifice of Christ. The beautiful composition of the work
when seen from a distance contrasts with the disconcerting, indeed disturbing,
effect produced close up by the wrinkled, scaly bodies of the grey lizards (fig.21).
Cardoso thus subjects the pre-Columbian and religious image to a process of
demystification in which the pain so clearly expressed in the form of reptiles
desiccated and perforated is not necessarily redeemed: 'Mythic pre-Columbian
spirituality is interrupted by the endemic mortality of a society surrounded by
seemingly endless psycho-social and political violence.'[67]

 The violence of *Dancing Frogs on Wall* and *Crown for a Chibcha Princess* derives
from the historical context in which Cardoso began working as an artist:

The start of my reflections about death came at the end of the 1980s, which coincided
with the worst of the persecution of [Colombian drug lord] Pablo Escobar, with the killing

23 **María Fernanda Cardoso**
*Jugaban fútbol con las
cabezas* 1991
*They Played Soccer
with Heads*
Two human craniums, clay,
plastic tubing, wire
20 × 30 × 117

of Presidential candidate Luis Carlos Galán, the bombing of the police headquarters and the blowing up of the Avianca plane, amongst other things. That was a period of very intense violence ... Every day there were massacres, so, how could I express my concern?[68]

Two of the earliest works with which Cardoso sought to answer this question were *Sol negro* 1990 (*Black Sun*) and *Jugaban fútbol con las cabezas* 1991 (*They Played Soccer with Heads*). In the first of these, a stylised black ball is impaled on a slender metal spike; the close-up view reveals that the blackness of the sun is formed by hundreds of dead flies (fig.22). In the second, which is based on the urban legend that Colombian drug smugglers played football with the decapitated heads of their enemies – and indirectly anticipated the point blank assassination in 1994 of the Colombian national football team player Andrés Escobar – Cardoso constructed a sphere from the pale hemispheres of two human skulls, which are brought together in the form of a mortuary ball (fig.23).

Contemplation of the frogs dancing on a wall, like that of the lizards, flies and skulls, has a destabilising effect on the spectator. Cardoso's sculptures, in their beautifully detailed evocation of the natural, animal and human worlds, seem graceful and innocent but are, when seen from close up, extraordinarily violent. 'My strategy', she has said, 'is to make the spectator an accomplice by having them enjoy an aesthetic experience which has a disturbing basis. This complexity means that my relationship with the spectator is never black or white but complex and full of contradictions, with multiple levels of interpretation.'[69] It is this quest for a form of expression of multiple and paradoxical meaning that enables Cardoso's work so effectively to combine life and death, religious and scientific elements, and, for the viewer, pleasure and revulsion. Like the frogs, living between land and water, her sculptures inhabit a kind of 'limbo',[70] a zone of indiscernibility, in which the combination of antithetical binomials becomes the determining element of the work of art.

The double dimension of *tempo*

Neto transforms space through the organic rules of exuberance; Orozco sabotages industrial goods in order to create imaginary vehicles; Garaicoa consumes the city in a mythical narrative that reinvents the project of community; Cardoso embalms death in her reflection on unending psycho-social violence. But how can we describe the art of Rivane Neuenschwander (b. 1967, Belo Horizonte)? What does the work of this artist actually do? Critics and curators have found it hard to identify the ideas that Neuenschwander has enacted through her installations, sculptures, sketches, photos and videos. In an account published in *ArtNexus* in 2007, critic Richard Leslie observed that 'you can't really capture Rivane Neuenschwander',[71] and in an article in *Flash Art,* justifiably entitled 'Ethereal Materialism', the curator Jens Hoffman added: 'Although her work might appear to be slight in its constitution, it is incredibly strong and complex.'[72]

Neuenschwander is difficult to understand not only because her work simultaneously foregrounds a number of different forms of research (on the formation of language, the functioning of memory or the vulnerability of nature) but also because it is based on a very specific contradiction: that of using 'modest' forms to approach 'major' themes. For example, the installation *Palavras cruzadas (Scrabble)* 2000 [*Crosswords (Scrabble)*] is a reflection on the creative possibilities of language. It lays out on the floor of the exhibition space a cardboard labyrinth some few centimetres high and a number of letters made from peeled and dehydrated oranges (fig.24). There are no great contraptions or high-tech resources; the work does no more than present precarious corridors and a basic alphabet with which the visitor interacts, using the letters to form words in each of the micro-spaces created by the installation. In this way the piece uses a minimum of resources to activate not only the spectator but language itself and reinvigorate the idea that languages, far from being static entities, are flexible systems of communication reinvented on a daily basis.

A second example of this tendency is *Carta faminta* (*Starving Chart*), which was also made in 2000. Here Neuenschwander approaches another issue fundamental to the Brazilian countercultural tradition, ingestion, as it has been understood since the publication of Oswald de Andrade's *Cannibal Manifesto* (1928) and the subsequent Tropicália movement. Reflecting on cultural cannibalism or the way in which artistic forms 'eat' each other up, the artist does not attempt a striking spectacle or use hyperbolic machinery. We are simply given to see a series of slender leaves of rice paper, which, as they are eaten by little snails, take on the aspect of a partially devoured mappemundi. By these very modest means, the work effectively incorporates the three original senses implicit in the idea of *antropofagia*: a 'metaphor' of an ancestral cultural rite, a 'diagnosis' of colonial trauma, and a 'therapy' intended to cure this trauma with its carnivalesque and unbridled humour.[73] The snail – a hermaphroditic mollusc much favoured by European colonial gastronomy – reconfigures the map of the world with its slow but unstoppable ingestion. As Neuenschwander herself has admitted: 'I like the idea of using the most ordinary things to try to talk about more complex issues.'[74]

One of the latter is undoubtedly *o tempo* in the two principal acceptations of the Portuguese word: *tempo*, on the one hand, as weather, the state of the atmosphere, the climate; on the other, as time, the duration of what is mutable, the uninterrupted sequence of incidents whose study has occupied scientists, artists and philosophers since the very birth of civilisation. In her installation *Continente-nuvem* 2007 (*Continent-Cloud*), Neuenschwander designed a translucent false ceiling over which moved a number of balls of foam, incessantly creating different forms (fig.25). The spectator observing the changing shapes as they move might be watching clouds crossing the sky. The false ceiling hides the

fans that move the balls and thus enhances the element of surprise when the balls configure new outlines, as if they were giant amorphous bodies or maps of invented continents. Neuenschwander's practice here reverses that of the Land art artists: while they left the exhibition space behind to work directly with nature, she brings natural phenomena back into the gallery.

In *Chove chuva* 2002 (*Rain Rains*), an installation realised in the Museu de Arte da Pampulha of Belo Horizonte, Neuenschwander hung twenty-five aluminium buckets in a large room with chrome-plated columns designed decades before by the architect Oscar Niemeyer (fig.26). Half of the buckets hanging from the ceiling at various heights have been pierced, so that they let the water that they contain fall drop by drop into the buckets situated directly below them. In this way, within the Museum, a natural event is produced ('rain') while comment is humorously passed on 'the not uncommon precariousness of Brazilian rooftop construction and maintenance: water leakages, especially after storms' being common occurrences.[75] The hanging buckets in fact empty themselves every four hours and so, for the installation to go on functioning, someone

25 **Rivane Neuenschwander**
Continente-nuvem 2007
Continent-Cloud
Correx, aluminium, Styrofoam
balls, fluorescent lighting,
electric fans and timers
Installation, Museum Boijmans
van Beuningen, Rotterdam, 2009

26
Rivane Neuenschwander
Chove chuva 2002
Rain Rains
Aluminium buckets, water,
steel cable and ladder
Installation, Museu de Arte da
Pampulha, Belo Horizonte

must empty the lower buckets into the upper buckets with the aid of a small, chrome-plated stepladder. *Rain Rains* thus requires the participation of a person, whether a museum employee or a visitor, for its regular revitalisation. In this respect, the work additionally alludes 'to recycling, and, indirectly, to sustainable development, a maintenance of balance that might also be a metaphor for the emotions'.[76] Bearing in mind that each bucket, each 'rain', has to be refilled by somebody, the curator Lysette Lagnado declared that this arrangement is 'more than a jeux d'esprit, it is positively salutory':

Negotiating with participants – voluntary and involuntary, as the situation requires – has been essential to Rivane's more recent works. The result foregrounds the multiple layers of cooperation, drawing on other people's productive talents in a way analogous to the transformations of capitalism. It is a manifestation of pure biopotency. That characteristic may not, after all, be so alien to Brazil. As the art critic Mário Pedrosa pointed out in a 1959 text on Brasília, 'our past is not fatal because we reinvent ourselves every day'.[77]

Indeed, the aspiration to remake the past and transform the logic of production through interactivity with spectators is present throughout Neuenschwander's work. In *Ici là-bas aquí allá* 2002 (the title means 'here there' in French and Spanish), an installation made in the Palais de Tokyo in Paris, visitors are asked to sketch the Eiffel Tower from memory and then climb a number of staircases to a point where they can see it through a high window and thus establish whether their sketch coincides with the real thing. In *Eu desejo o seu desejo* (*I Wish Your Wish*), conceived in 2003 and subsequently installed in cities including Beirut, London and Pittsburgh, visitors encounter hundreds of coloured tapes fixed in orderly fashion in holes in the wall, on which they can read the wishes inscribed by earlier 'spectators' of the work (fig.27). New visitors can take away one of the ribbons tied around their wrists and fix in the now empty hole a piece of paper with their own wish written on it. Neuenschwander prints the new wish on a new ribbon, which will be exhibited at the next site of the installation, thus converting every individual who has taken part into a co-author of the work. A third work by Neuenschwander, suggestively entitled '...' 2005, confronts spectators with a number of typewriters that the artist has installed in the gallery and modified so that instead of letters they can only write full-stops and symbols. Those who wish to may 'write' and then hang their works on the walls of the room. Just as the duration of the 'portraits' that Félix González-Torres made with chocolates and sweets in the early 1990s depended on what was done with them by their 'users', the life of certain of Neuenschwander's installations directly depends on the interventions of her more or less active spectators.

Forming words with oranges, making wishes with coloured tape, writing without letters and sketching the Eiffel Tower from memory – these are all ludic activities, ways of taking part in the game of art, which is necessarily constructed

27 **Rivane Neuenschwander**
Eu desejo o seu desejo 2003
I Wish Your Wish
Silkscreen on fabric ribbons
Installation, Museu de Arte
Moderna Aluisio Magalhães,
Recife

within specific spatio-temporal coordinates. Filling buckets of water that drip 'rain' serves to 'temporalise' the exhibition space and emphasise – as Orozco and Garaicoa have also done – the way in which every artistic object depends on the fourth dimension. The interest of *Rain Rains* thus comes not only from the way in which it recreates the natural phenomenon of rain but from its understanding of time as an abstract transilience. The Brazilian curator Moacir dos Anjos has rightly pointed out that 'a singular occurrence (drops falling at a given cadence) thus becomes the condition for understanding a generic fact (the idea of time within which an event occurs). The abstract is obtained from the ordinary.'[78]

A work like *Estórias secundárias* 2006 (*Secondary Stories*) exemplifies how Neuenschwander's research on time as *klima* goes on to become an investigation of time as *khronos*. In this installation, Neuenschwander again constructs a translucent false ceiling which on this occasion, instead of 'clouds', supports dozens of small circles of paper, pieces of confetti some 10 cm in diameter in a multiplicity of colours: lime, lemon, rose, cherry, turquoise and so on (fig.28). Unlike *Continent-Cloud* – and here lies the true originality of *Secondary Stories* – the ceiling is perforated so that the pieces of paper not only shift about over the heads of the visitors but filter through the holes and descend onto the floor of the gallery. The 'rain' of confetti again occurs within a specified period of time and when all the small pieces of paper have fallen onto the floor, the work has run its course and may be considered complete. The perception of the work on the part of the spectator also changes according to the state in which he or she finds it. When the coloured circles are moving overhead and falling through the air, the work is reminiscent of the joy and excitement of the Rio de Janeiro carnival. By contrast, when all the confetti has piled up on the floor, it tends to evoke a 'certain melancholy after the days of madness and excess', as Neuenschwander has said.[79]

In Neuenschwander's 'game of creation', *khronos* can be both generative and destructive. The curator Rosa Martínez has pointed out that Neuenschwander's works 'broaden perception and thus give form to some of the landscapes of contemporary anxiety'.[80] Among the thousand or so wishes collected in Pittsburgh after the exhibition *I Wish Your Wish*, 'several dozen reflect the anguish of having soldiers in the Iraq war, or dissatisfaction with the current government [that of George W. Bush]'.[81] In the collages that make up *Carta de agua* 2007 (*Rain Chart*), Neuenschwander exhibits maps that have been damaged by rain and in the video made with Cao Guimarães, *Inventario de las pequeñas muertes (soplo)* [*Inventory of Small Deaths (Blow)*], made in 2002, one can see beautiful, fragile soap bubbles that could burst and disappear at any moment. These works, Neuenschwander says, 'stand as a metaphor for the problems stemming from environmental neglect and the implications of this for the future'; they 'understand the moment at which the flow of life is interrupted by the arbitrariness of chance'.[82] Just as her reflection on *klima* is not monolithic but plural, so the passage of *khronos* appears in her work

28 **Rivane Neuenschwander**
Estórias secundárias 2006
Secondary Stories
Correx, tissue paper, steel
cable, fluorescent lighting,
electric fans and timers
Installation, Tanya Bonakdar
Gallery, New York

29 **Héctor Zamora**
Delirio atópico 2009
Atopic Delirium
14000 kg of plantains
Installation,
Plaza San Victorino, Bogotá

not as something unpredictable and redemptive but as an irrevocable, imminent flux that is 'not transcendent'.[83]

Calendario de expiración 2002 (*Deadline Calendar*) exemplifies the use of a 'modest' form to approach a 'grand' theme. Neuenschwander composed twelve collages, one for every month of the year, with pieces of paper or cardboard from food-wrappings showing the expiry date. She grouped them in sequential order so that every day of the month was included in each collage and thus the series as a whole constituted a calendar of the 365 days of the year. By emphasising that everything has an expiry date, the work suggests the futility of the human determination to organise and compartmentalise time in relation to capitalist production. The ephemeral character of the commodity reminds us that, after a certain date, it has already decayed and is fit only to throw away. Even in reference to the work of art, posterity and eternity do not exist. When asked why she used ephemeral materials in her works, Neuenschwander replied:

Perhaps [because of] an inability to get to grip with more concrete things; or a wish to understand the fragility of life, the finite nature of things, our impermanence in the world; or the simple observation of the passing of time and our being part of nature, and still subject to cycles; and perhaps all this together.[84]

Bursting point

In October 2009, the artist Héctor Zamora (b. Mexico City, 1974) intervened in two modernist buildings in Bogotá as part of the collective project *Lugares comunes* (*Commonplaces*) commissioned by the municipal Arts Council and comprising works by a total of ten artists. Zamora's work, entitled *Atopic Delirium*, fell midway between sculptural installation and artistic intervention in the public space, and consisted of filling two floors of two office buildings in the centre of Bogotá with bananas (fig.29). So many bananas were used that they stuck out the windows of both spaces, giving the impression that nature's invasion of the office environment had filled it to overflowing.

Like Walter de Maria, who filled a gallery space with earth in his famous *Earth Room* 1968, Zamora borrowed from the practitioners of Land art a disruptive tactic of spatial kind in order to interrogate our perception of the built landscape. In an aesthetic sense, *Atopic Delirium* stood out because of the contrast between the cold surface and metallic colour of the windows and the lively colours and rugged form of the bananas. The installation lasted several weeks and over the course of this time the green bananas naturally ripened, so that the work changed colour from the initial green to yellow and brown. On the symbolic terrain, the banana clearly has significant social resonance in Colombia, not merely because it is an essential part of the staple diet and gastronomic culture of the country. Its central role in Colombian economy and history cannot be overstated.

With Ecuador and Costa Rica, Colombia is the world's principal banana

exporter; these three countries together represent 63 per cent of total exports of this fruit. Banana cultivation is a vital sector of the agriculture and food industries of the country. For instance, in the year 2000, Colombia devoted some 60,000 hectares to the cultivation of bananas and earned some $450 million from banana exports.[85] In historical terms, the banana evokes both the colonial period, when plantations first began to be exploited, and the conflicting relations that the Colombian citizens have endured over the course of the twentieth century with North American companies and with the United Fruit Company in particular. Zamora himself pointed out that the first comments elicited by *Atopic Delirium* among the Bogotá public turned, 'as one might expect, on the US banana companies and the political situation'.[86]

The United Fruit Company has cut and is still cutting a bloody swathe through the history of the country. In today's Colombia, people still remember the 'Massacre of the Bananeras' (banana companies) in December 1928, when, under pressure from the multinational, the government of Miguel Abadía Méndez ordered in the army to repress a strike in which thousands of workers were protesting against the harsh working conditions imposed by the company. The fictional recreation of this historical episode by Gabriel García Márquez in *One Hundred Years of Solitude* (1967) has lost none of its relevance: the same company was implicated in the Bananagate scandal in Honduras in 1975 and in the late 1990s, under its new name Chiquita Brands International, was accused of direct participation in drug trafficking. In March 2007, it was fined $25 million by the US Department of Justice after it had been demonstrated that the company was illegally financing Colombian paramilitaries.[87]

Beyond the significant use of the banana as sculptural object, *Atopic Delirium* acquired a political meaning by virtue of its location within Bogotá's urban grid. Zamora made the installation in two similar buildings found on the same street, the Avenida Jiménez, which forms the border between the rich zone of the north and the poor suburbs of the south. The first of the two buildings, the Edificio Monserrate, lies only a kilometre from the second, which stands opposite the Plaza de San Victorino in a very different socio-economic context. As the artist has said, with this work he wanted to talk 'about social class, and I found out how great a social distance there can be within a few blocks. Higher up you find expensive restaurants; lower down, in San Victorino, they are all popular and a lunch costs no more than 5,000 pesos',[88] that is, less than £2 sterling. He noted that the intervention in the rich area gained much less attention from the public than in the southern building, where the work was a much-praised talking-point:

The reaction of the owners of the two spaces was also very interesting. In San Victorino, the owner of the premises was a very nice gentleman, and much taken with the project. At the other end, we were working with a lawyer who owned the office, a man with lots

31 **Héctor Zamora**
Enjambre de dirigibles
2009
Zeppelin Swarm
Stuck zeppelin
Installation, 53rd Venice
Biennale, 2009

of money, of high social class, who arrived two days before the opening and wanted us to close the exhibition, because he didn't understand that this could be art. Finally everything came down to 'I want more money'.[89]

In this respect, *Atopic Delirium* 'set up a dialogue between social classes of Bogotá', a dialogue that is undoubtedly conflictual.[90] The distribution of wealth among the city's seven million inhabitants is such that 49 per cent of the population live below the poverty threshold. Indeed, the title of the work may refer to this astounding difference between social classes. The 'delirium' suggested by Zamora's bananas may be the delirious economic policy of the Latin American governments that have functioned as 'banana republics'. This famous term, coined by a US humorist early in the twentieth century, has ever since been employed in eloquently pejorative fashion to describe the social and cultural backwardness of countries where the local oligarchy has worked for powerful

32 **Héctor Zamora**
*Paracaidista, Av. Revolu-
ción 1608 bis* 2004
*Parachutist, Av. Revolución
1608 bis*
Self-construction system
74 m²
Installation, Carrillo Gil Art
Museum, Mexico City

multinationals and the process of de-democratisation has grown ever more intense.[91] The critique made by Zamora's intervention is nevertheless global rather than local since the delirium is, as the title specifies, 'atopic'; that is, it is not attributed to any specific place though it could indeed relate to Bogotá, Tegucigalpa or any other place where the *bananera* policies of an antidemocratic government prevail – on this or any other continent.

As we have seen with Orozco, Garaicoa and Cardoso, Zamora's artistic practice explores, rather than avoids, conflict. His most important works seem to arise from a tension that is present at formal level but at times transcends the work itself to affect the social and cultural environment in which it has been installed. In one of his first interventions, *Pneu* 2003, made for the Galería Garsh in Mexico City, Zamora created an inflatable work of red plastic in the form of a gigantic tube 130 metres long and 2 metres wide, which occupied the inside and outside of the gallery. When inflated, this object overflowed out of the door of the exhibition space, rising to the roof of the building (fig.30). His recent project for the fifty-third Venice Biennale, *Enjambre de dirigibles* 2009 (*Zeppelin Swarm*) made use of a similar strategy, wedging a gigantic Zeppelin into a narrow street of Venice's old city centre (fig.31). The white dirigible jammed between two brick buildings of the Arsenale seemed permanently about to burst.

Such tension is not confined to the works that Zamora has designed using inflatables. In one of his best-known interventions, *Paracaidista, Av. Revolución 1608 bis* 2004 (*Parachutist, Av. Revolución 1608 bis*), he constructed a living space

measuring 70 square metres out of steel, wood and cardboard, and attached it to the upper floors of the Museo de Arte Carrillo Gil in Mexico City. Hung from the flat roof of the building as if it really had been parachuted in, it parasitically appropriated the institution's electricity and in exchange gave back the liquid and solid remains produced by the sole inhabitant of this living space, that is, Zamora himself. The work proved very polemical and generated considerable hostility in the immediate socio-cultural neighbourhood (fig.32). The construction of the work was interrupted for six months by legal disputes that caused 'great institutional and bureaucratic pains'.[92]

When *Paracaidista* was completed, it was strongly criticised, especially by the Mexican association of architects, which considered the work a direct insult to its profession.[93] Another installation planned two years later for the twenty-seventh São Paulo Bienal, *Geometrías dañinas* 2006 (*Injurious Geometries*), in which the artist planned to place floating structures on one of the city's lakes, was categorically banned because the Ministry for the Environment considered it 'unacceptable' and prevented its realisation.[94] These negative reactions to Zamora's work on the part of various sectors of the establishment undoubtedly have something to do with their subversive power; as Cuauhtémoc Medina has pointed out, they are intended to produce 'proletarian metastasis'.[95]

Atopic Delirium also generates tensions between the natural and the built, between the private and public space, between dissident art and the authorities that keep an eye on it. Bulging with bananas, the offices in which Zamora intervened encapsulate the moment in which the container is no longer able to confine what it contains. The words that the artist himself used to define one of his first projects could equally be applied to this irreverent installation in which 'the energy of nature and the organic, which needs to escape and grow, literally violates the internal state of the gallery, escaping out onto the street [in order to] activate the public space'.[96]

What seems interesting about the metaphorical connection that Zamora establishes between the notions of hyper-production and explosion is the way it explores the phenomenon of superabundance – whether of bananas within the offices or air within the dirigible – as a phase immediately prior to crisis. His works thus constitute a challenge to the optimism of the liberal and neoconservative ideologies, showing that, in the context of the global recession at the end of the first decade of the twenty-first century, the culminating moments of the capitalist economy are irremediably linked to its deepest troughs. Zamora's work ultimately demonstrates that a system oriented exclusively towards profit is neither sustainable nor even possible and that the rich quarter to the north of the Avenida Jiménez could never have come into being without the deprivation of the poverty-stricken southern quarter.[97]

Videographic practices

Taking position

In a series of videos made with spinning tops, the Argentine artist Miguel Ángel
Ríos (b. Catamarca, 1943) has established a direct dialogue between sculptural
space and video imagery. *A morir* 2003 (*'Til Death*), *Retorno* 2003 (*Return*), *A matar*
2004 (*To the Kill*), *Amor* 2005 (*Love*), *En el filo* 2005 (*On the Edge*) and *Aquí* 2007
(*Here*) are six short pieces edited to be projected in loop format. Their visual style
challenges the supposed incapacity of the two-dimensional image to produce
a spatial experience similar to that generated by an installation or expanded
sculpture.[1] It is no coincidence that the artist himself designed and produced
the black-and-white spinning tops seen dancing in these videos, as though he
were indeed a sculptor. Designing the tops was only the first step; each of the
six choreographies required long and meticulous preparation. The production
process was so laborious that filming just one of these videos, *Here*, took eight
months, during which Ríos constructed various sets, brought together more
than sixty spinning-top players and made hundreds of takes.[2]

To activate our perception of the different levels of videographic space, Ríos
positioned the camera in very heterodox fashion. For example, *On the Edge*,
a two-channel video lasting four minutes and composed of a score of shots
on each screen, is filmed almost entirely from a floor-level camera, so that the
tops are both very close and level with the spectator's gaze (fig.33). When the
enlarged video is projected on the walls of an exhibition space, the spectator is
immediately involved and begins to identify with the rhythm and energy of the
spinning or falling tops. They are seen not from above as tops conventionally are
but from the floor that they spin across in their many different humours: fearful,
doubtful, decisive, heroic or intimidating. In a recent projection in the Tabacalera
Cultural Centre in San Sebastián, Ríos told those in charge of the exhibition
that the bottom of the projected image must align with the physical floor.
In this way, the top recovers its sculptural weight; it is not a figure projected
high on the wall (and therefore requiring a metaphorical pedestal) but spins
across a monumental screen 5 metres by 9 metres on the very same *Grund*
trodden by the visitors to the exhibition.

In some shots, Ríos inclined or bent the board on which the tops were
dancing, making them rock from side to side and race towards the spectator
or vanish into the depths of the shot. He has them zigzagging front-to-back
or diagonally in oscillating trajectories and these movements emphasise and
energise the three-dimensionality of the space recreated within the plane of the
shot. This aim to investigate the spatial possibilities of the medium is further
intensified by the use of more than one screen. *Love* and *Return* are single-channel
projections but *On the Edge* uses two screens, *'Til Death* three (fig.34) and *Here* no
fewer than five synchronised channels. Unlike certain authors of contemporary
video art more concerned with effect, Ríos does not multiply the image merely

33 **Miguel Ángel Ríos**
En el filo 2005
On the Edge
Two-channel video
installation
4 min, 23 sec

34 **Miguel Ángel Ríos**
A morir 2003
'Til Death
Three-channel video installation
4 min, 54 sec

for the sake of it or in order to impress the spectator. In *Here*, each of the screens recreates a different 'battle'; the tops move from one screen to another and are transformed and metamorphose as they move between the five picture planes (fig.35). The artist has designed the work in spatial terms, creating an ambience that involves the viewer and ensures that the image on each screen, though independent, also interacts with the other four. In the pentagonal *Here*, the notion of 'expanded cinema' finds its practical demonstration: the complexity of the piece is an answer to the spatio-temporal challenge set by Ríos, who once admitted that he could commit to an artistic project only if it was 'difficult, impossible and dangerous'.[3]

The floor-level camera, the manipulation of the set and the many interactive screens all emphasise the spatial investigation undertaken through these videos. When a further device, montage, is added to the mix, generating collisions not only between the tops themselves but between the various planes that constitute the work, Ríos is using a specifically audiovisual resource that allows him to subordinate the spatial dimensions to the fourth dimension of time. But timing is an element that comes into play not only through montage. *Return* in fact consists of a single take of more than two minutes avoiding any kind of editing. Here the temporal element is contrived with two video resources that Ríos exploits to the maximum: rewind and slow-motion. Thus at the start of the video we see a set of black tops on the ground immobile and as if dead; they slowly stand up and begin to spin, acquiring the life that they seemed to lack, gaining their balance and slowly recovering their normal speed, so that by the end of the piece they are revolving with real élan. The revitalisation of paralysed and reified reality has become possible thanks to the filmic recourse of rewinding and slowing down the movement of the image.

This series of videos, like some of the installations discussed in the first part of the book, also implies a revision of modernism. Looking for antecedents for Ríos's generation of movement through the repetition of forms, we come to works as early as the cinematographic experiments of Viking Eggeling or Walter Ruttmann and the activation of sculptural objects in the filmed version of Oskar

35 **Miguel Ángel Ríos**
Aquí 2007
Here
Five-channel video installation
4 min, 27 sec

Schlemmer's *Triadic Ballet*.⁴ Raphael Rubinstein has pointed out that:

Ríos' visual language is abstracted and pure, an epitome of modernist form. The spinning tops in *Aquí* are streamlined white and black shapes set against an anonymous, neutral background. The ambience is as absolute and controlled as in a painting by Piet Mondrian or a sculpture by Constantin Brancusi.⁵

Ríos himself referred to Pablo Picasso's *Guernica* 1937 as a direct influence on *Here;* in *Guernica* too, black and white are chosen as the 'colours' of war.⁶

This visual programme is combined with particular attention to the soundtrack. The noise made by the tops falling, spinning and racing across the board, which Ríos records in real time and amplifies for the projection, is thunderous; often akin to the rumble of bombers approaching their target, it intensifies the warlike character of the works. In *Here*, to the 'crack' heard when tops collide is added Ríos's voice shouting '¡Aquí! ! ¡Aquí!' ('Here! Here!') as he indicates to his assistants where further tops must be launched to sustain the battle. 'I left the voice on the soundtrack', Ríos says, 'because it makes the spectator feel right in the middle of the action. You identify with the tops. This is not a typical film soundtrack. It is frontal and direct. "You are here. Right here."' ⁷

For all the formal audiovisual resources that he exploits, Ríos is no devotee of formalism. This formal precision and purity answer his need to transmit a particular content as effectively as possible. Asked what his formidable series of videos is ultimately about, Ríos answers as follows:

[The series] is not about the game, but a metaphor about life, competition, overpopulation … The spinning top represents a human being; you don't see it as a toy. You can imagine each one as a human being in the field trying to survive. And the ones that have more energy are the blacks, because they really want to take the power over the white spinning tops. That's basically the idea. The white [tops] represent the power, they are more organized and, like the military, they control the whole situation in the field. The black are, I would say, different nations, different races, and they try to take over. This is the way to find a metaphor to express the way we are living today, which is *very* violent.⁸

The play of the tops enables the artist to recreate in art the pitiless struggle

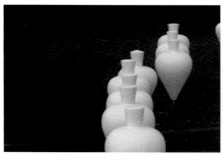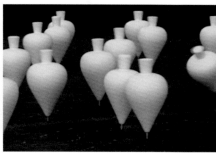

for survival on a backdrop of unyielding aggression and competitiveness. The contest between white and black in *On the Edge* and *Here* is a metaphor for the violent relations between armies and civil populations, between the forces of order and the citizenry as these have been experienced throughout the world but more particularly in Latin America during the past few decades. His recreation of battle through radical investigation of video form is echoed in a section of *Matiné* 2009 (*Matinée*), a video by the Argentine artist Liliana Porter, in which diminutive plastic figures are dragged across the screen by a viscous current of red paint, a kind of acrylic lava, in an eloquent simile of socio-political tsunamis of whatever kind. In the same way, as Ríos's dancing tops collide and fall, surveying or surrounding each other and smashing each other off the board, the 'choreography of power' is symbolically presented.

Ríos himself was a witness to and victim of such violence in 1976. That year the Argentine military coup d'état prepared the way for the self-declared Process of National Reorganisation. During his dictatorship, General Jorge Rafael Videla led the 'Dirty War': a process of systematic repression, kidnap and torture that led to thousands of 'disappearances' over the period 1976–83. Ríos was detained by the Argentine police and taken to the 'sinister centre of political repression' known as the 'Federal Coordination' in Calle Moreno in Buenos Aires;[9] he has since lived in exile in the United States and Mexico. But the violence illustrated in his videos refers not to a particular historical act of aggression but to the experience of violence in any place and at any point in time. What Ríos conveys in his works is the abstract character of violence inevitably articulated by a strategy of punitive power and the proof that no such power can subsist without violence. As Rubinstein has observed:

There is a riveting quality to Ríos' videos, something that makes them eminently watchable. Of course, this has everything to do with their artful making, which involves dynamic composition, dramatic framing, subtle editing, and Ríos's behind-the-scenes perfectionism. These are formally beautiful works of art. But a significant part of their ability to keep viewers transfixed has also to do with the ritualized spectacle of controlled violence and competition. The visual appeal of *Here* and its predecessors is related, to some extent, to other violent spectacles in society, such as bullfights, boxing matches, soccer and football games, and war movies and westerns. The videos are situated at the intersection of *homo ludens* and *homo bellicus*. The anthropomorphic quality of the tops underscores these parallels, making it clear that the 'violence and power' on view are human in origin.[10]

They are indeed human – as are the instinct and desire to rebel. Attention is frequently drawn to art's capacity to scrutinise the micro-physics of power but that other ability of the artist, to suggest a possible social transformation by means of images, is sometimes forgotten. In this respect, Ríos has not only visualised the violence of power play but spoken of the desire of the 'black

36 **Donna Conlon**
 Coexistencia 2003
 Coexistence
 Video
 5 min, 26 sec

tops' to subvert the order imposed. Every time one of them falls spinning onto
the board and confronts a white top, the artist is taking position: situating
his discourse in a transgressive artistic tendency. To that extent, his videos do
not confine themselves to expressing a metaphor about the violence of the
contemporary world but also, in their coded way, constitute an exhortation to
whatever rebellion will bring an end to that violence.

The absent multitude
Like Ríos's 'tops' series, the video work made by Donna Conlon (b. Atlanta, 1966)
over the last six years, alone or in collaboration with Jonathan Harker, displays
extraordinary aesthetic unity. Conlon, a resident of Panama since 2003, has to
date directed a dozen or so video pieces on subjects associated with recycling
and ecology. Her style is unique and unequivocal. No actors or persons appear in
her imagery (very occasionally a hand or a foot intrudes into the shot) and there
are therefore no words or dialogues; the pieces are constructed on the basis of a
delicate staging that attains its ultimate meaning through a minutely calculated
montage. None of these works has any musical soundtrack and post-production
technical devices such as fade-outs are rarely used to link shots. Despite this
austere, almost Bressonian method of filming and editing – or precisely because
of it – Conlon's works possess multiple levels of meaning.

 Coexistencia 2003 (*Coexistence*), one of her earliest and perhaps the best-
known of her works, was recorded in a wood in Panama. The video begins with

a zoom that leads the spectator to scrutinise what seems an anonymous corner of forest through which march hundreds of rust-red leafcutter ants. But soon after, the viewer is in for a surprise: some of these ants are laboriously carrying not pieces of leaves but small artificial 'leaves' painted with national flags and symbols of peace (fig.36). The only components of this formally simple work are the intense sound of the natural background and a series of shots detailing the 'insignificant' happening wrought by the disciplined insects. But it is bound to elicit a thoughtful reaction – not only because the ants, as workers, are symbols of industry and organisation. Ant society, like human society, is organised through hierarchical structures, the division of labour and the capacity to resolve complex problems through collaboration. The different flags that impart a note of colour to the procession of leaves directly refer to the need for dialogue between the countries represented (two short consecutive shots focus on the tiny flags of the United States and Cuba). Although the title *Coexistence* and the symbols of peace emphasise an anti-war message in the spirit of the United Nations, Conlon's video also cultivates paradox and irony; these are not, after all, humans carrying the flags but tiny insects whose automated and obedient movements reveal a discomforting facet of the hierarchical and highly disciplined society of the ants.[11] *El basurero* 2009 (*The Garbage Dump)*, a later video, emphasises the dystopian vision of the insects by showing them depositing a number of one dollar notes at the foot of a tree in a pile of rubbish that the ants generate from detritus, organic remains and the inert bodies of their own dead 'colleagues'.[12]

Conlon's vision of nature is neither simplistic nor idealised. Before becoming an artist, she studied biology at the University of Kansas. In her oeuvre, the natural world, for the most part observed in its contact or contrast with the industrial world, does not simply represent generation and life but also degradation and death. The artist does not succumb to facile pseudo-ecological stereotypes and present nature as an idyllic environment. A set of photographs made in 2007 entitled *Proyecto para mejorar la naturaleza* (*Nature Improvement Project*) shows sculptures made from insects into which Conlon has inserted extra wings and legs and antennae, showing that nature is imperfect and can be improved. Similarly the processes of industrial development are not presented exclusively in condemnatory fashion. Though her work undeniably constitutes a critique of ecocide and the destruction of the planet's biodiversity, Conlon's vision is dialectic and incorporates into her discourse the Benjaminian notion that every process of civilisation is at the same time a process of barbarity, thus suggesting that industrialisation invariably comprises some element of progress – limited as this may be. Her artistic practice does not therefore constitute any particular ecological programme but offers a kind of *ecosophy* not unlike that once argued by Félix Guattari.[13]

37 Donna Conlon
Todo arreglado 2004
All Fixed Up
Video
2 min, 26 sec

In a series of videos made using urban detritus, Conlon reuses rubbish as a tool of creation and regeneration. *Singular solitario* 2002 (*Singular Solitary)* presents some hundred shots of the artist's feet walking clad in various old shoes found in the rubbish dumps of Baltimore; *Refugio natural* 2003 (*Natural Refuge*) similarly makes use of an extended series of static shots to show the hand of the artist lifting up urban junk (a beer can, a tobacco tin, a newspaper, etc.) to discover surprising evidence of animal life (beetles, grasshoppers, worms, etc.) beneath it. *Todo arreglado* 2004 (*All Fixed Up*) again presents the hands of the artist, this time placing small junk objects found in the street (plastic bags, tetra briks, cigarette lighters, bottle tops) in the convexities and concavities of street furniture (streetlamps, fences, gratings) in inventive and perspicacious fashion (fig.37).

In these three videos, refuse is treated like a found object and recycled through a process of unexpected relocation and reuse. The sober composition is brought to life through a constant montage of short shots. The detailed inventory of quotidian places and rubbish, in general accompanied by two mixed soundtracks – one for continuous ambient noise and the other for the particular sound made by each object – eventually becomes, through the accumulation of small and apparently insignificant details, an authentic creation of practical and aesthetic choices.[14] The question inevitably raised by the videos – what can be done with a random object? – indirectly raises a further question about the possibilities that can be extracted from the real. The surprising emotional intensity and poetic calibre of these videos comes not only from their critique of the destruction

of the environment but also from the way in which they anticipate the development of a method for revolutionising daily life.

At the same time, the videos reveal the various stages of Conlon's creative process: the selection of a 'found object', its physical relocation and/or reuse and the consequent alternation of its meaning. These bring to light her affinities with Gabriel Orozco, for instance. In their very different ways, both artists have rehabilitated, in the practices of assemblage and collage, ways of working that have historically served to symbolise the bohemianism of the avant-garde. As in Agnès Varda's ingenious film on recycling, *The Gleaners and I* 2000, in Conlon's videos recycling involves picking up from the street discarded objects evocative of the imaginary consumer (bottle tops, plastic bags, chewing gum) and reusing them as the squandered surplus of contemporary society. As the artist has said:

My work is a socio-archaeological inquiry into my immediate surroundings. I collect and accumulate ordinary objects, images, and repeated actions from my daily life and local environment, and then use them to reveal the idiosyncrasies of human nature and the contradictions inherent to our contemporary lifestyle. The development of my projects often begins with simply noticing an out-of-context object or an illogical occurrence. I have used damaged trees and plants that I have found in the woods, insects that have flown into my studio, lost shoes, and garbage from the streets and sidewalks to describe and question human behaviour, especially the conflicts I observe in our urban, natural, and social environments.[15]

By taking the object out of its context or placing it at the heart of an illogical happening, Conlon goes on to propose a broader intellectual enquiry that relates her works to notions such as the critical character or life-giving qualities of art. For example, the five-minute video *Más me dan* 2005 (*The More They Give*) is a single shot of the artist's hands opening a plastic bag from which she successively extracts other bags of different colours, each smaller than the last, in the manner of Russian *matryoshka* dolls. The work of art thus presents itself as an insoluble and enigmatic game, since at the end of the video we still do not know what the last bag, a tiny black bag, contains. At the same time, the video makes an intelligent comment about the world of brands. The genuine attractiveness of each of the bags, which were designed by supermarkets, department stores and luxury-goods stores, speaks of the promises made by the commodities that they are supposed to contain and for which they serve not only as temporary wrappings but even as a kind of substitute. The anxious movements of the artist's hands also alerts us to the Diogenes syndrome, a form of disturbed behaviour accompanied, in consumer societies, by morbid accumulation of domestic rubbish.

In the series *Video (Games)*, made in 2009 with the collaboration of Harker, the notion of games seems again to be analysed from a critical point of view by revealing the tension and competitiveness that games involve. In one of

the videos, the hands of an off-screen person enter the shot to compose on the ground the word 'we' with letters made from fragments of brick. When the hand of another off-screen person turns the letter 'w' upside down, thus transforming it into the 'm' of 'me', a battle breaks out between the two hands each seeking to impose its own word. To paraphrase the poet Jaime Gil de Biedma and his 'game' of verse-making, we might say that the game of setting an individual against the collectivity... is no game at all.[16] It is a confrontation in which the two agents take up opposing, conflictive positions.

The life-giving quality of art, that is, the capacity of the artwork to endow an inert, commonplace object with artistic life, can be seen in two other videos by Conlon. *Marea baja* 2004 (*Low Tide*), filmed on a beach in the Bay of Panama, 'animates' some one hundred used tyres by making them roll, one after another, towards the edge of the sea. *Brisa de verano* (*Summer Breeze*), made in collaboration with Harker three years later, shows how a standard wire-grid fence can become a kind of collage as the wind picks up and flattens pieces of coloured plastic litter against it. These are two examples of a dynamic – rehearsed in some degree in all her works – that could be described as a process of de-reification.

Conlon's personal universe reaches its highest level of expression in the video *Estación seca* (*Dry Season*), made with Harker in 2006. Here the image is of the outskirts of a mountain of green glass under a grey sky. This glass-bottle dump rises before the spectator's eyes like a sleeping giant. The imperturbable silence of the locality is suddenly broken when a bottle falls from the sky and explodes against the mountain, breaking into pieces, in a metamorphosis by which it almost instantaneously fuses with the mass of broken green glass (fig.38). After a while, a further bottle falls, to similar effect. After a further pause, a third, fourth and fifth bottle shatter on the glass mountain and irrevocably integrate with it. Then the fall of the bottles accelerates and there begins an avalanche of sounds; the overwhelming explosion of glass and the almost musical racket made by these explosions overwhelms one's senses. Bottle after bottle clatters down with the urgency of hurtling raindrops in the torrential storms of the Central American tropics. This febrile acceleration reaches a climax at the culminating point of the video, when dozens of bottles disintegrating in their violent contact with the mountain spin across the screen, seeming almost to score its surface. Then, rather in the manner of the adagio of Haydn's Symphony No.45 (the 'Farewell'), in which the instrumentalists of the orchestra one by one stop playing and leave, the number of falling bottles gradually begins to diminish till, at the end of the video, there fall four, then three, then two, then one last bottle by way of farewell, like that final drop of rain before the skies clear.

Dry Season was filmed with a small video camera, no effects and in a single shot that lasts barely two minutes. This technical confinement worked to prodigious effect on the imagination of the two artists, who expanded the

38 **Donna Conlon and**
 Jonathan Harker
 Estación seca 2006
 Dry Season
 Video
 2 min, 2 sec

expressive potential of video art. The work is, in its own way, a revision of one of the classics of experimental cinema, *Rain (*1929) by Joris Ivens, in which the state of mind generated by rain is explored at length. But Conlon and Harker were able to avoid the problem that Ivens himself criticised later in his film, that of excess formalism. Over and beyond its audiovisual playfulness, *Dry Season* has serious political content. This is not simply because the rain of animated empty bottles directly alludes to ecological catastrophe. Here the drought is merely one symptom of a great cataclysm: the irreparable destruction of our environment and ultimately of our own species. As the artist has noted: 'We interact with our immediate environment, and with other people, in ways that are often illogical or selfish, leading to an ultimate sense of loss and futility.'[17] Given that sensation, the work 'addresses our disregard for and thoughtlessness toward our world, and involves both myself and the viewer in a sense of responsibility.'[18]

Alongside Conlon's dialectical reflections on the natural and the industrial and the way in which she animates the *objet trouvé,* a political concern inhabits her entire production, where it is expressed in more or less direct fashion; it is generally articulated around a very specific idea, that of the absent or kidnapped multitude. Conlon has invoked the people in her oeuvre through its explicit absence. In none of her videos do we see an eye, a mouth or a face. Yet the human and indeed the multitude are always present. They have been replaced by worker ants, rolling tyres or bottles smashing against the rubbish tip. Each shoe in *Singular Solitary* is a metonymic evocation of a man, woman or child walking with just one shoe. Each recycled and reused object refers to the citizen who once put it to use and might again do so. Referring to so-called 'Third-World Cinema', the French philosopher Gilles Deleuze noted that in many films made in underdeveloped countries, there was no sign of the people; there was only an absence in expectation of a multitude that had yet to arrive:

This acknowledgement of people who are missing is not a renunciation of political cinema, but on the contrary the new basis in which it is founded. Art, and especially cinematographic art, must take part in this task: not that of addressing a people, which is presupposed already there, but of contributing to the invention of the people. The moment the master, or coloniser, proclaims 'There have never been people here', the missing people are a becoming, they invent themselves, in shanty towns, or in ghettos, in new conditions of struggle to which a necessarily political art must contribute.[19]

In the work filmed by Conlon in Panama we find precisely this desire to bring to crisis point the video style constructed in the large nations; she does this through an anti-figurative *mise en scène,* by strict and abstract editing, by giving life to discarded merchandise, confronting the mutually opposed participants in the game of knowledge and finally evoking an absent multitude, a potential future multitude: 'Not the myth of a past people but the story-telling of the people to

39 **David Zink Yi**
Huayno y fuga detrás 2005
Huayno and Fugue Behind
Single-channel video
installation
3 min, 47 sec

come.'[20] This counter-discursive fable is generated by Conlon from minimal resources: a small video camera, a constant succession of short shots, and the replacement of the actor by the animated object.

The rhythm of the shadows

Other recent videos from Latin America show that the use of editing – so deftly practised by Ríos and Conlon – is not essential to the creation of a complex and intelligent audiovisual work. Two videos created in 2005 by the Peruvian artist David Zink Yi (b. Lima, 1973) employ nothing more than a long take – a single shot without either editing or cutting. The first of these, *Huayno y fuga detrás* (*Huayno and Fugue Behind*) lasts almost four minutes and was filmed in the bustling market of a village in the Peruvian mountains. In a single take, Zink Yi shows a travelling musician (we see only his tanned hands) interpreting a piece of Andean folkloric music on the harp (figs.39). Through the strings of the instrument, the camera registers the gazes and expressions of a varied group of passers-by who stop to listen to the instrument. The shot is far from static, since Zink Yi makes several 360-degree revolutions around the axis of the harp, in which he captures the physiognomy and expressions of the people who gather around and listen to the piece of music with varying degrees of attention. The second video, *Sin título (Santiago)* [*Untitled (Santiago)*], was also shot in the Andes, in the village of Huancayo, during the celebration of the feast day of the patron St James (Santiago) on 25 July. This time the long take lasts six minutes and focuses on a patch of soil onto which are projected the shadows of people dancing in a circle to the sound of another popular Peruvian melody (fig.40). The people to whom these dancing silhouettes belong are celebrating the traditional summer solstice festival and the beginning of the rainy season.

Simple as these two videos may seem, it is a deceptive simplicity in regard to both form and content. In *Huayno and Fugue Behind*, the artist seems to have taken up position on a mobile platform that allows not only the camera but the musician to revolve steadily. Zink Yi's travelling shot is untypical: the camera does not move around a static subject but activates that subject by placing it at his side so that harp and musician revolve with it. *Untitled (Santiago)* is also the result of careful planning. The tracking shot has been made in the awareness that it will subsequently be turned – lifted – and moved from the horizontal to the vertical mode; consequently the shadows do not lie flat on the ground but stand up before the spectator as if alive and autonomous.

At first glance, the common feature of these two videos is a theme that defines much of Zink Yi's video work: music. Starting in the early 1990s, he has made a dozen or so pieces integrating rhythm and melody as a mode of reflecting on and expressing reality.[21] Zink Yi has always made use of indigenous Latin American and/or Afro-Caribbean musical forms such as the rumba, *cumbia* or the *huayno*

40 **David Zink Yi**
Sin título (Santiago) 2005
Untitled (Santiago)
Single-channel video
installation
6 min, 15 sec

(an archaic Andean genre normally taking the form of a fugue). The soundtrack plays an essential role in both *Huayno and Fugue Behind* and *Untitled (Santiago)*.

The stylistic choices made in these videos – that is, the image performing 360-degree revolutions and the vertical display in which the shadows revolve – allow Zink Yi to dispense with editing while retaining the potential for spatio-temporal investigation inherent in the videographic medium. While other Latin American video-artists have based their works on the exact and effective collision of images, Zink Yi has chosen to create his work through a combination of the travelling shot and post-production resources such as altering the dimensions of the screen or projecting the video in the form of a sculptural installation. Thus his two earlier videos, *Independencia I* 2003–4 (*Independence I*) and *Alrededor del dosel* 2004 (*Around the Canopy*), also comprise single takes capturing movement in real time which are presented as two-channel installations in which the images interact on two different screens occupying contrasting positions within the exhibition space: the two opposite walls of the cubicle in which the two videos of *Independence I* are projected or the floor and wall of *Around the Canopy*.[22] We might say that, with Zink Yi, the editing occurs not *within* the video work but *outside* it.

Throughout the history of experimental cinema and video art, the use of the long take has usually been accompanied by an investigation of the audiovisual space. By reducing the temporal dimension to a single continuity (the real time activated by the single take), the artist lays aside the possibility of developing parallel or cross-edited time and focuses on the space captured in the shot. Using the long take and rejecting the dynamic inevitably created by editing, Zink Yi is forced to activate several spatial layers within a single frame. *Huayno and Fugue Behind*, for example, shows, in the first instance, the hands of the musician and the strings of the harp; behind these, we see the faces of the passers-by; and behind them, the cars, shops and houses that surround the market. These three spatial segments also constitute three layers of meaning. *Untitled (Santiago)* similarly makes play with two spaces, or rather two spatial trajectories: to the shadows that rise up from the horizontal and move around in circles are briefly and intermittently added parts of the dancing bodies that produce these shadows; in the inverted projection, they cross the screen moving upside down as if defying the laws of gravity. The colourful feet and legs 'rising' and 'falling' through the shot contrast with the dark shadows cast onto the greyish soil. Another recent video by Zink Yi, *Sin título (3200m)* 2006 [*Untitled (3200m)*], similarly shows space divided into three levels: the foreground, in which little tops are revolving; the middle ground, in which a group of youngsters is playing football; and the contextualisation shot or backdrop, formed by the houses, trees and mountains that surround the location from which the video takes its title – a town located 3,200 metres above sea level (figs.41). By using the long

41 David Zink Yi
Sin título (3200m) 2006
Untitled (3200m)
Single-channel video
installation
8 min, 40 sec

take in these works, Zink Yi initially reinforces the experience of reality but then alters that experience with techniques of production (the revolving camera) or post-production (the inverted image) so that the realistic effect is attenuated, resulting in an unrealistic and even dream-like atmosphere. Both pieces might be said to challenge Bazin's well-established theory that the long take, by producing and 'embalming' an image in real time, is particularly well suited to capturing reality in empirical fashion.[23] Zink Yi's videos are brief and at first seem entirely documentary in character but are in fact laden with lyricism and fantasy.

Huayno and Fugue Behind and *Untitled (Santiago)* have in common their use of the long take, indigenous musical references and spatial investigation. But they also share a fourth characteristic, no less important though it is, perhaps, less explicit: a very specific aesthetic. An aesthetic that opposes the Eurocentric gaze in which Latin America was understood as Other and the continent stereotypically constructed as a strange and mysterious world concealing savagery beneath exotic appearances. Zink Yi's discourse is aligned with the preoccupations of recent post-colonial theory – which has incorporated the notion of the colonised subject and the narratives of oppression advanced by influential theorists such as Edward Said and Gayatri Spivak – but his challenge to Eurocentrism is rather indirect and subtle. His work does not raise its voice to question the way in which social and economic colonialism has been imposed (and is still being imposed) on Latin America, but serenely and melodiously establishes new aesthetic connections as yet unexplored by contemporary video art. As Dominic Eichler has accurately observed: 'Zink Yi's cross-cultural engagement is based less on a brutal exposure of market forces than on an ethics

of close personal ties.'[24]

The fact that *Huayno and Fugue Behind* does not make use of the standard travelling shot (which moves around the static subject), instead making the harpist revolve with the camera, clearly demonstrates that the artist has not come to observe and capture the Other. On the contrary, he places himself at the Other's side and revolves alongside him in a world of which they are both, for one fugitive moment, the epicentre. 'I'm very interested in exhibiting in Peru or in Cuba, which is where I have made most of my works,' Zink Yi recently remarked: 'I am not interested in the exoticist attitude of collecting images and taking them to Europe to sell them like postcards.'[25] The strings of the harp separating the spectator of the video from the inhabitants of the Andes can thus be understood as a metaphor for the bars historically used by European (or Latin American) white elites to subjugate indigenous peoples. But they can also be seen as a warning to the conventional spectator that these bars may imprison anyone who looks at the world through prejudices and stereotypes.[26]

In *Untitled (Santiago)* the commentary is even more subtle: the Andean people, represented as a passing shadow, can never be grasped. They turn and dance outside the reach of any camera that claims, in the manner of the conventional anthropological documentary, to capture the 'good savage'. Any attempt to subsume the multiple Latin American cultures under a common definition with which to digest them is doomed to failure. To this extent, Zink Yi's video reminds one of the remark made by the historian Eric Hobsbawm: 'No state or empire has ever been large, rich or powerful enough to maintain hegemony over the political world, let alone to establish political and military supremacy over the globe. The world is too big, complicated and plural.'[27]

That Zink Yi's work should celebrate this complexity and plurality seems inevitable if we bear in mind the multiracial ancestry of this Peruvian artist, which includes Latin American, European, Asian and African roots. Zink Yi has lived in Germany since he was eighteen, filmed much of his work in Cuba, and currently resides between Lima and Berlin. It does not seem feasible to label him in national terms, since he has, as he himself remarked, a 'layered notion of identity'.[28] Rather than conventional ideological criticism, it is the expression of this multiplicity and richness that enables him to defy the paternalistic vision of Latin America still entertained in the West.

Maladjusted memory

One of the aims of the video work of the Chilean-Swiss artist Ingrid Wildi Merino (b. Santiago de Chile, 1963) is to represent the human being: to restore the 'missing people' and show the body of that 'Other' who vanishes into shadow or fantasy. Unlike Conlon or Zink Yi, Wildi Merino makes her videos directly with the faces of the men and women that she portrays. Almost all of

her works are composed using static frontal shots of people who speak to the camera on various subjects previously agreed with the artist. Her videos are, above all, psychological studies of the personalities and emotions of the people interviewed and therefore tend to eliminate external space or visual motifs extraneous to this essentially analytic task.

Her intense commitment to listening to others is present for example in *Cualquier parte I* 2001 (*Wherever I*) and *Cualquier parte II* 2006 (*Wherever II*), two videos in which Wildi converses with several cinema projectionists, Swiss and Egyptian, about their jobs and their experience of projecting films daily; in *Continuo* 2002 (*Continuous*), in which she records the declarations of four inhabitants of the Swiss Mitteland who reflect in French and German on their emotional relationship with an object they particularly love (a metronome, a plant, a piece of burnt toast); or in *Los invisibles* 2007 (*The Invisible*), in which Wildi Merino interviews five Colombian immigrants, male and female, of varying ages, who are working illegally in Switzerland. These personal micro-histories, their cumulative effect enhanced by editing, transcend their own particularity and acquire a universal value not only through the themes preselected by the artist (illegality, unemployment and racism) but above all because of the intimacy and integrity with which these stories are told.

Wildi Merino has confronted her own family history, some of it painful, with great honesty in two other works. In *¿Aquí vive la señora Eliana M…?* 2003 (*Does Señora Eliana M. Live Here?*), she travelled through Chile from Santiago to Arica in search of her mother, a clairvoyant who abandoned her in strange circumstances while she was still a child; and in *Retrato oblicuo* 2005 (*Oblique Portrait*), she portrayed without either condescension or sentimentality her brother Hans Rudolf Wildi, who gives an account in this video of the symptoms and effects of his depression (fig.42). In both works, personal confession forms part of a broader set of collective reflections since, as the artist's brother states, 'everybody has a story and all stories are important for History'. Through the narrative of her own life or that of others, Wildi Merino has taken up a very clear position: in the words of Philip Ursprung, she has always sided with 'those on the margins, those in danger of disappearing without a trace'.[29]

Wildi Merino grew up in Chile until her family was forced by the advent of the Pinochet dictatorship to emigrate to Switzerland. She studied in Zurich, a German-speaking city, and subsequently in Geneva, this time in French. This bilingualism, and the difficulties that it presents for any non-native speaker, is present in her works, in all of which more than one language is spoken and subtitles appear in one or more languages. The problematics bearing on any discourse, written or spoken, are thus essential to Wildi Merino, whose approach to linguistic reality is neither comforting nor conciliatory.

In videos like *Wherever I* or *Continuous*, Wildi Merino takes care not to

eliminate those passages in which her interviewees stumble or contradict themselves; on the contrary, she makes space for their sudden changes in sentence construction, for inconsistencies and even incongruities. The language of her characters might be described as maladjusted in the manner of the *non sequitur* or the non-native speaker. Her refusal to edit out such solecisms reminds the spectator that they are habitual and unconsciously present in everyone's informal speech – still more so in the speech of those who, for whatever reason, cannot easily adjust to social conventions.

In her audiovisual oeuvre, Wildi Merino has made this linguistic maladjustment into a stylistic metaphor. The consistency of the metaphor further emphasises the heterogeneity that her videos recreate. Thus stammering goes beyond being a mere characteristic of the speech of a Colombian emigrant; it comes to characterise a videographic style constructed on the basis of linguistic error. It is a sort of small revenge wreaked by someone who has been obliged to speak another language, that is, a person who has had to abandon their maternal language to survive in a new country. Paraphrasing the two last verses of a poem by the Salvadorean poet Roque Dalton ('Because I'm an expatriate / You're an excountry'), Adriana Valdés notes that, in these videos,

43 **Ingrid Wildi Merino**
Si es ella 2000
If it's Her
Video, French with
English, German or
Spanish subtitles
11 min, 48 sec

'something is happening to this language [which] does not emerge unscathed
... Just like the migrant's former country, the mother tongue has become an ex-
language.'[30] In similar fashion, something has happened to the video discourse.
This verbal imbalance becomes a way of opposing the homogenised and artificial
representation of conventional televisual reporting – which is thus criticised as
an obsolete (ex-)representation.

Perhaps Wildi Merino's most successful work is *Si es ella* 2000 (*If it's Her,*
fig.43), a video lasting almost twelve minutes, created from three interviews
made in French and Spanish with three different men. The video shows a total
of forty-nine successive shots in which the three men each describe a woman
whom they once loved. The first man wears a blue jersey, he is young and of
Maghreb origin; the second is somewhat older, wears a black jacket and speaks
French; the third mixes French and Spanish, wears a grey shirt and is of Latin
American origin. Their descriptions are detailed but the way in which the edits
constantly interrupt their speech makes the descriptions elliptical to the point of
doubt and confusion: are they speaking about the same woman? Is this woman a
mother, wife or lover? The emotional intensity grows as the video continues, as if
the spectator were attending a psychotherapy session where stereotyopical male

and female roles have been swapped. The men speak, traumatised and feminine, about their feelings, while the women, perhaps because they are absent, gradually acquire greater strength and authority. At the same time,

by cutting and pasting, the artist manages to articulate a space and a time that depicts the space and time of each of the three stories – and yet at the same time it is also another story, one of ever-changing relationships, one that reflects the speculations of a viewer who may make a number of different assumptions and must correct them along the way as the piece progresses.[31]

The editing process of *If it's Her* has stripped the narration of any component of banality to focus, *à la* Rohmer, on human relations and emotions (friendship, love and its loss). Any superfluous action or commentary has been eliminated. The lost woman therefore reappears in many different facets as emotional companion, visionary healer or sexual elder woman. Wildi reduces the plot to essentials in order to go directly to the heart of the feeling, which reaches its greatest intensity in the intensely moving final three shots, when the protagonists finally pronounce the names of their beloved: 'In German, her Christian name is Teresia'; 'María Filomena, yes, her name is María'; 'Yamna Kermiche Behllil'...

If it's Her evokes 'the people' through their presence rather than their absence. But their presence is incomplete, fragmented, damaged, broken. There is nothing totalising in Wildi's work. Totality is never so much as adumbrated: the framing of the Colombian illegal immigrants cuts off their heads in order to emphasise that these are *invisible* workers (fig.44); in the interview with Hans Rudolf Wildi there is no reverse angle to identify the body whence comes the off-camera voice making this *oblique portrait*; and the words of the projectionists, whether in French or Arabic, are not articulated in complete or closed form – their observations about the phantasmagorical character of actors ('They're like spectres... they die in one film and reappear in another') are laden with doubts, silences and omissions, perhaps because they were not born in a specific place but *wherever*.

In his book on the cinematographic medium, the French philosopher Jacques Derrida suggests that cinema fails in its pretension to impose a symbolic order on the disorder of the world but acquires its true significance when it accepts and represents this very disorder, from which it can never escape. In Derridian fashion, Wildi Merino's work (dis-)centres itself around discordant elements. From the outset, it 'places' itself 'in' the out of place, the 'out of joint', as if this were the only way to attain its authentic sense:

Memory always organises itself around a tension, an interruption, a defect, out of the wound of some kind of dissymmetry. It organises itself best in a state of disorder or maladjustment. It works by and resonates to disharmony. It is only after the falling due

O amor tem a ver com a economia?

44 **Ingrid Wildi Merino**
Los invisibles 2007
The Invisible
Video, Spanish with
Portuguese, English or
French subtitles
35 min

of the falling, at the fall, at the overdue date, the date of decadence, that it keeps what it keeps. A memory appeased no longer has a chance; it can do little but doze off. A harmonious, reconciled, euphoric memory – a happy memory – I can't imagine it doing anything other than getting lost.[32]

The great enemy of Wildi Merino's video art is the distancing of reality through excessive formalism – she recently remarked that 'art has to do with life not art'.[33] Her work nevertheless exhibits a refined formal structure. Contriving a concise style with which to integrate the broken speech of marginal or traumatised people, Wildi Merino has had to distance herself from the formal conventions of documentary cinema: she never uses the conventional voice-over, never attempts to disappear as the creator of the interview, nor does she use the camera to capture the interlocutor in the manner of television reporting. Many of her works are filmed in neutral indoor spaces, with a fixed camera set opposite the interviewee and a white wall as background. That might suggest an aggressive style. The contrary is true: in Wildi Merino's work, it is not people that she interrogates but reality, and her scrutiny implicitly understands that reality as invariably fractured.[34]

When, in *The Invisible*, she records only the bodies of the immigrants, this is not a strategy of contempt but a clarification of the way in which society views the immigrant as a headless, faceless subject lacking civil and political representation. The 'invisible man' is this illegal immigrant who, at the end of the video, describes how he was able to cross the Franco-Swiss border one night on foot without being seen because the border-guards were watching football on their tiny television set. The video's other protagonists testify to the way in which Swiss society constantly brings them face-to-face with their marginality and their voice is therefore the abstract and symbolic voice of all Latin American emigrants.[35] The composition of the shot (the video form) clearly derives from a concept; Wildi Merino articulates a visual analogue (the headless body) for the 'invisibility' of the illegal worker. The artist herself has very concisely observed: 'The form arises from the content.'[36] Because there is no face, because spectators cannot look the protagonist in the face, they are forced to listen to the immigrants, who finally *speak*. Then, inevitably, viewers hear the immigrants' thwarted, weakened, incomplete language – a language that begins timidly to vocalise memories, desires and protests that have so often been repressed.

The language of the forgotten
Perhaps the most important quality of the video *Cinco puntos* 2005 (*Five Dots*), made by the Ecuadorian artist Tomás Ochoa in an Argentine reform school for minors, is its determination to dismantle the 'authority' of the film-maker. In the early 2000s, Ochoa, like Wildi, directed a series of videos in which individuals marginalised by the system were given the opportunity of speaking to the

camera. In *Espejo* 2002 (*Mirror*) this meant the men and women queuing from the small hours in front of the United States Consulate in Guayaquil (fig.45); in *SAD Co.* 2003 the former workers of an Ecuadorian goldmine employed by a North American multinational; and in *6mm3 – El cuarto oscuro* 2004 (*6mm3 – The Darkroom*), the inhabitants of an Andean mountain village that had been submerged after the construction of a dam. *Five Dots*, however, challenges these earlier works by incorporating the voices of the persons portrayed in entirely participatory fashion (fig.46).

In *Five Dots*, it is not the author of the video who interviews the protagonists but the teenagers themselves, the young internees in the Center for Socio-Educative Orientation (COSE) in Mendoza; they take their places both before and behind the camera in order to construct their own narrative as both protagonists and producers of the audiovisual discourse. Ochoa (b. Cuenca, 1965) met the young detainees after giving a workshop in photography and video at their institution and confined himself to lending them the camera so that they could film a series of self-portraits. He further suggested two exercises to them: singing 'songs, phrases picked up in the street, invented by them, dreamed about, altered by remembrance' and reading 'excerpts of the "punishment technology" studies conducted by Michel Foucault in his book *Discipline and Punish: The Birth of the Prison* (1975)'.[37]

Five Dots therefore presents three types of footage: 1) frontal shots of the detainees singing songs learned in the street or invented at the reformatory; 2) a series of similar takes, frontal and in colour, of the same protagonists reading sentences from Foucault about the punitive system; and 3) a collection of brief shots that serve as transitions between scenes, filmed in black and white and slow motion, and which show the faces and semi-nude bodies of the detainees at various moments of their stay in the reformatory. The songs deal mainly with drug consumption, possession of arms, fear of solitude, the loss of love and their youthful hopes and dreams. One verse sung by three voices runs 'and again and again and again I escaped from *el COSE*' ('y otra vez, otra vez, otra vez, del COSE me fugué'). The sentences from *Discipline and Punish* mainly refer to the need for political and judicial authorities to publicise crimes and punishments. Thus we hear from the mouths of the detainees themselves sentences such as 'the art of punishment must rest on a whole technology of representation' or 'a secret punishment is a punishment half-wasted'. Among the black and white images is a brief shot – perhaps filmed in front of a mirror – of a detainee looking through the camera.

Ochoa has said that the value of *Five Dots* consists in its timid attempt to allow the young prisoners to generate, however briefly, their own discourse, as against that physically and psychologically imposed on them by the forces of order: the psychiatric and judicial authorities and the communication media. He thus

directly confronts 'the indignity of speaking for others'[38]:

It is in heterotopias, or counter-spaces, preeminently jails and reformatories, where metaphors, codes and imaginary worlds that implode meaning flow freely. This implosion takes place at different semantic levels but it is expressed with the body and on the body. [*Five Dots*] examines the relationship between exercising punishment based on control over the body of the convicted subject and his resistance to power by virtue of his capacity to produce symbols. The project's title refers to the tattoo that most young prisoners have in one of their hands, five dots tattooed between the thumb and forefinger, which mean that, when the hand is shut tight, a mortal ambush is being laid: four of them are on our side, the fifth one is army or police. When marginal, discontinuous, disqualified, non-legitimized wisdom is involved, it facilitates the arousal of submerged wisdom: Foucault contends that 'the knowledge that the dominant culture does not need for itself is the only one that is not assimilated by power, that is, it is the only one that shall not be assimilated as a weapon of repression'.[39]

In *Five Dots*, this 'submerged wisdom' rises to the surface by means of a video practice that places the camera in the hands of the disqualified social community. Although the origin of this strategy can be traced back to the experiments with collective cinema made as early as the French demonstrations of May 1968, in Latin America the first community-authored projects began only in the latter part of the 1980s. In 1987, for example, the Brazilian documentary-maker Vicente Carelli created the collective Vídeo nas Aldeias (Video in the Villages), which brought video production and post-production equipment to various indigenous communities in Brazil and has since produced more than eighty documentaries and video-works. In 1996, the Chilean artist Alfredo Jaar suggested that the Museo del Oeste in Caracas provide still cameras to the inhabitants of the poorest slums of the city in order to exhibit the resulting photographs on a continuous basis in the museum's exhibition spaces. Since 1998, the collective Chiapas Media Project/Promedios has been producing and distributing videos made by the peasant communities of the states of Chiapas and Guerrero in the south-west of Mexico, thus showing that, even in the areas worst affected by poverty, it is possible to organise a form of knowledge 'not assimilated by power'.[40]

In addition to recovering this legacy of communitarian strategies, *Five Dots* also enters into dialogue with two recent pieces of video art that use music and songs to portray communities marked by violence. *Bocas de ceniza* 2003 (*Mouths of Ash*), a series of videos made by the Colombian artist Juan Manuel Echavarría, is made up of close-ups of persons directly affected by the armed conflict between the revolutionary guerrillas and the paramilitary forces in his native country. Each of the people portrayed sings a song in which he or she expresses – and perhaps redeems – a part of the pain inflicted on them through

the atrocities perpetrated during the Colombian drug wars. Another video made in the same year, *Nueve* (*Nine*) by Brooke Alfaro, shows two rival gangs from Panama City, 'Los Palestinos' and 'La Banda de Tabo', singing rap. The title refers to a semiautomatic 9 mm automatic pistol, which is the preferred weapon of the members of both gangs. The video was projected in the form of a two-channel installation onto the facade of a building situated in one of the most dangerous slums of Panama City.

In *Five Dots*, Ochoa counters the discourse that presents young detainees of COSE as delinquents who must be punished; by handing them the camera, the prisoners speak for themselves. They are half-child, half-adult and have created startling self-portraits whose social codes vary between unaffected playfulness and pure survival.[41] One of the headlines included in the 'ethnographic dossier' that complemented the project, published after the escape of some of the detainees, states: 'Of the ten fugitives from COSE, seven are charged with homicide.' Like the Mexican teenagers portrayed fifty years earlier in Luis Buñuel's *Los Olvidados* (1950), the Argentine protagonists of *Five Dots* inhabit a world of terrible injustice and violence. This is no fiction: after Sub-Saharan Africa, Latin America is the second most violent region in the world. Of the twenty-three countries with the highest rates of criminality, thirteen are in Central or South America. In states such as Brazil, Colombia, Venezuela, Mexico and Honduras, murder is the principal cause of death. This extremely high level of homicide, directly motivated by extremes of poverty and social inequality, has led to an explosion in the number of prisoners and penitentiary institutes. As a BBC report recently revealed, on the basis of data from the United Nations Latin American Institute for the Prevention of Crime and the Treatment of Offenders,

there are more than 590,000 people in Latin American jails. Many detention centres are overcrowded, and some have no electricity or running water. There has also been a rising number of riots, hunger strikes and fires. Joanne Mariner, deputy director of the Americas Division of Human Rights Watch, told the BBC that many prisons in the region have currently two to four times more inmates than they can hold.[42]

The critique made by *Five Dots* must, in any case, be understood as transcending the specific conflict that it portrays, that is, the imprisonment and punishment of young 'criminals'. In the same way as the ultimate objective of *Discipline and Punish* was to 'study the metamorphosis of punitive methods on the basis of a political technology of the body in which might be read a common history of power relations',[43] the video thus made in collaboration between Ochoa and the internees of the COSE is intended to demonstrate the possibility of an artistic practice that rescues dissident and marginalised discourses and subverts the established order. Relative to this intention, Carlos Jiménez has said that to 'convince is always to inflict a double defeat: to defeat the defeated and to defeat

him again so that he assimilates as his own the victory of the vanquisher. Thus the convinced is a victor amnesic of himself; the vanquished presenting himself as the victor. In *Five Dots*, Tomás Ochoa attempts to drive this perverse hypostasis to a turning point'.[44]

Interrupted cinema

A large part of the video-work of the Argentine artist Jorge Macchi (b. Buenos Aires, 1963) can be inscribed within an important tendency in experimental cinema and alternative video art: that of subverting the mechanisms and codes of representation of the film medium itself. In a number of videos made between 1992 and 2007, Macchi has proposed a humorous variation of the various paradigms and codes of hegemonic cinema. Where Wildi Merino challenges the silence imposed on marginalised emigrants and Ochoa confronts the violent logic of the punitive system, Macchi makes an institutional critique of the film apparatus as an essential instrument of ideological propaganda.

As Noel Burch noted in his famous essay *Theory of Film Practice* (1969), most films constantly deploy an established narrative structure, which he described as 'the institutional mode of representation'. In avant-garde film practices, there seems always to have been a desire to challenge these conventions, which may have been present from the first but became particularly noticeable from the 1960s on. This experimental strategy – which we might term 'the alternative mode of representation' – tends to foreground or directly denounce the internal functioning of the cinematographic system. That is, it tends to deconstruct, interrupt or disturb filmic narration in order to emphasise that all films are social constructions and, as such, a channel by which ideology is transmitted.[45]

Two works made by Macchi in the 1990s radicalise this tactic of invasion or de-naturalisation of the conventional film narrative. *La flecha de Zenón* (*Zeno's Arrow*), co-directed with David Oubiña in 1992, is an animation of barely eighty seconds' duration showing the countdown that habitually precedes film projections. The work includes the beeps made by the counter every time it marks a number (10, 9, 8...) and is entirely predictable until the figure '2' appears. At this point, Macchi perverts the 'natural order' of cinema so that, instead of the film beginning, the spectator continues to see the countdown, which now shows the figures resulting from successive division by two: 2; 1; 0.5; 0.25; 0.125; 0.0625, 0.03125; 0.015625... (fig.48). The numbers, however, become smaller and smaller, eventually turning into a miniscule horizontal line that disappears before our eyes – though they do not cease to exist since we can still hear the bleeps. The surprise effect of *Zeno's Arrow*, a film about a film that will never begin, invites us to reflect on the nature of time in cinema

and, by extension, on time in general.

In *Super 8* 1997, Macchi returns to the 'cinematic preamble'. The image shows a section of film such as precedes any film. We see a red line that zigzags with the projection (whose crackling noise is heard as part of the soundtrack) and, accompanying the line, passing letters and numbers of the kind generally employed as code marks for the exclusive use of projectionists (fig.47). These are the seventy seconds of disposable film customarily used to protect the celluloid that contains the film itself but which are used here by Macchi to constitute his work of art. That the work is entitled *Super 8* and not *35 mm* or *70 mm* is, moreover, a clear indication of the artist's stance in favour of a domestic, amateur and anti-industrial film format that has, in this case, been digitised.

These two videos by Macchi take their place within a complex multi-disciplinary oeuvre dealing intelligently with themes of a philosophical kind such as the intervention of chance, the absurd nature of violence and the difficulty of conceiving the infinite.[46] For example, *Zeno's Arrow* alludes to the paradox set out by the Greek philosopher, in which he demonstrates in aporetic form the impossibility of movement by subdividing the trajectory of an arrow.[47] In setting out a dilemma about the very possibility of an event, this video dialogues with another work by Macchi, the sculpture *Vidas paralelas* 1998 (*Parallel Lives*), in which, in Duchampian fashion, two broken mirrors are set one in front of the other. The fact that both mirrors are broken in identical form challenges the spectator's empirical knowledge that no two mirrors break into absolutely identical pieces.

Super 8 also foregrounds another recurrent preoccupation in Macchi's oeuvre: that of violence and oblivion. To the sound of the projector that accompanies the red line are later added the deafening noise of a chainsaw and the desperate cries of a woman. This may be the soundtrack of a horror film appropriated by Macchi for his own use as cinematic found footage. Here the paradox consists in obliging the spectator to listen to a highly expressive sound lacking any visual justification or origin. When the sound is not accompanied by the relevant image, the pain becomes less visceral and, by the same token, more abstract. Something similar happens in another work, the installation *Un charco de sangre* 1998–2004 (*A Pool of Blood*), made with cuttings from the Buenos Aires daily *Crónica* in which the expression 'a pool of blood' appears in relation to incidents of street violence. As the artist himself has said, all these news items 'refer to wholly anonymous people'.[48] This anonymity – the blood belongs to no known person – produces, in Macchi's view, inattention, neglect and oblivion. In a text published on the occasion of the group exhibition *El final del eclipse* (*The End of the Eclipse*), Macchi wrote:

48 **Jorge Macchi and David Oubiña**
La flecha de Zenón 1992
Zeno's Arrow
Video
1 min, 20 sec

For some years now I have been keeping a news item cut from a London newspaper: 'Baby died beneath drunk babysitter'. Apparently the babysitter had too many glasses of cider and sat on the sofa without realizing that the baby she was guarding was there as well (I wonder who, besides those involved in the tragedy and myself, remembers this story). It doesn't matter what I did with the story. I reference it here because it exemplifies two issues that generally call my attention: the accident and the leftover. One alludes to the story itself, the other to what happens when it becomes news. [But] the notoriety of the story is fleeting: the news item quickly recedes as the reader turns the page, the baby gets lost among politicians, race horses, and comic strip characters, and becomes a leftover. The circle quickly closes: knowledge, terror, and forgetfulness.[49]

In his video-sculpture *La máquina de tiempo* 2005 (*The Time Machine*), Macchi again works with filmic fragments or remnants. The piece was originally commissioned by Artpace in San Antonio, Texas, and employs a number of film sequences in which the words 'The End' appear. The sculpture consists of a wooden structure like a table that contains within it five television screens visible through glass windows. In each of these, the final moments of a Hollywood film go round and round on a loop. It is no coincidence that these feature films, of which we see only the sequences in which the words *The End* appear are paradigmatic examples of the institutional mode of representation. By excerpting the ends of films such as John Ford's *Stagecoach* (1939) or Fred

Zinnemann's *From Here to Eternity* (1953), Macchi is openly reflecting on the 'end' of 'classic film narratives'. There is nothing nostalgic or elegiac about the work: the screens are arranged in different directions and the various original soundtracks are not synchronised, so that the spectator is unable to see or enjoy the film segments simultaneously. The artist himself has observed that *The Time Machine* 'is not a machine that allows one to travel through time; it is a machine that produces present time on the basis of films that are continuously about to die, or, more precisely, permanently dying'.[50] The cinema that in *Zeno's Arrow* was incessantly beginning in *The Time Machine* is constantly ending.

The strategy of cutting up original film material is present in a fourth video by Macchi, *La pasión de Juana de Arco* 2003 (*The Passion of Joan of Arc*), in which the artist reduces the duration of the famous film made in 1928 by Carl Theodor Dreyer from 110 to 10 minutes by leaving out almost all the images in the film, preserving only the captions and the occasional frame from a film that itself once represented the cinematic avant-garde. By chopping up the original feature, Macchi not only reclaims the idea of subverting the institutional mode of representation – in this case a classic of European *auteur* cinema – but completely transforms the experience of the spectator, who, instead of *seeing* a film, *reads* it.[51] And whatever pleasure this reading might provide is again sabotaged by the discontinuity of the soundtrack and a flux of images in which, between one caption and the next, images of the expressive faces of Renée Jeanne Falconetti and her judges are randomly intercalated (fig.49).

Macchi's *Passion of Joan of Arc* is reminiscent of a similar strategy of reappropriation adopted three decades earlier by the American experimental film-maker Standish Lawder in his film *Intolerance (Abridged)* of 1972, in which the director reduced D.W. Griffith's famous film of more than two hours to barely ten minutes. Lawder recently noted that Griffith's film had always seemed to him 'intolerably long' and he made the film by selecting only one in every twenty-six frames of the original film.[52] The radical deconstruction practised by Lawder and Macchi can be understood as countering the narrative element in masterworks of cinema by an exercise in mutilation reminiscent of literary cut-up or Debordian détournement. Indeed, revision of the cinematic tradition of cinema has become a common practice in contemporary video art, as we see from the trajectories of other video artists such as the German Mattias Müller, the Swiss-American Christian Marclay or the South African Candice Breitz.[53]

In *Fin de Film* 2007 (*End of Film*), a work commissioned by the Fundación Bienal do Mercosur and made in collaboration with the composer Edgardo Rudnitzky, Macchi presented another work that alters the 'natural logic' of cinema.[54] It is a video that presents some five minutes of credits such as pass across the screen at the end of any film; in this case, however, the credits are out of focus and therefore illegible. When the possibility of information is thus

excluded, the credits are perceived as mere visual marks in motion. The video then begins to function

as a music box in which each of the lines of text activates the sound as it appears on the screen. By following the regular rhythm of the appearance of each of the lines of information at the bottom of the screen, Rudnitzky composed a piece based on the measurement of the lines of text and the distribution of the blocks: because at times there are two columns of information and in others a single centred column, the piece is composed for two voices when there are two columns and one voice when there is only one. For this reason the orchestra must be divided into two parts along a virtual axis.[55]

Credits are often considered an 'innocent' or 'irrelevant' part of any film because they receive very little attention from most viewers. By centering his work entirely on them, Macchi reminds us that the credits nevertheless represent an essential moment for the cinematographic institution, since they determine the hegemony internal to the production of the film. Who takes priority in the credits? Why does the director appear alone while the electricians and sound technicians appear as a group? Why are some credits considered more important and presented in larger letters than others? The film credit is very informative about authorship and authority in film production – as we know from the many

arguments between producers, directors and screenwriters who have been left out of the credits during the centenarian history of the cinema.

At the same time, *End of Film* offers its authors the opportunity to sabotage the primacy of image over sound, which is all but universal in conventional cinema. Because the credits are illegible in this instance, the spectator can do no other than listen to the soundtrack. Relative to the merely illustrative use assigned to music on the screen – according to an old Hollywood saying 'the best film music is that which you don't hear' – Macchi and Rudnitzky subvert the roles generally assigned to these two media. This practice is reminiscent of the experimental model proposed as early as the 1940s by Theodor W. Adorno and Hanns Eisler in their book *Composing for the Films* (1947), where they suggested making a film in which the image would derive from an original musical composition rather than the other way around.[56]

The out-of-focus credits also reintroduce an element present in all five of these video works: frustration. While hegemonic cinema counts satisfaction as an essential objective of its narrative mode (hence the omnipresent happy ending), Macchi consistently provokes unease and discomfort in the spectator: the film that never begins (*Zeno's Arrow*), the murder that cannot be seen (*Super 8*), the endless departure of a feature film that is never shown (*Time Machine*), the mutilated projection of a famous masterpiece (*The Passion of Joan of Arc*), or the passage of illegible credits (*End of Film*). Macchi thus humorously emphasises the fact that our life as spectators is dominated by the same dynamic as our lives as subjects and citizens: the constant and frustrating struggle between reality and desire.

Combining ideas deriving from semiotics, psychoanalysis and Marxism, theory about the film apparatus ultimately constitutes a critical reflection on the dysfunction of late capitalism as a system.[57] The debates that have gained ground, particularly since the 1960s, concerning the photographic character of cinema, the ontology of editing and the modes of filmic consumption, have always attempted to counteract the simulacra of reassuring happiness that the society of spectacle tirelessly attempts to transmit. Macchi's videos can ultimately be seen as processes for demystifying the 'natural' order of the image; as he himself has said, they 'make visible that which is so visible that it becomes invisible'.[58]

The possibility of counter-obedience
In 2003, the Bolivian artist Narda Alvarado (b. La Paz, 1975) made a work entitled *Olive Green*, which is both a video art work and a performance in the public space. In spite of its brevity – it lasts a bare four and a half minutes – the video piece activates various aesthetic and political interpretations through the use of strictly audiovisual resources. Among the initial shots, for example, the technique of fast motion is immediately noticeable: Alvarado applies it to present the site in which

the action will take place, one of the main avenues of La Paz along which traffic is constantly flowing. Though the soundtrack is heard in real time, the image accelerates in order to emphasise the bustle of the city.

In this establishing shot, taken from above (perhaps from a bridge over the avenue), a person dressed in uniform halts a police motorcyclist and orders him to stop the traffic. Like the lorry-driver used by Santiago Sierra in his action *Obstruction of a Freeway with a Truck's Trailer*, the motorcyclist stops his vehicle at right angles to the flow of traffic and immediately interrupts its movement. Then, in a series of brief shots, Alvarado shows a squad of young police officers coming down a staircase and parading two by two across the avenue (fig.50). We hear the pounding steps of the cadets while the horns of the cars begin to sound and the traffic jam starts to form. The police in their green uniforms block the traffic on the avenue. In their right hands they each carry a white plate that contains a single green olive.

The video moves to slow motion when, at the climax and central point of the work, the cadets raise the olives to their mouths and eat them. Each policeman slowly chews his olive as if taking part in some military ritual. In a series of medium and close shots, the artist shows the policemen eating in slow motion (fig.51) and thus in direct contrast with the accelerated long shot with which the video began. Compared to the passages of everyday life, another time and another rhythm are imposed by order of the police. The change is not therefore simply spatial (the blocked avenue): the videographic medium allows Alvarado to slow the movement of time in the same way as the police have slowed the flow of traffic.

At the end of the performance, each policeman leaves the olive stone on his plate; the squad moves off in orderly fashion, the traffic regains its customary rhythms and the viewer has witnessed an arbitrary and absurd military action. However, the absurdity of the scene only emphasises the effectiveness of the police gesture. The obedience of the policemen and their consistently elegant execution of orders remind us that many military actions, incomprehensible though they may be for the civilian majority, occur with the implacable logic that defines the armed forces in general. There may be an element of caricature to *Olive Green* but if so it lies in an excess of reality; over and beyond any rational sense, this *ad absurdum* military and police obedience has underpinned certain tragic events in the recent history of Latin America.

At all events, the work avoids any facile Manicheism. The fearful faces of the young policemen, all of them of mixed race, remind us that the Bolivian government and police force recruit their foot soldiers from the working classes. Alvarado is not critiquing the individuals who process past us in rigid formation but the system that obliges them to march like automatons. The senselessness of this peculiar order is manifest in the faces of the astonished

cadets as they accomplish the absurd action required (eating a little olive). Jorge Villacorta and José-Carlos Mariátegui have pointed out that 'it is not possible that in the fulfillment of this order the police officers are not aware of the gratuitous impertinence of the action, causing public disorder'.[59] And in the confused gaze of the cadets the potential for rebellion is indeed observable.

Alvarado herself speaks of the video thus:

What interested me was the idea of creating chaos with the help of the forces of order, the idea of employing the power of authority to realise an anarchic act. The work also refers to the constant protests and demonstrations that occur daily in the street and at the time were integral to the image of the capital. [*Olive Green*] had to become absurd and crazy in order to acquire its significance. In February 2003, thirty people died and 250 were injured – citizens, police and soldiers among them – during the demonstrations in the streets of La Paz, after the government had announced the income tax required by the IMF as part of the so-called 'austerity package'. After these events, it became clear that the police formed part of the working class and were as poor as the majority of the population. In this climate of social, political and economic depression, many artists wondered about the sense or utility of our work. How could one be making 'art' when the rest of the country was experiencing the injustice that I have described? [60]

Alvarado here refers to events related to the *impuestazo* or 'great big tax' that the government of President Gonzalo Sánchez de Lozada sought to impose in Bolivia in January 2003, supposedly in order to eliminate the country's gigantic fiscal deficit. The tax caused a general strike and a police mutiny that resulted in a confrontation with the armed forces in La Paz's Plaza Murillo in which thirty people died. The army of the Sánchez de Lozada government again turned to military repression in the autumn of the same year to put an end to the riots in the Altiplano against the planned export of Bolivian gas to the United States via Chilean ports. In the 'October Massacre', seventy people died and hundreds were injured. This in turn contributed to the mobilisation of the majority of the population of the country and the eventual change of government in October 2003.[61]

Olive Green was a complex video to make, not only because of the difficulties surely encountered in obtaining the authorities' permission to perform the action presented in the video. It seems likely that it was recorded with a number of different cameras and in at least two different takes, since, in the long shot made from the bridge, we cannot see any of the street-level cameras with which the medium and close shots of the cadets were taken. And we know that in order to make another video with a similar theme, filmed in the same year, *Del Atlántico con amor* 2003 (*From the Atlantic with Love*), Alvarado did record several takes.[62] *From the Atlantic with Love* also shows a ceremonial official act but this time the military rite is executed by the artist herself:

she hands over to the Bolivian naval personnel assembled in a town square a bucket containing water from the Atlantic Ocean. Alvarado is again making an ironic historical commentary, as in the Pacific War of 1879 Bolivia was forced to cede its shoreline to Chile and with it any access to the sea.

The fact that the original title of *Olive Green* is in English stresses the political character of the video. *Green* refers not only to the colour of the olives and police uniforms but also to the popular etymology of the word *gringo*, which is supposed to derive from the contraction of the first words of the phrase 'Green, go home!' used by the Mexican people in the nineteenth century as a protest against the presence in their country of United States soldiers dressed in green. The title is the more relevant in that the ex-president Sánchez de Lozada is known in Bolivia as 'the gringo' because of his educational background in Washington and Chicago.

Alvarado's early interest in and intervention in the public space can be traced back to her studies in architecture, and in *Olive Green* she does not only intervene in the geographical order of the city. Through a specific stylistic resource (slow-motion), a video artist changes the rhythm of the authorities themselves. By slowing down the cadets' mastication of the olives, she subverts the dynamics so evidently asserted in the video – the fact that the police can impose itself on the population in a matter of seconds. Thus *Olive Green* as an artistic action sets itself up against military action. Just as the video-work of Miguel Ángel Ríos denounces the violence explicit in all authoritarian agendas, Alvarado's work presents itself as a symbolic act of counter-obedience. Like the videos of the other artists that we have examined in this chapter – from Conlon's *Dry Season* to Ochoa's *Five Dots*, from Zink Yi's *Huayno and Fugue Behind* to Wildi's *The Invisible* – *Olive Green* once again demonstrates the expressive power and political meaning of the video form. It also confirms that

there exists today among the artists in Latin America a desire to take up critical positions relative to the abusive strategies of the political, economic, linguistic and socio-cultural powers-that-be. This aim becomes especially combative and physical in the public art of urban action.

Actions in the public space

3

Playing in the labyrinth

In his work *La paradoja de la praxis I* 1997 (*Paradox of Praxis I*, fig.53), Francis Alÿs (b. Antwerp, 1959) chooses a block of ice of the kind daily distributed through the streets of Mexico City for use in refrigeration. The starting point is a quotidian activity and an object of an apparently insignificant nature. In the course of his artistic action, Alÿs goes through the streets of the capital pushing the block of ice, at first with considerable effort, as though undertaking exhausting physical labour, and later, as the day passes and the ice melts, with greater fluency and ease. By mid- to late afternoon, when the ice has been reduced to a little ball, the artist finds it easier simply to kick it along. By the end of the working day, the ice has turned into a little puddle of water which finally disappears. Aware of the normal use of that piece of ice, Alÿs nevertheless prefers to push the block through the city until it has completely melted in order to deprive the object of its original function. The ironic subtitle of his action refers to this paradox: 'Sometimes making something leads to nothing'.

Paradox of Praxis I is a site-specific and indeed time-specific work. The activity of pushing the block of ice lasts one entire working day. Alÿs records the start of his task at 9.15 in the morning and completion at 6.47 in the evening. This form of intervening in spatio-temporal coordinates brings to mind certain happenings or examples of conceptual art from North America – one is reminded of the ephemeral works *Fluids* 1967 by Alan Kaprow or *Bliz-aard Ball Sale* 1983 by David Hammons, both made with ice – while at the same time revising the parameters of the minimalist cube, an artistic tradition revisited by other artists of his generation. Indeed, Alÿs has admitted that the piece is 'a way of coming to terms with certain sculptural forms, such as minimalism'.[1] It seems clear that Alÿs has maintained an interest in the contextualising goal of minimalist sculpture, which was originally intended to transcend the aesthetic autonomy of the art object. But he also attempts to impart another emphasis, which is why in *Paradox of Praxis I* he chooses literally to dissolve the cube in its context; in this way the perfect geometry of the ice block mingles with and is contaminated by its everyday physical and social environment, while its rigidity ultimately gives way to the impact of the changing and imperfect landscape that surrounds it. The minimalist form dissolves and thus incorporates the quotidian flux of real life, so when the block of ice has melted, the *object* has given way to *action* and *work* has become *play*.

Over the course of the 1990s, Alÿs found himself deeply involved in a practice consisting of ephemeral urban interventions, which essentially involved walking through the city unnoticed by any particular audience. Taken together, his works *Paradox of Praxis I*, *Turista* 1994 (*Tourist*) and *El goteo* 1995 (*The Leak*), among others, constitute one of the outstanding examples of contemporary artistic practice in the public space, as they attempt to develop a methodology

52 **Francis Alÿs**
El goteo 1995
The Leak
Action performed in
São Paulo

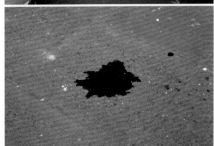

with which to blur the frontiers dividing art and life.[2] Alÿs's urban actions not only critique the way in which the concept of modernity has imposed itself as an ideologeme in Latin America but also the process by which artists themselves have been subjected to this ideologising tendency. To articulate his discourse, Alÿs subjects the artistic object to a radical modification and 'places' art as playful and emancipated work. Like other artists currently developing their practice in the public space, he belongs to a tradition of art as sabotage that arose with the anti-artistic Dada movement in the early twentieth century and found one of its most transformative expressions in the activities of French Situationism of the 1950s and 1960s.

For Alÿs, the creative process is more important than the finished artistic product, rather as we have seen with Orozco's *Parking Lot* and Garaicoa's *Now Let's Play to Disappear*. Alÿs gives priority to the process, enduing it with its own power since the methodological basis of many of these urban actions is rooted in the concept of flux. For example, in *The Leak*, an action undertaken in São Paulo two years before *Paradox of Praxis I*, the artist emerged from an art gallery and began to wander the surrounding streets. In one hand he carried a perforated tin of paint that, as it dripped, left behind a fine trail of blue paint on the ground (fig.52). This trail in due course allowed Alÿs to make the return journey to the gallery, where he hung the empty tin of paint on the wall.

This too was a form of contextual action realised in space and time: a project intended to take art out of its 'ivory tower' like the visit that the Dadaists organised in 1921 to the church of Saint-Julien-le-Pauvre in Paris.[3] Moreover, *The Leak*, as its title suggests, evokes the dripping paintings by Jackson Pollock. Speaking of the drastic leap in Abstract Expressionism from painting on the vertical easel to painting on the floor, Harold Rosenberg defined the horizontal canvas as a field within which to 'act' rather than a space in which to reproduce the world.[4] At the same time, Alÿs's piece is reminiscent of the work of Asger Jorn in *Mémoires* (1958), a book made in collaboration with Guy Debord, in which drip paintings by Jorn sketched random and fluid lines over the psychographic maps that Debord had constructed with fragmentary maps of Paris.

To that extent, *The Leak*, like *Paradox of Praxis I*, reintroduces the idea of temporalising space, imprinting on the map a temporal experience that precludes its reification.[5] The liquid trail left by the cube of ice and the perforated tin of paint sketch on the 'floor' of the city the wanderings of the artist through the complex urban labyrinth. By their composition as fluids that cross the most changeable and movement-infested spaces of the city, these works give form to Alÿs's desire to revise traditional public art. They do not aspire to a permanent location in the kind of site assigned by urban planning – for example, in the centre of public squares, in parks or in front of monumental facades. Alÿs completely renounces the monumental and commemorative tradition of art

54 **Francis Alÿs**
Turista 1994
Tourist
Action performed in
Mexico City

in public places with its familiar burden of authority, preferring to inscribe his works in the ephemeral time of vernacular spaces, spaces that he himself calls interstitial: 'When I decided to step out of the field of architecture, my first impulse was not to add to the city, but more to absorb what already was there, to work with the residues, or with the negative spaces, the holes, the spaces in-between.'[6] In thus proposing a fluid public art running counter to anything solid and stable, Alÿs returns to Benjamin's idea of the streets as the dwelling place of the collective and of the collective as an eternally restless, eternally moving essence.

On a number of occasions, Alÿs has described the action of walking as 'a form of resistance'.[7] The idea of strolling at random in the manner of the *flâneur*, of wandering like a vagabond, offers de facto a rebellion against the logic of production. By thus rejecting the regulating system of the city, Alÿs is able to maintain a distance from which he can critically observe social relations in the urban world. He becomes a walking observer and this artistic position allows him to review the old promises of modernity and analyse the way in which these have become inscribed in the urban landscape and daily functioning of the Mexican capital.

Is this simply his recreation of the historical legacy of *flânerie*? Or does it suggest a *nec plus ultra* of the modernising sensibility? After settling in Mexico in the early 1990s, the artist discovered the notion of fragmented modernity and began to turn it into a motif to be scrutinised in his own work:

I looked into one of the West's most controversial exports, the model of modernization (as moving away from tradition), in order to analyze Mexico's complex relationship to that imported ideology, and to investigate in particular how the syndrome of progress and the dogma of productivity are lived and understood south of the US border.[8]

Rather than bringing the project of modernity to its culminating point, his work is intended to function as an allegory of the infinite deferral of that modernity, which is to be understood as a project still in progress. Hence the melted cube of ice can also be read metaphorically: only by becoming conscious of the ideologising aspects of modernisation (progress as syndrome) can modernity reach those elements within it that constituted an authentic project of collective emancipation.

It is this theoretically alien urban context that granted Alÿs – he trained as an architect in Venice – his artistic freedom. He himself recognises that his art was born of the strong stimulus constituted by Mexico City, his impression of 'how dysfunctional the whole thing seemed'.[9] In this he resembles Gordon Matta-Clark when the latter settled in the dilapidated New York of the 1970s, the perfect example of the entropic city. Impressed with the dysfunctional nature of the city that presented itself before him as almost completely inscrutable in its

many parallel economies and levels of functioning, Alÿs confined himself in his first phase of artistic action to 'a period of observation, to see how other people manage[d] to function within this urban chaos'.[10]

Tourist, another of his early actions, is intimately connected with this tactic of observation (fig.54). In 1994, the artist planned to stand in the very central Plaza de la Constitución, known as Zócalo, alongside a set of tradesmen who offer their services directly in the street through placards defining them as commoditised subjects: 'plumber', 'electrician' or 'painter/plasterer'. Alÿs, positioning himself in the context of the Mexican capital, wrote for his placard the word 'Tourist'. This denomination not only emphasised his status as a foreigner in the city but more concretely his position as an individual outside reality, someone marginal: an outsider. His profession as artist-tourist is not comparable with any other profession in the labour market. A person who makes art is in some sense a non-worker, a figure that makes nonsense of the systematised scission between work and leisure. But this critique of the 'dogma of productivity' carries within it a veiled commentary on the way in which artists have to 'sell' themselves within the model of modernisation ideologically imposed by 'progress'.[11]

In *Paradox of Praxis I*, Alÿs also reactivates the work/leisure dichotomy, since what seemingly began as a productive task eventually disintegrates into a kind of game. The destiny of a block of ice exposed to the heat, particularly during a hot day in the historic centre of Mexico City, is not even slightly mysterious: the end of the story is to some extent inscribed in its beginning if we place our trust in one of the simplest laws of physics. His action makes visible the paradox that doing something may lead to nothing and thus formalises the idea of anti-productive work. The ice, for its part, like any other element liable to alter its physical states to the point of disappearing, is the perfect metaphor to combat the notion of the work of art as a commodity.

Alÿs transforms an innocuous and banal street activity into a self-reflexive exercise on the role of the artist in contemporary society. He uses the recreation of a completely demystified and repetitive task, that of distributing blocks of ice in the city, to develop a critical perspective on his own status in the labour market. It requires all the strength in his body to push a block of ice in its original form and this is emblematic of the load constituted by the artist's commitment, of the burden and weight of the artist's responsibility. However, to the extent that the ice disappears, art itself becomes ludic and ceases to 'weigh' on him. Thus art moves from alienated work (the burden) to emancipated work (play). As Alÿs once remarked, in *Paradox of Praxis I*, 'I continued questioning the mechanics of artistic production and the status of production itself.'[12] Like *The Leak* and *Tourist*, the work implies an attack on the 'professionalisation' of the artist within the post-Fordist system and this ultimately takes us back to the Situationist Utopia of liberating civilisation from the chains of work. As the Debordian graffito read:

55 **Doris Salcedo**
Noviembre 6 y 7
2002
November 6 and 7
Installation, Palace of Justice,
Bogotá

Ne travaillez jamais (*Never work*).

The old aspiration of the avant-garde to fuse art and life had necessarily to begin with a critique of daily life that might lead to its complete transformation. Debord once defined daily life as 'whatever remains after one has eliminated all specialized activities'.[13] In his view the revolution of daily life needed to 'create the conditions in which the creative aspects of life always predominate over the repetitive'; this 'will mark the end of all unilateral artistic expression stocked in the form of commodities'.[14] To meet this programme, Debord's strategy was to develop tactics that could restore principles of play and pleasure. Games must therefore be permitted in the labyrinth in which the subjects and objects commercialised by our grim consumer society have lost their way.

In his urban interventions *Tourist*, *The Leak* and *Paradox of Praxis I*, Alÿs has combined elements of *flânerie* and wandering – one might say his was a committed *flânerie* or a solitary *dérive* – to deactivate the artistic object and convert it into action. In his hands it becomes not a commodity but aesthetic and political argument. As he himself has stated:

Walking is a very immediate method of unfolding stories. It's an easy, cheap act to perform or to invite others to perform. The walk is simultaneously the material out of which to produce art and the modus operandi of the artistic transaction. And the city always offers the perfect setting for accidents to happen.[15]

Assault on the Palace of Justice

On 6 November 2002, at 11.35 am, a wooden chair began slowly to descend one of the walls of the facade of the Palace of Justice, which lies in the Plaza de Bolívar, at the very centre of Bogotá (fig.55). A few minutes later, passers-by were surprised to see that a second chair, similarly hanging from the roof of the building, was also descending as if to accompany the first. As the day wore on, more and more chairs came sliding silently and mysteriously down the walls of the Palace, to the great astonishment of all the citizens who, over the course of the next few days, could see the facade of the building almost completely covered by this ephemeral installation by the artist Doris Salcedo (b. Bogotá, 1958). The intervention *November 6 and 7* (fig.56) recalled the events that had occurred exactly seventeen years earlier, in November 1985, when the Supreme Court of the country was the scene of a battle between the armed forces of the state and the guerrillas. This armed confrontation, in which more than three hundred hostages had been taken, left fifty-five people dead, among them the President of the Constitutional Chamber of the court and ten other magistrates, while a number of others disappeared. It was one of the most critical moments in the contemporary history of Colombia, marking the trajectory of then president Belisario Betancur, the guerrilla group Movimiento 19 de Abril, and, by extension, the violent way of 'making politics' in Colombia.

In her installation, Salcedo lowered each chair at the precise moment when, according to the information available to the artist, the people inside the building in 1985 were murdered. Therefore the action began at 11.35 am – the time at which the first crime, the assassination of a guard, was committed – and lasted for exactly the duration occupied by the seizure and recapture of the Supreme Court: fifty-five hours.

Concerning the genesis of her project, Salcedo has said that the assault on the Palace of Justice 'belongs to the past, but when we think about it on the anniversary, it announces its spectral return'.[16] In an interview published in 2005, the curator Hans-Michael Herzog asked her about the attack on the Supreme Court and her motives for making this piece in memory of the victims of the attack. Salcedo replied:

It is unacceptable for a country's Supreme Court to be completely wiped out by an act of violence. That is to say that the country, its government and citizens, can allow the massacre of the highest representatives of justice. This is without precedent in history. Just think of the implications of a country left without justice. This act happened on November 6 and 7, 1985, and it marks the moment when the internal conflict in Colombia worsened. Before this, violent acts took place, but from that moment on the decline became appalling and conditions deteriorated for Colombian people. It is a moment people have tried to forget; very little was published about it, and the press hardly mentioned it. The colonel who organized the totally brutal actions was absolved. The current government has made him a public figure and to their shame, he forms part of the government. With such a degree of denial, I felt the need to address that event in my work.[17]

Reacting to the violence generated by narcoterrorisimo, organised crime, governmental corruption and the internecine conflict between guerrillas and paramilitaries that has condemned Colombia since the 1960s to a state of permanent crisis, Salcedo began developing her oeuvre in the 1990s, intending a critique of the unbearable situation of the country at both socio-political and economic levels. Throughout her career, she has employed everyday objects such as the chairs of *November 6 and 7* to evoke the victims of violence who once used them. For example, in the series *Atrabiliarios* 1992–3 (*Defiant*), the shoes sewn with surgical thread are vestiges or relics of people murdered in one of the conflicts endemic to Colombian society. 'While researching specific cases of disappearance', Salcedo noted, 'I discovered that the only feature common to all cases, which enabled the identity of the missing people discovered in a common grave to be determined, was each person's shoes.'[18] In other series, such as *La casa viuda* 1992–5 (*Widowed House*) and *Unland* 1995–8, the artistic object is a piece of transformed furniture: a table, wardrobe or bed presented as a trace of its former user through a formal modification that might consist in truncating or combining or filling it with concrete, clothes, bones or human hair. Such

56 **Doris Salcedo**
Noviembre 6 y 7
2002
November 6 and 7
Installation, Palace of
Justice, Bogotá

modification – not unlike furniture assemblages such as *Subdesenvolvido* 1964 (*Underdeveloped*) by the Brazilian artist Waldemar Cordeiro – imparts to the furniture the aspect of something 'wounded, both physically and psychically'[19] and thus commemorative of the victims.

In both series, as in *November 6 and 7*, the initial impulse to reflect on a particular case gradually acquired a more universal character. The title *Widowed House* refers to Colombian housing whose residents suddenly disappear as a result of political violence, whereas that of *Unland* – Salcedo coined this word in reference to the concept of deterritorialisation – speaks of a sense of helplessness no longer specific to the Colombian or Latin American citizen, but one that has become 'the underlying, general condition of society as a whole'.[20]

In *November 6 and 7*, the chair undoubtedly acquires a symbolic character. The image of an empty chair induces a sense of absence and silence in the spectator. Salcedo's work is in this respect reminiscent of a number of pieces by Joseph Beuys, and more specifically, the sculpture *Ionesco* 1985 by Arman, made with dozens of folding chairs in the town square in Lille, and alluding to the famous 'tragic farce' *The Chairs*, written by the Franco-Romanian Eugène Ionesco in 1952. In Arman's sculpture, as in Salcedo's intervention, the proliferation of unoccupied chairs, those eloquently mute objects, symbolises the presence of an absent multitude.[21] But for the Colombian artist, the chair serves at the same time to establish a comparison between two divides: inside/outside and human/inhuman.

Every time you see a chair, you know that it is a place for a human being, and that all of us human beings could be in that place. What interested me with the chair was to choose an element that we necessarily found in interiors and to place it outside, on the façade of the building, in a position that a human being could not occupy. I think that is how we are at war: in a completely inhuman world.[22]

The dangling chairs of *November 6 and 7* memorialise the victims of the attack on the Palace of Justice and present an uninhabitable space: nobody can sit on them. If we bear in mind that the artist once referred to the history of the wars as 'an endless struggle to conquer space',[23] the near-unconquerable space generated by the installation can be interpreted as a direct challenge by Salcedo to the aggressive logic of belligerence. 'Where there is violence inner life is not possible,' she has said. 'It is a possibility only offered by peace, tranquility and respect for the life of others. As I concentrated the work on the front of the building, I emphasized the exterior, the absence of an inner world.'[24]

But *November 6 and 7* does not confine itself to spatial reflection. Its ephemerality – the fact that it was dismantled after fifty-five hours – makes clear Salcedo's concern to exploit and develop the temporal value of the

installation. By commemorating the individual crimes through the lowering of chairs (over the course of the two days marking the anniversary of the attack), the work emphasises movement and acquires a theatrical aspect. It becomes, in the artist's words, 'a staging'.[25] Moreover, as Rod Mengham has accurately observed, 'the dual temporality of the performance subjected the viewers to a real-time experience of duration inflected with a sense of historical displacement. Siege and artwork were implicated in the same historical narrative as complementary events.'[26]

November 6 and 7, as a commemorative intervention in the public sphere worked out on both spatial and temporal levels, answers to the 'need' perceived by Salcedo to confront the general oblivion on the part of governmental institutions and media: 'We [Latin Americans] not only have to deal with economic precariousness but with the precariousness of thought: an inability to articulate history and therefore to form a community.'[27] The social content of Salcedo's works acquires its maximum expression as an echo of the silence to which the victims of the violence find themselves subjected. To that extent *November 6 and 7* takes up the legacy of Adorno in the form of a question posed at the end of his *Aesthetic Theory* (1970): 'But then what would art be, as the writing of history, if it shook off the memory of accumulated suffering?'[28]

Salcedo has explained on many occasions that at the heart of her work is the experience of the witness or victim of political, social or economic aggression: a witness who is necessarily wounded or even absent. The accumulated suffering is here expressed as negation but as a negation injected into the positive flow of the urban public space. 'If I manage to make a good piece that circulates in the center of society,' the artist has said, 'then their pain will enter into the core of this society. The victims will become the main protagonists.'[29]

In recent works of public art, Salcedo has created new spatial interventions that activate political memory in the context of historical amnesia. For example, *Sin título* (*Untitled*), an installation made for the Istanbul Biennial of 2003, again makes use of the chair as motif, this time multiplying it in astounding fashion in a vacant lot between two buildings at the centre of the city. (fig.57). Salcedo filled this patch of ground with more than 1,500 chairs, whose chaotic accumulation has something about it of a catastrophic event. Conceived as a kind of commemorative anti-monument, as the image of 'a topography of the war which is already inscribed in our daily lives',[30] *Untitled* is located in a fissure, a crack, an abandoned crevice of the urban space.

Precisely this notion of fissure came to the fore in the best-known work by Salcedo at the time of writing, *Shibboleth*, installed in 2007 in another public space, the Turbine Hall of London's Tate Modern. Here the artist created a crack 167 metres long in order to question the socio-economic divide between the First and Third Worlds, or, in other words, between Europe and Latin America

(fig.58). According to Salcedo, this work reflects the experience of the immigrant, which is gradually and imperceptibly becoming part of 'the heart of Europe'.[31] By subtly subverting the monumentality of the hall and creating a disruption in the apparent stability of its *Grund*, Salcedo articulates the point that all First World social spaces are constructed by concealing the internal contradictions on which they are based. Just as the apartments full of bananas by Zamora reminded us that in the current post-Fordist system there can be no wealth without poverty, the fissure constructed by Salcedo critiques from an artistic perspective the triumphalist vision that denies the strong contradictions and violent conflict on the basis of which hyperdeveloped societies are daily constructed.

Monolithic interpretations of *November 6 and 7* or any other of Salcedo's public installations are doomed to fail. Her work is so valuable precisely because it is constructed on the basis of a multidimensional vision of the conflict that she recreates or evokes. There is no sense in her work of an easy redemptive vision. She believes that the work of art should induce in the spectator a feeling of frustration, displacement and insecurity. Thus, in relation to the project that she made at the Palace of Justice, Salcedo 'wanted to put forward an image that would be at the intersection between the desire to remember and the drive to forget'.[32] Forgetting, like forgiving, arises here as a complementary and necessary part of grief and mourning, processes that are necessarily fragile, painful and unfinished. Therefore the work does not emerge as the solution or closure of a problem but as a sensitive and intelligent redefinition of a given conflict. On this point, Salcedo has said:

I do not believe in the possibility of aesthetic redemption. I do not believe that art can redeem anything[;] I believe that the word that defines my work is the word 'impotence'. Art is impotent, art does not solve anything, art cannot solve problems, art cannot bring anybody back to life, art cannot remedy reality. And I believe that what defines art is its lack of power, and because it has no power, it is different from military power, or economic power, or political power. This is where the essence of art lies, in the lack of power.[33]

Here again the thought of Adorno finds an echo in those of the Colombian artist: paraphrasing a famous sentence of Adorno's on the functionality of philosophy, we might say with Salcedo that, precisely because it was good for nothing, the installation *November 6 and 7* was nevertheless useful.[34]

Conditions of circulation

When, in November 1998, two years after moving to Mexico City, the Spanish artist Santiago Sierra (b. Madrid, 1966) negotiated the loan of a lorry from a vehicle rental company, he was quite open about what he wanted to use it for. Once the lorry was circulating through the city, the driver (one of Sierra's earliest contracted employees) followed the artist's instructions; he entered

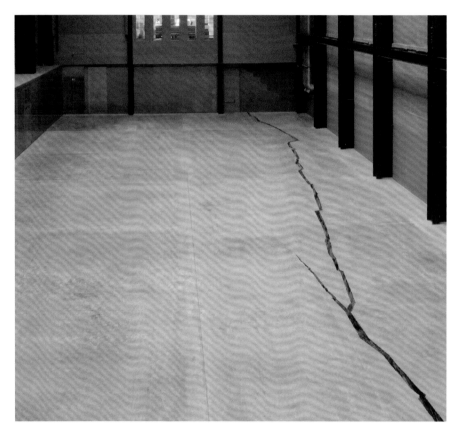

58 **Doris Salcedo**
Shibboleth 2007
Installation,
Tate Modern, London

the Southern Ring Road and blocked the traffic for five minutes by placing the trailer at right angles across the three lanes of one carriageway. As expected, the action produced an immediate traffic jam by blocking the flow of vehicles on the motorway.

With *Obstruction of a Freeway with a Truck's Trailer* (figs.59), Sierra was attempting a type of mobile public sculpture that would not only interact with the urban environment but momentarily obstruct circulation in the city. The enormous white prism on wheels represented first and foremost a disproportionately large rectangular cuboid. Briefly placed in a peripheral transit zone, its impact on the site was characterised by two main features. On the one hand, unlike modern public sculpture, the sculptural object was not located in the traditional kind of symbolic and consensual site at the centre of a public square nor intended like such sculpture to reinforce permanently the universality of the modern language of monuments. On the other, the unabashed and unavoidable presence of a lorry in the middle of the carriageway symbolised

Sierra's recurrent obsession with provoking conflictual relations within the context of his sculptural practice.

Throughout his career, Sierra has attempted to bring frictions of a formal or spatial kind before the eye as a way of foregrounding the dissociation between art and reality.[35] From very early on, he found a model of artistic work with which to express the relationships of mutual misunderstanding that the system has so effectively established. His methodology consists primarily in the superimposition, or, more precisely, the imposition of rigid, rational patterns, cubic or geometrical, on the changing, fragmented or unfinished organic forms that represent the individual and his or her environment.[36] Following the minimalist legacy, in *Obstruction of a Freeway with a Truck's Trailer*, the artist attempts to 'place a minimalist object in a given situation and see what effect it has' at a practical and specific level: 'I am doing something *real* when I place an object on a motorway.'[37]

Undoubtedly, the references to the dilemma of the cube and the body that permeate almost the entirety of Sierra's work can be traced back to Robert Morris and the well-known dialectics of minimalism and anti-form. Minimalist art claimed to subvert the idealism of modern sculpture, declaring that modern sculpture directed the awareness of the spectator to the play of internal relations in the sculptural work. By the use of forms reduced to the essential and surfaces kept neutral or even reflective, minimalism emphasised the external relationships of the work in order to reorient the perceiving subjects to an awareness of themselves and their spatial conditions. This shift consequently introduced the notion of site-specificity in the mid-1960s. However, as the critic Douglas Crimp has pointed out, the contextualising project of minimalism failed because it was incapable of developing a materialist critique of modern idealism:

The critique of idealism directed against modern sculpture and its illusory sitelessness was, however, left incomplete. The incorporation of place within the domain of the work's perception succeeded only in extending art's idealism to its surrounding site. Site was understood as specific only in a formal sense; it was thus abstracted, aestheticized.[38]

Although the artistic perception of the minimalist work depended on context, the sculptural context itself continued to be conceived in purely formal terms and therefore as a politically neutral space. Sierra's work is an attempt to overcome this tendency and thus transcend the incomplete aspiration of minimalism.

In *Obstruction of a Freeway with a Truck's Trailer*, the rigid formal vocabulary of the trailer (a neutral blank prism, lacking logos or ads) was used by Sierra to draw attention to the rigorously reticular structures informing its environment: in this case, the commonplace road setting. The artist recorded the entirety of the action in a six-minute video as a fixed long shot from above. Once the truck had blocked

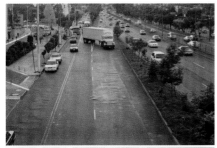

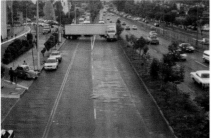

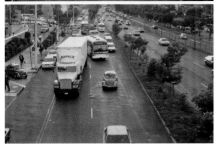

the flow of traffic and cars had begun to form a traffic jam behind it – it was probably not coincidental that the dimensions of the trailer nicely matched the breadth of this section of the motorway – Sierra continued to record the section of carriageway now entirely bare of traffic.

This is precisely the point at which we perceive the play of spatial relations that the artist sought to create by inserting an artistic action into this context. A particular tension is triggered when the directional vector indicated by the continuous and discontinuous lines of the carriageway is challenged by the position of the trailer. The trailer becomes a vector of opposing forces. The intervention thus reveals a force field greater than that initially caused by the abrupt irruption of the lorry; that which governs city planning and more concretely the ordering of the traffic. In a correlative process, whereas the geometry of the trailer seemed to evoke the geometry of its surroundings, what at first seemed a vernacular landscape without obvious interest is momentarily revealed as a cold, precise authoritarian landscape designed for a specific use. And the continuous and discontinuous lines painted on the roadway emerge as the most evident signs of this aspect of the built environment.[39]

Twenty years earlier, in December 1979, the Chilean artist Lotty Rosenfeld had realised the urban intervention *A Mile of Crosses on the Pavement* (fig.2). In this action, Rosenfeld used white tape to create perpendiculars to the discontinuous white lines of the Avenida Manquehue in the city of Santiago de Chile (specifically the section between Los Militares and Presidente Kennedy), thus creating a string of crosses 1,600 metres long. The artist wanted passers-by to reflect on the way in which they followed orders in the public space, where the authorities acted in subliminal fashion with the intention of creating unreflectively obedient subjects. Echoes of this intervention and of the idea of altering the objective delineation of the landscape – and the consequent unconscious assimilation of its laws – can also be perceived in other works by Sierra, such as *30 bloques de pan alineados* 1996 (*30 Blocks of Bread Lined Up*), in which the artist lined up rectangular slices of bread along the intersection of Calle Fútbol and Calle Ciclistas in Mexico City in order to displace the tangent to the semicircle formed by the pavement. In his earlier works in Madrid before he left for Mexico, such as *Trozos de calle arrancada de 100 x 100 cm en su cara superior* 1992 (*20 Pieces of Road Measuring 100 x 100 cm Pulled Up from the Ground*) or *50 kg de yeso sobre la calle* 1994 (*50 kg of Plaster on the Street*), Sierra had already identified the circulation spaces of the city as sites for artistic exploration.[40] His early works show his interest in the morphology and functioning of streets as essential parts of the capital's infrastructure for the transport of both merchandise and workforce and in the vehicles that, like machines, make this transport possible by their confinement within certain spatio-temporal coordinates. In his works, Sierra has said, 'the whole repertory of material objects, whether they be cars,

benches or flagstones, are always employed in their quality as containers of the human body or of the merchandise that the human body produces.'[41] Transport time can be quantified in monetary terms and the social relations in the street – mass movements and human encounters – can also be considered in commoditised terms: people going to and from work, consuming in businesses, and distributing or exchanging services and products...

All these dynamics answer to a model of a reified conduct that is inherent in the capitalist forces that govern the city's operations. The body is the object from which profit is obtained to the extent that its vital energy is converted into work. In this respect, Sierra's practice is reminiscent of another Benjaminian thought concerning movement in the modern city. Individuals, Benjamin tells us, do not make use of the conditions of circulation; on the contrary, the conditions of circulation make use of the individuals.[42]

Obstruction of a Freeway with a Truck's Trailer is a reflection on the way in which authority over the individual is exercised through the organisation of landscape and the management of time. It foregrounds the interconnection of these two categories via the momentary suspension of their logic. Sierra works on notions of circulation and flux, obstruction and redirection, as an alternative to the spatialisation of regulatory power in the city and its conditions of circulation. The instructive irruption of his sculpture is a type of action reminiscent of the protest demonstrations based on barricades and the blocking of traffic. The use of the work of art as a spatial obstacle is also evocative of earlier works of Land art and public sculpture such as *Iron Curtain* made in 1962 by Christo and Jeanne-Claude in Paris's narrow rue Visconti or the famous *Tilted Arc* 1981–9 sited by Richard Serra in New York's Federal Plaza. Through a tactic of negation or interruption, these pieces stimulated a conscious appreciation of the built environment and undid the false 'naturalisation' of urbanism and its condition as *doxa*.[43]

The context in Sierra's oeuvre is always a specific place. *Obstruction of a Freeway with a Truck's Trailer* deals with the artist's relation with Mexico City, to which he moved permanently in 1996 at a time when the country was undergoing a grave political and economic crisis. Like Alÿs, Sierra encountered in Mexico a 'chaotic repertory of formal elements reflecting the violence generated by social conflict'.[44] Mexican roads were often the object of spontaneous blockades on the part of the citizens who were increasingly frustrated by the gradual deterioration of the urban infrastructure. Sierra has explained that this intervention arose as a form of 'revenge' for the fact that the roads were sometimes blocked for hours at a time. The Autopista de la Amistad, the site of his action, had been constructed for the Olympic Games of 1968 and had become a symbol of the projected modernisation of the country.[45] Sierra's entire corpus is underpinned by his understanding that situations of crisis

60 **Santiago Sierra**
Puente peatonal obstruido
con cinta de embalaje 1996
Footbridge Obstructed
with Parcel Tape
Action performed in
Calzada de Tlalpan and Río
Churubusco, Mexico City

or disintegration are a by-product of an economic order that, though it has imploded, seems to require such crises to ensure its continuity. This is why he was interested in investigating peripheral situations and the entropic process of marginal spaces as these phenomena are reflected in the daily life of Mexico City.

Though the urban fabric regulates and orders the forms, uses and traffic of the city in general, the citizens of Mexico City are not paralysed by the imposition of new norms of circulation. This Sierra demonstrated in an earlier work in which he had similarly implemented an obstructive spatial strategy: *Puente peatonal obstruido con cinta de embalaje* 1996 (*Footbridge Obstructed with Parcel Tape*). Acting by daylight as he had with the lorry intervention, Sierra temporarily blocked access to a pedestrian bridge over the Tlalpan motorway, using criss-crossing bands of parcel tape (fig.60). He himself said that nobody seemed inconvenienced by his act: pedestrians simply continued down the street to look for another crossing point.[46]

By thus imposing an obstruction, Sierra not only contextualises the work of art (by bringing art to the street or bringing the street into the space of art) but politicises that context. He reveals the complicity of the artist within the capitalist system by symbolically emulating in his own work exercises of exploitation, subordination and even sadism. Both in *Obstruction of a Freeway with a Truck's Trailer* and *Footbridge Obstructed with Parcel Tape*, Sierra intended to test the limits of the individual's capacity for obedience by altering the conditions of circulation through which the system exercises its authority. In this way he subjects the participants of his action (or direct spectators) to a doubly disruptive process by both abruptly blocking their way, and, in the case of works based on contracting the services of others, paying others to perform humiliating tasks. Meanwhile, the indirect spectators of the artwork are both witnesses of – and participants in – the relations of power and submission that it unleashes. These relations can be extrapolated to the relations of subordination endured by underdeveloped countries. 'Violence is not something that functions exclusively outside of art,' the artist has said: 'Art is contained by society and its mechanisms and can also generate violence.'[47]

In 1999, in Mexico City's Museo Rufino Tamayo, Sierra presented *465 personas remuneradas* (*465 Paid People*). For this project, he commissioned an employment agency to contract 465 young men of mixed-race appearance, who were instructed to occupy the gallery en masse on the night of the opening. As Adriano Pedrosa has written, these *actors* brought both the conditions endured by cheap labour and the issue of racism directly into the museum. In doing so, they illuminated the exclusiveness characteristic of the artistic scene, which is 'perhaps greatest in Third World countries'.[48] The spectators of this work were forced to reflect on their own position and that of the entire art institution (including that of the artist) within this complex map of tense and unequal relations.

In an interview with Mario Rossi, Sierra acknowledged:

We all know how privileges are obtained and we all know that art is not sold in alleyways or street markets. So I don't see myself as teaching any lessons to anybody; my survival depends on the strength of a specific social group and therefore on the detriment of many others, which means that what we are talking about here is complicity and not critique. Far from any happy end articulated by the position of the author, the work gains extra strength precisely because it doesn't resolve anything and forces the spectators to take up their own positions in the absence of any models. Some see me as a critic and others as a sickly exploiter; I don't care much because I am not talking about myself anyway.[49]

Public words

Puerto Rico-based artists Jennifer Allora (b. Philadelphia, 1974) and Guillermo Calzadilla (b. Havana, 1971) have been working together since 1995. The duo exemplifies the condition of the global artist as a traveller who develops projects in various points of the planet and whose ephemeral and nomadic strategies answer to the site-specific variables encountered in each of their destinations. Among the multitude of media that they use – video, sculpture, sound interventions, actions and installations – sculptural works constitute the majority, but these are opened up by the artists to incorporate the idiosyncratic forms of public communication and social exchange. Thus the collaboration and participation of the audience is often indispensable to the materialisation of their projects.[50]

Tiza (Lima) [*Chalk (Lima)*] was one of the works programmed for the third Bienal Iberoamericana, which took place in the city of Lima in 2002. Allora and Calzadilla returned to the idea of an earlier project in order to find out what would happen in a different context, the first version of the piece having been executed in New York in 2000 on the occasion of the Museum Mile Festival in Fifth Avenue. The concept of the work was to produce gigantic bars of chalk and deposit them on the surface of roads and pedestrian areas. Nothing further was planned; passers-by would come across these unexpected objects abandoned in the street and decide how to respond to them as their socio-cultural conditions dictated. The place that the artists chose for this second version of *Chalk* was the Paseo Santa Rosa, one of the main arteries of administrative power in the Peruvian capital.

The gigantic bars of chalk seem at first glance inert and closed in on themselves, lacking any possibility of an active relationship with their surroundings (fig.61). But soon the material properties of chalk aroused the curiosity of the passers-by. A kind of white clay created from gypsum and water, chalk is traditionally made in small bars and used to write on slate surfaces; its recognition as a paradigmatic educational instrument associated with learning and childhood games encouraged people to begin experimenting with the chalks, finding out whether they did indeed leave marks on the ground. They soon found

out that, with help, they could move them, manoeuvre them, or break them into pieces in order to be able to write or draw on the paving. Paradoxically, the public was thus collaborating in the involuntary process of the dematerialisation of the work through the fragmentation and consummation of the chalks.

As Jennifer Allora explained, 'the objects are thus caught between dissolution (as a set of physical bodies) and realization (as a proliferation of graphic traces)'.[51] Measuring 262 cm in length and 20 cm in diameter, these gigantic bars of chalk mark a return to the Oldenburgian formula of monumentalising commonplace objects. But the participative intervention also gives rise to a contrary process: their monumentality is soon reduced to human scale as the activity of sketching, decorating, scribbling and writing words or love letters on the ground becomes a kind of collective reclamation of public art.

The sight of the ground thus inscribed takes us back to Henri Lefebvre's notion of the public space as a place of exclusivity that is maintained by rejecting what is different but by the same token can become something unstable and permanently susceptible to ambush. Calzadilla has said: 'As artists, we are interested in practices that ... place the body in the center of public forms of subjectivity linked to the organisation of power.'[52] When located in the administrative heart of the Peruvian capital, what seemed an innocuous artistic action and even an infantile game eventually became an effective tool for reappropriating the public space.

The artists' objective was to distribute the chalks in the square housing the Peruvian local and state government, precisely because this was the most 'ideological' and heavily regulated space in Lima. In this square all kinds of official acts and events are celebrated and it is also the focus for protests and demonstrations. The government has therefore provided that, as of midday, any citizen may make a public complaint by walking once round the perimeter of the square. Coming across the pieces of chalk, some of the protesters discovered another way to make their demands visible. Protest slogans mingled with signatures, declarations of love and other anonymous messages written on the ground. They registered the multitude of positions and voices meeting in the square, which had temporarily become an arena of discussion about the functioning of government, individual liberties and the use of public space. It was not long before the police arrived accompanied by members of the city cleansing services, who picked up the pieces of chalk and scrubbed the entire surface of the square clean to restore 'normality'.

In this work, Allora and Calzadilla make language an integral component of the aesthetic experience.[53] The relation of their sculptural-performative project to the history and politics of the site is closely connected to various forms of social communication, expression, debate and discourse. At the same time, the artists are attempting to place themselves within a tendency that positions

itself against the tradition of the monument and the didactic and propagandistic rhetoric that in general accompanies monuments: a rhetoric that usually transcends the socio-historical particularities of the context accommodating the monument. A revision of this sculptural genre seeks precisely to alert the spectator to the official interpretation of history and democratic values in the public sphere.[54] In 1986, taking as their backdrop the politics of memory in post-war Germany, another duo of artists, Jochen and Esther Gerz, proposed a type of counter-monument: one that would answer their concern to design an antifascist commemorative sculpture without having recourse to the authoritarian character of the typical public monument. To this end they decided to erect a square-section monolith on whose surface the public could write. The column gradually sank, disappearing into the ground as its surface was covered with graffiti and messages. This complex and heterogeneous group of inscriptions represented the city of Hamburg and its way of confronting the past; it also symbolised the impossibility of fixing collective memory in a simple sculptural form, since the sculpture simply disappeared once it had served to stimulate ideas in its audience.

In *Chalk*, Allora and Calzadilla similarly seek to transfer the work of thinking about the public space to the spectator – thus converting the spectator into the subject of the work. This idea arises from an understanding of place as the convergence of discursive parameters of a historical, social and cultural kind. As Allora has said:

The work complicates the principle of site-specificity. The chalks are the same form, produced in the same way, the same color every time. It's the same formula over and over. But the marks they leave, whether linguistic, visual, or just unreadable traces, stand as an index of a particular person in a particular place and time, under particular socio-political conditions.[55]

With its minimal, conceptual genealogy, this subtle urban intervention expresses a type of critical and simultaneously ludic approach to reality characteristic of the work of Allora and Calzadilla. The discreet way in which they infiltrate the controlled landscape of the street unleashes a rich constellation of references and associations, and functions at a variety of levels. The graffiti on the pavement are marks of the self-expression of a heterogeneous collectivity and thus open local perception to new meanings, contradictions and antagonisms.

According to J.J. Charlesworth, the success of *Chalk* comes from the way in which it transmutes the regulated notion of public art into something politically unregulated, while transforming the art object into 'an odd residue, literally to be washed away'.[56] And by their use of forms of non-specialised popular protest combined with a realignment of the category of public sculpture, Allora and Calzadilla open sculptural practice to other registers of place; in particular they open it up to expressions of dissent in the public sphere through forms of political

inscription that depend on the active participation of a community.[57]

A similar design on politically controversial territory appears in a series of works relating to the Isle of Vieques in Puerto Rico. Occupied by the United States Army for six years as a bomb-testing site, the island symbolises the colonial relationship of the United States with Puerto Rico. In April 2003, a civil-disobedience campaign organised under the slogan 'Free Vieques' concluded with the closing of the Atlantic Fleet Weapons Training Facility (the official name of the testing ground). For *Terreno marcado (Huellas)* 2001–2 [*Land Mark (Footprints)*], the artists made shoe-soles, each embossed with protest messages chosen by different individuals. The same individuals then crossed the territory from which they were banned by naval edict and, wearing the shoes with embossed soles, walked through the bombing range, leaving their footprints on the ground. The artists took photographs of these prints, recording a type of mark different from those made on the island by many years of US military manoeuvres (fig.62). In *Devolviendo un sonido* 2004 (*Returning a Sound*), a motorbike with an exhaust converted into a trumpet circulated through the occupied zone emitting strident sounds that parodied the use of that instrument by the army (fig.63).

Both works are a reflection on the economic and cultural hegemony that the United States has exercised and continues to exercise in its Latin American

63 **Allora and Calzadilla**
Devolviendo un sonido 2004
Returning a Sound
Action performed in
Isle of Vieques

'backyard'. But Allora and Calzadilla conceive the work of art as a mediating agent that catalyses a series of cascading actions, each of them designed to be ephemeral.[58] The metaphorical fragility of art in this context – emphasised by the material vulnerability of chalk scribbles or footprints on the sand – functions as a reminder of the fragility of all critical discourse that does not take formal shape in regulated political action. It also points to the intrinsic instability of any expression of consensus in the public sphere, thus commenting on the illusory nature of any aspiration to permanence on the part of the authorities.

Warning to the civilised

It is difficult to place the Venezuelan artist Javier Téllez (b. Valencia, 1969) in any given artistic discipline. Although much of his work is presented in the form of installations or video, the majority of his pieces are in fact performances, actions or re-enactments, the result of work created in direct collaboration with patients in psychiatric hospitals. Since the early 2000s, Téllez has made a series of works interpreted and co-written by the mentally ill with the objective of elaborating a critique of the taboos and prejudices that affect such people in today's society. In projects created in Mexico City, Sydney and Berlin, the artist has worked with 'these self-selected groups in re-staging of popular myths, or casts them in rituals and parades', such that the work can slide 'easily between the categories

of participatory events and documented performances'.[59] This process of co-production, effectively situated midway between institutional critique and artistic workshop, is essential to Téllez's trajectory, since it challenges not only the stereotypes currently associated with madness but also the bourgeois concept of artistic authority.[60]

Perhaps the best-known image of his work is that of the human cannonball crossing the frontier between Mexico and the United States by air after being fired from a cannon situated on a beach in Tijuana (fig.64). However, more than a mere photograph, the work *Alguien voló sobre el vacío (Bala perdida)* [*One Flew Over the Void (Bala Perdida)*] is a complex action whose documentation includes both photographic and videographic materials. Realised in 2005 for the inSite arts programme held in Tijuana and San Diego since the early 1990s, Téllez's work was an artistic event unfolding in several phases: it was first a creative workshop realised with patients from a psychiatric hospital in the frontier city of Mexicali; then the 'march' of these patients to the Pacific Beach where the frontier ends (clearly marked by a wooden barricade); and third and last, a performance starring a professional human cannonball who flies over the state barricade in complete defiance of the law.

Explaining the way in which the work arose, Téllez observed:

I always attempt to propose an idea that will trigger some sort of dialogue. This idea or 'imago' is sometimes related to the specificity of the site: for example, the idea of the human cannonball crossing the Mexico-US border in Tijuana. In this case the idea was developed in conversations with psychiatric patients from the Baja California Mental Health Center in Mexicali (CESAM); we organized a workshop with those interested in the project and ideas were exchanged. The patients saw the geopolitical border between the US and Mexico as a metaphor for another frontier: that which confined them to the mental institution. Through the presence of the human cannonball, they embraced the idea of the circus and created an animal parade, in which the patients wore animal masks.[61]

In addition to wearing masks, the patients of CESAM carried placards that they had made themselves bearing accusatory slogans such as 'We patients are humans too' or 'A life with drugs is no life at all'. As we have seen with the video *Five Dots* by Tomás Ochoa or in earlier pieces by Téllez himself – his installation *La extracción de la piedra de locura* 1996 (*The Extraction of the Stone of Madness*) had already incorporated works made by the inmates of a psychiatric hospital – the artist is not pretending here to supplant others or to speak through their mouths. Téllez rather seeks to generate a reflection on the division between common sense and madness through the medium of those have been designated 'mad' in the particular context of the geopolitical frontier between Mexico and the United States.

The artist's task, in collaborating with the inmates of psychiatric centres, is a difficult one, requiring great tact and sensitivity if he or she is not to succumb

to the temptations of commiseration, sentimentality or even exploitation of patients. Téllez is perfectly clear about his position: 'In my practice I try to create a flexible space where those represented can intervene in their own representation ... If there is a critique of the mental institution it makes more sense that it be articulated by the patients.'[62] In the case of *One Flew Over the Void (Bala Perdida)*, this intervention can be directly observed in the parade and the slogans on the placards. The march down to the beach was not, as has been said, a 'procession';[63] it was an overtly political demonstration, a protest action and a demand for representation. The action in which the demonstration culminated, the crossing of the frontier by the human cannonball as a symbolic illegal immigrant, shows that the circus spectacle is less irrational – and of course, much more entertaining – than that other process of control and security daily experienced on the real border between two countries. The destiny of those who attempt a clandestine crossing of the border is, on the other hand, often tragic.[64] If the video documenting the action shows anything genuinely crazy, it is not the entirely comprehensible demands of the patients or the festive spectacle of the human cannonball but rather the barricade that dramatically divides the beach and strides down into the sea in its absurd attempt to impose territorial separation on the immense waters of the ocean.

Understood in all of its three phases, the work illustrates Téllez's idea that 'the psychiatric hospital's walls separate space not only from "here" to "there"; it also works from "there" to "here". This is to say, we here are just as trapped by that exclusionary wall.'[65] Literally flying over the geopolitical frontier between Tijuana and San Diego is a metaphorical way of encouraging society to transcend the contemporary scission between sanity and madness: both delimitations are, in the last analysis, man-made and determined by psychological, social and economic values. In the face of the rigidity with which, in contemporary society, barriers are imposed, not least in the form of frontiers and tariffs, *One Flew Over the Void (Bala Perdida)* presents 'humor and celebration as healing alternatives to isolation, segregation, and racism'.[66]

It is not just Téllez's title that alludes to the famous novel by Ken Kesey, *One Flew over the Cuckoo's Nest*, which was set in an asylum in Oregon and adapted for the cinema by Milos Forman in 1975. The idea of taking the patients out of the psychiatric hospital, leaving the oppressive hospital architecture behind, recalls the boat trip taken by the inmates in Kesey's novel on the very same ocean to whose shores the patients of CESAM made their protest march.[67] By realising part of his work in the public space, Téllez also confronts the architecture of both hospitals and museums:

Growing up as the son of two psychiatrists, I often visited the psychiatric hospital where my father worked. At that time I also began to go to museums, and I remember that even back then I already found a lot of similarities: hygienic spaces,

64 **Javier Téllez**
Alguien voló sobre el vacío
(Bala perdida) 2005
One Flew Over the Void
(Bala Perdida)
Action performed in Tijuana

long corridors, enforced silence and the weight of the architecture. Both institutions are symbolic representations of authority, founded on taxonomies based on the normal and the pathological, inclusion and exclusion.[68]

In this sense, *One Flew Over the Void (Bala Perdida)* does not simply make fun of the border control but challenges the representative spaces of psychiatric centres and counters so-called 'museum pathology'.[69] Téllez had already broken out from the limits of the museum space in two earlier works: in *El Léon de Caracas* 2002 (*The Lion of Caracas*), he organised a procession through a shanty-town suburb of the Venezuelan capital, in which various members of the Policía Metropolitana carried on their shoulders a stuffed lion with which the inhabitants of the zone interacted; in *La Batalla de México* 2004 (*The Battle of Mexico*), the artist collaborated with a fictitious 'liberation army' formed by the inmates of a psychiatric hospital dressed for the occasion in Zapatista balaclavas and camouflage uniforms. But if the process of re-enactment that takes place in Téllez's works reminds us of any one film, it is the docudrama *The Mad Masters* (1955) by Jean Rouch. In this 'ethno-fictional' film, the French documentary-maker gives a detailed visual account of the *hauka* ritual in which certain African tribes colonised by the French army go into a state of trance and recreate, in the form of dance, the military ceremonies of the French soldiers and officers. When those interpreting other actions by Téllez – from *The Battle of Mexico* 2004 to *Caligari y el somnámbulo* 2008 (*Caligari and the Sleepwalker*) – freely play psychiatrists, protesters or rebels, one cannot help but remember the process of inversion recorded by Rouch, in which the African servants of the Empire imitate and recreate the violent and repressive gestures of the French authorities in the hope of extracting and stealing their powers of domination.

In Téllez's works, the visual documentation shows the fictional recreation of a circus-style event, a myth or even a classic film. This appropriation is used by the artist to effect a revaluation or reinterpretation of the established values of contemporary society. In *One Flew Over the Void (Bala Perdida)*, Michèle Faguet observed a re-reading that links Mexico (as country) to the madman (as social and literary figure):

Like the figure of the mentally ill, threatening and undesirable in proximity but also idealised through a long association with a freedom from social constraints that is thought to spawn creativity and genius, the idea of Mexico as cultural construct within the North American imaginary is a romanticised image of an underprivileged *other*: precarious, lawless, dangerous and yet seductive. Just as First World economies are sustained by the illegal labour that is a consequence of these borders, the construction of identity often depends upon identifying and then marginalising what one is *not* through an act of negation and ultimately exclusion.[70]

Like Téllez's other pieces, *One Flew Over the Void (Bala Perdida)* does not present a

65 **Javier Téllez**
*La Passion de Jeanne d'Arc
(Rozelle Hospital, Sydney)* 2004
Two-channel video installation
40 min, 55 sec; 97 min, 2 sec
Tate. Purchased with funds
provided by the American
Patrons of Tate, courtesy of the
Latin American Acquisitions
Committee 2008

structured and orderly proposition concerning the functioning of frontiers or of psychiatric centres but the de-centred, anti-conventional and collaborative expression of those who suffer and inhabit them. The direct participation of patients in Téllez's work means that his pieces 'claim no authority and lack any central point of view, creating an experience of vulnerability and ambivalence in the spectator'.[71] One example of this is his 2004 film *La Passion de Jeanne d'Arc (Rozelle Hospital, Sydney)*, in which a number of women resident in a Sydney psychiatric hospital speak of their pathologies while rewriting the subtitles of Dreyer's film on the basis of their own interpretation of the famous story of Joan of Arc, whom they understand as psychotic (fig.65). Another is *Oedipus Marshal* 2006, a recreation of the myth of Oedipus with members of a centre for mental health in Colorado, which was co-written with and starred Aaron Sheley, a film-maker and schizophrenic.

Three recent works made by Latin American artists relating to the line of delimitation between Mexico and the United States have also served to demarginalise 'the "border aesthetic" as a category within artistic discourse'.[72] For example, in *Toy an horse* 1997 (*Trojan Horse*), the Mexican artist Marcos Ramírez Erre made a wooden Trojan horse with two heads and a semitransparent body, which he placed on the border to interrogate the unequal bilateral relations between the two countries. In *La nube* 2000 (*The Cloud*), the Chilean Alfredo Jaar created a structure constituted of dozens of tiny white balloons that flew over the Valle del Matador ('Killer Valley') to form an ephemeral monument to those who lost their lives crossing the border. In *Curso de supervivencia para hombres y mujeres que viajarán de manera illegal a los Estados Unidos* 2007 (*Survival Skills Course for Men and Women Travelling Illegally to the United States*), the Guatemalan artist Regina José Galindo organised an intensive course for ten emigrants in which they learnt subjects related to orientation and first aid.

One Flew Over the Void (Bala Perdida), like these three pieces, gathers into the artistic world an important debate about the social inequalities generated by frontiers while establishing an original parallel between the figures of the mentally ill and the emigrant as individuals pushed to the margins of society. Téllez himself has said that he would like by means of his art to bestow 'visibility' on people and discourses condemned to invisibility within the social space, something that we have already seen in the works of Ochoa and Wildi Merino. He is not attempting to create a 'therapeutic art' so much as to reactivate a political discussion before it is forgotten and buried by the 'information society' – the society of spectacle. 'I am not interested in providing a cure for the patients,' Téllez has said. 'That is not the intention of the work. What is important is to question the boundary between normality and pathology. But it is clear that, if there is something to cure, that something is, undoubtedly, society.'[73] In this, the thrust of his work parallels Herbert Marcuse's famous observation

that those capable of functioning in a sick world are obviously ill themselves.[74] His objective is not therefore to alleviate the disorders of his patients but to 'cure' viewers of their false assumptions and indeed the 'sane' and 'civilised' of their innumerable concealed daily pathologies.[75]

The art of resistance

In the year in which Narda Alvarado was making her video *Olive Green* in La Paz, the Central American artist Regina José Galindo (b. Guatemala, 1974) realised in her native city a performance entitled *Who Can Erase the Traces?* 2003. In this action, Galindo, dressed in black, walked barefoot from the Constitutional Court to the National Palace, several blocks away, carrying in her hands a white basin full of human blood (fig.66). As she went, she placed the basin on the ground and dipped her feet in it so as to leave a trail of footprints of blood on the pavements of the city. Her progress through the city attained its most sensitive point at the end of the performance, when Galindo reached the National Palace with its row of armed guards. There, right in front of the uniformed police who were guarding the building, the defiant artist left the last two footprints and the bloody bowl. Like the work of Salcedo and Alvarado, *Who Can Erase the Traces?* makes a direct comment on military violence in Latin America. In this case, as the writer Francisco Goldman has pointed out, 'the ghostly footprints represent[ed] the hundreds of thousands of civilians murdered, overwhelmingly by the army, during the long years of war and after'.[76] It is estimated that the civil war that afflicted Guatemala between 1960 and 1996 caused more than 200,000 casualties (some dead, some 'disappeared') – and this in a country of 12 million inhabitants. It is thought that the army committed 93 per cent of the violations against human rights in this conflict, including more than six hundred massacres of the civilian population.[77] In this context, Galindo's idea of 'dipping her feet in blood to leave marks on the streets of the city, like the writer who dips a pen into an inkwell', came to be, in the words of Virginia Pérez-Ratton, 'a poetic metaphor for the act of inscribing inerasable memories – in this case, memories of those killed by the military'.[78]

Galindo's performance, however, is not simply an uncomfortable reminder – not least for the authorities that signed the peace agreements on 28 December 1996 – of the thousands of murders perpetrated by the Guatemalan army prior to that date. It is important to note that the blood in *Who Can Erase the Traces?*, as the title indicates, appears in the form of footprints, that is, as the traces and marks of a crime. Indeed, the true purpose of the work is perhaps less to denounce the war crimes and more to indict the state of impunity in which those who committed them are still living. When asked about the origins of her performance, Galindo noted that the idea arose the moment she found out in May 2003 that the presidential candidacy of the former dictator José Efraín Ríos

Montt had been approved by the Supreme Court of Guatemala:

[*Who Can Erase the Traces?*] emerged from rage and fear. When it was announced that
Efraín Ríos Montt had managed to win acceptance as a presidential candidate, I was
in my room, and I suffered an attack of panic and depression. I cried out, I kicked and
stomped my feet, I cursed the system that rules us. How was it possible that a character
as dark as this would have such power with which to bend everything to his will?
I decided then and there that I would take to the streets with my shout and amplify it.
I had to do it.[79]

General Ríos Montt organised a coup d'état in Guatemala on 23 March 1982
and was de facto president of the country until August 1983. During the sixteen
months of his mandate, he organised and commanded the so-called 'Patrols
of Civilian Self-Defence', paramilitary groups ordered to combat any kind of
opposition to his regiment at whatever cost. Recent reports by international
organisations indicate that during his campaign of open struggle against
communism known as 'Fusiles y frijoles' ('Rifles and beans'), tens of thousands
of Guatemalans died, for the most part indigenous Mayan peasants, with up
to 3,000 murders a month committed during the most bloody period of the
dictatorship.[80] Far from being judged for his crimes, Ríos Montt has taken and
is still taking an active part in Guatemalan political life through the party
that he founded in 1989, the Frente Republicano Guatemalteco (Guatemalan
Republican Front, FRG), which won the elections and governed under the
presidency of Alfonso Portillo between 2000 and 2004 – a period when Ríos
Montt was President of Congress.

Galindo's performance was a way of denouncing the immunity of the
ex-dictator and the criminal activities that he was still carrying out when she
created this work. On 24 July 2003, immediately after the realisation of *Who
Can Erase the Traces?* – and the legal decision to reject Ríos Montt's candidacy
on the grounds of his having ordered the coup d'état many years before – came
the violent demonstrations of 'Black Thursday' in which hundreds of masked
followers of the FRG assailed the capital of Guatemala with firearms and
machetes, successfully pressurising the political authorities to allow Ríos Montt
to stand in the elections.[81] Amid this convulsive atmosphere, Galindo realised
her action with surprising serenity:

The process of this performance was a bit cold, clinical. I went out to buy the human
blood in the morning, and then I began the walk … I suppose my mind fell completely
silent during that time. I was focused on the image of dipping my feet and leaving the
footprints at every step along the way. But when I got to the Palacio Nacional and saw
the line of police officers guarding it, I ignited. I walked more firmly, I reached the main
doors, I saw the eyes looking back at me, and I left two final footprints side by side. I left
the basin holding the blood there too. Nobody followed me, nobody said anything.[82]

Thanks to the Guatemalan critics and curators who wrote about Galindo's action, the performance came to be discussed in the public sphere. The curator Rosina Cazali, for example, distributed images of *Who Can Erase the Traces?* along with a text in which she declared the candidature of Ríos Montt unacceptable. The principal goal of distributing this information was to create a kind of political counter-propaganda. The paradoxical fact that, in the elections of 2000, the FRG gained strong support from the very rural communities that had suffered most under the dictatorship of Ríos Montt clearly demonstrated that government propaganda could 'disappear' not merely people but also the fragile memory of the Guatemalan people. As Galindo stated about Cazali's collaboration:

these efforts were necessary, because Guatemala is a country without memory. The people, with little access to education, are easy to mislead with promises and the little gifts that politicians hand out during election campaigns. The official party, to which Ríos Montt belonged and belongs, made a huge effort and had all the power to reach the Guatemalan minorities, who had difficulty connecting the actual Ríos Montt (the presidential candidate) to the past dictator-president who was guilty of the greatest crimes against their own people, their own blood. Every effort was necessary, any help at all, it was all needed to shout out the truth, by whatever means.[83]

True information against false propaganda, artistic activity against judicial impunity: each of the marks left by *Who Can Erase the Traces?* must be understood in this context of extreme aggression and legislative inefficiency in today's Guatemala. And not only in relation to the sanguinary past of the country (of the more than six hundred documented massacres that took place during the war, only two have resulted in trials at the time of writing), but also in relation to its present; as the lawyer and committee member of the International Commission against Impunity in Guatemala, Carlos Castresana, has declared, currently only 2 per cent of the cases of homicide reported in Guatemala are ever solved. For example, in 2007 there were 1,960 murders and only forty-three convictions.[84] 'The ruling impunity, in collusion with the silence of the institutions, is not a motif to be represented through the jubilant attitudes of post-modernism', Cazali has stated. 'Regina Galindo belongs to a group of artists who reject the hegemonic *status quo*. Her conceptual premises reserve the right to choose forms susceptible of being camouflaged in a duel that has been left unspoken for reasons of collective convenience or individual inertia.'[85]

Indeed, in the many performances that she has realised since the year 2000, Galindo has used her body to create works of art that directly denounce the political and socio-economic injustices of her country. Many of these pieces have created controversy owing to the way in which they incorporate violence as an artistic method: in *No perdemos nada con nacer* 2000 (*We Lose Nothing by Being Born*), the artist arranged that she should be sedated and her sleeping body placed in a plastic bag and deposited on the rubbish dump of Guatemala City (fig.67);

67 **Regina José Galindo**
No perdemos nada con nacer
2000
We Lose Nothing by Being Born
Action performed at Ninth
Performance Festival, Ex Teresa
Arte Actual, Mexico City, and
Second Festival of the Historic
Centre, Municipal Landfill,
Guatemala, 2000

in *Himenoplastia* 2004 (*Hymenoplasty*), Galindo underwent this operation in a clandestine clinic in the capital; in *Golpes* 2005 (*Blows*), realised for the fifty-first Venice Biennale, she entered a closed tube and whipped herself 279 times, the number of women who had been murdered the previous year in Guatemala; in *Limpieza social* 2006 (*Social Cleansing*), she had her naked body 'cleansed' with a high-pressure hose as happens with convicts on entering Guatemalan prisons; in *150.000 voltios* 2007 (*150,000 Volts*), she received an electric shock from the Taser device used by the police to detain suspects; and in *Mientras, ellos siguen libres* 2007 (*Meanwhile, They Remain Free*), naked and eight months pregnant, she remained 'tied to a bed with real umbilical cords in the same way as pregnant indigenous women were tied down to be raped during the armed conflict in Guatemala'.[86] In relation to this last piece, Galindo has recently stated:

During the armed conflict, the damage to the female population was part of the strategy used in the war to fill the people with fear, because by killing a woman they also killed the possibility of life. In fact, over the last few years, this has again become part of Guatemalan reality, only on a larger scale. Women are murdered daily in the most brutal forms. Generally male bodies turn up with their throats cut, with a coup de grace, stabbed, or asphyxiated, but the bodies of women show evidence of having been raped and tortured before being murdered.[87]

Although Galindo undoubtedly relates to a tradition of contemporary performance that uses the individual body to articulate a feminist critique of the system, as seen in the work of Ana Mendieta or Tania Bruguera, the Guatemalan artist always uses her own body to generate collective discourse in which 'the experience of others' is reflected.[88] 'In every action', she has stated, 'I attempt to channel my own pain, my own energy, in order to transform it into something more collective.'[89] As Eli Neira has said, her actions are 'little acts of resistance': 'the individual body in confrontation and resistance as a metaphor of the global body'.[90]

While Galindo's work can certainly be understood as an individual and feminist critique of Guatemalan reality, it also transcends this geographical confinement and relates to broader problems that affect all genders, ethnic groups and social classes. The fact that her art has been realised and exhibited in Europe, America and Australia demonstrates the extent to which it 'concern[s] any context of injustice, racism or obliteration of historical memory'.[91] The recurrent use of blood by Galindo constitutes an appeal to the collective unconscious, thus enrooting itself in a Latin American tradition of universal resonance that ranges from *Trouxas ensanguentadas* 1969 (*Bloodstained Bundles*) by Artur Barrio, in which the Brazilian artist dragged bags full of animal remains across various urban landscapes, to the more recent *Limpieza* 2009 (*Cleansing*) by Teresa Margolles, in which the Mexican artist literally scrubbed the floors

of a Venice Biennale pavilion with a mixture of water and the blood of persons murdered in her native country.

A considerable part of Galindo's production, however, excludes her own personal participation and takes the form of more abstract and sculptural interventions. For example, *Corona (más de 6.040 asesinatos en el año de paz)* 2006 [*Crown (More than 6,040 Murders in the Year of Peace)*] was an ephemeral public sculpture made with flowers, which Galindo placed in the Plaza Central of Guatemala City to 'celebrate' the tenth anniversary of the Peace Agreements; *XX* 2007 was an intervention constituted by fifty-two gravestones that the artist placed in the anonymous mass graves of the Cementerio de Verbena where unidentified bodies are buried; and *Tumba* 2009 (*Tomb*) was an action realised in the Caribbean, which involved throwing into the ocean seven sacks of sand of weight and dimensions similar to those of human bodies in order to make them 'disappear' (figs.68).

It has been said that Regina José Galindo's art is at once religious and activist, but her oeuvre challenges any facile and rapid categorisation. When her performance with bloody feet in *Who Can Erase the Traces?* was connected with the idea of religious penitence, the artist emphasised that she was not attempting to emulate such rituals: 'To be honest, I don't know or understand much about religion ... I think that my images refer more directly to real, everyday suffering, to the martyrdom (if you want to call it that) of human beings in their daily existence in this world of oppression, hierarchies and power.'[92] When the piece was interpreted as political activism, she also denied this: 'An activist is someone who has faith. I have no faith. I make art.'[93] Neither religious image nor political action: Galindo, like the other Latin American artists who have taken and are taking a counter-discursive and anti-hegemonic position, demands that art enjoy its own, independent field of action governed by its own rules – one that reflects directly on reality and perhaps aspires less to change the world than to modify the perceptions of those who inhabit it.

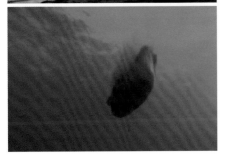

Conclusions

Beginning in the early 1990s, the artists featured in these pages reclaimed strategies belonging to a tradition of political art that had been censored during the dictatorships. Over the course of the transitional periods and recent re-democratisation of Latin America, their work has come to be seen as an alternative to decorative and post-utopian art. Unlike the current trend towards depoliticised artistic practices that 'avoid or postpone the utopia implied by dreams of the continent's social emancipation',[1] the works discussed in this book seek to recover that utopian project, trigger debate about society in the public sphere, combat apathy and stimulate participation on the part of spectators of contemporary art.

It is true that disruptive aesthetic tendencies have for the most part been marginalised when they have not been broken up and annihilated. Over the last few years, we have seen a campaign that not only, in the words of Suely Rolnik, 'instrumentalizes art, but even more perversely, instrumentalizes the very desires of creation and action, placing them at the service of the production of capital as its principal source for the extraction of surplus value'.[2] But this does not imply that every artistic manifestation today must necessarily be, as some would have it, 'synonymous with an artificial artefact', nor that we are living in 'a world without social utopias or political ethics' where 'art has abandoned aesthetics'.[3] Rejection of the banal artworks so extensively produced should not blind us to the existence of a contemporary art scene in which there are multiple forces of renewal.

A critique of the artificiality of revival aesthetics and the trivial commercialisation of much of contemporary art is both legitimate and necessary but we should also defend other artworks that seek to reactivate the social imagination in new, vigorous and creative ways. Regressive tendencies undoubtedly exist in the contemporary art of the continent but counter-discursive art is also produced: art that restores the antagonistic artistic traditions of Latin America and can actualise that legacy with intelligent, dissident reflection on the social and philosophical conflicts of our era. My objective in this book has been to select, gather and analyse some of the most paradigmatic examples of this type of artistic production.

Necessarily implicated in the geographical, economic and political contexts of Latin America, the works featured in this book are by no means free of the contradictions that determined and defined those contexts. As discourses taking form in the Latin American socio-cultural fabric, the pieces that I have studied are not immune to the processes of amalgamation and neutralisation that characterise the globalised cultural industry of the early twenty-first century. As Michel Foucault once pointed out, 'what escapes [the state's] power is counter-power, but counter-power is nonetheless a player in the same game'.[4] The paradox of 'counter-power' generates – and will no doubt continue

to generate – intense debate relative to any aesthetic of opposition and disagreement. But we should not on that account dismiss the merits – however symbolic or ephemeral – of such resistance. Foucault himself, before pointing to this contradiction, remarked: 'We need to recover the problem of war, of confrontation. We need to begin the tactical and strategic analyses all over again at an extraordinarily low, humble, daily level.'[5]

All twenty artists in this book have sought to ensure that their own distinct, divergent voices are acknowledged within the hegemonic discourses of Latin America. The works discussed, beginning with Ernesto Neto's *Weight of Particles* and ending with Regina José Galindo's *Who Can Erase the Traces?*, propose emancipatory actions through very diverse aesthetics; these run the gamut from near-formalist practices to interventions close to political activism as such. These are multiple and various gestures of dissent that must be understood, in the words of Jacques Rancière, as 'a disturbance of the visible order of the social structure'.[6] They demand a place for 'the part with no part' and a *praxis* of contemporary art that

shifts the focus from great names and events to the life of the anonymous; it finds symptoms of an epoch, a society or a civilisation in the minute details of ordinary life; it explains the surface by subterranean layers; and it reconstructs worlds from their vestiges.[7]

Faced with the 'distribution of the sensible' as it is determined by the dominant system of representation, the art of contraposition defends artistic creation as a 'form of visibility' – one that inscribes a sense of community in the people (*demos*) and reclaims the role of the avant-garde. And it does so not as an elitist or partisan *advanced guard* but as a proponent of 'the idea of the potentiality inherent in the innovative sensible modes of experience that anticipate a community to come'.[8] The lack of conformity among the artists in this book is therefore consistent with the *mésentente* or 'disagreement' called for by Rancière, a democratic conflict between what is included and what is excluded in the dichotomies visible/invisible, heard/unheard, thinkable/unthinkable...

These artists have sought to create free thought and emancipated labour rather than homogenised, mass-produced art. In some cases they intervened in the urban context in ephemeral ways, hoping thus to attenuate the frontiers between art and daily life and convert the work of art into an event that might reactivate the multiple subjectivities of the city (Alÿs, Allora and Calzadilla, Ochoa). In other cases they constructed new sculptural objects from common and vernacular materials or intervened in the exhibition space, recreating imaginary vehicles, organic elements or specific historical events (such as the assault on the Colombian Palace of Justice, the Bolivian October Massacre or the murders ordered by Ríos Montt in Guatemala). Seeking to trigger a genuine

participatory experience on the part of their spectators, artists also alluded to particular historical events (Salcedo, Alvarado, Galindo), criticised the various forms of institutional repression in Latin America and abroad (Téllez, Wildi Merino) and examined the processes of postponed and cancelled modernity on the Latin-American continent (Garaicoa, Zamora). A critique of violence was conducted in works that might initially seem more formalist and abstract (Orozco, Neto, Ríos or Conlon) but similarly confronted existing political issues in original ways by inventing new aesthetic forms.

The various anti-authoritarian works that we have studied over the course of the book have embraced the use of new technologies, interdisciplinary media and 'poor' and ephemeral materials. Indeed, the technological use of digital, video or web art has contributed to promote 'pro-democratic networking and consciousness-raising activities' in today's Latin America.[9] The aspiration to combine various artistic media has produced works that are fully interdisciplinary, mixing sculpture and installation, video and performance, installation and public art. As Cuauhtémhoc Medina has pointed out, this multiform hybridity, at times all but unclassifiable, serves to reinvent the very notion of contemporary art, transcending the idea of art as a single-discipline, long-lasting, 'quality' product: 'A common element in this desperate multiplication of practices was to question the beauty of [art's] role, excited references to "profundity" and "high culture", the requirement for technical serenity, universality of meaning, national pride, belief in modernity, etc.'[10]

In fact, for each dissident aesthetic-political stance, a new form had to be found. Each artist has constructed an independent universe with its own rules, 'its own alphabet, its own landscapes, signs, antecedents and references'.[11] In the first part the work of six artists with very different styles was analysed. As we have seen, Neto modifies the space of the installation with biological forms and generates living organisms to confront a space that remains instrumentally rational, controlling and suffocating; Orozco reinvents the sculptural object using metamorphosed vehicles and seeks to swap certain rules for others in order to infringe the logic of capitalist productivity; Garaicoa revises the notion of Utopia with an imagination that is simultaneously creative and destructive, so that the programme of his works comes to include their own extinction; Cardoso captures the movement of nature, geometrising and embalming it in the manner of still life in order to denounce the astonishing psycho-social violence of her environment; Neuenschwander reflects on the double dimension of time as both *klima* and *khronos* and turns the spectator into a co-author recreating natural events or interminably transmitting desires; Zamora, finally, intervenes directly in the urban fabric to point out how the insuperable class divisions of a society on the point of exploding are spatially demarcated.

The second part studies 'videographic practices' of similar distinctiveness. Ríos brings video to his encounter with sculpture in a choreography of power that reconfigures the paradigms of modern art; Conlon documents ecological disaster and articulates an eco-wisdom of sustainability (natural, social and psychological) by evincing the absence of the people (*demos*); Zink Yi challenges the conventions of the Eurocentric and neo-colonial documentary (the Other is always seen in a long take) with the sound of indigenous rhythms and convokes a people present only as witness and shadow; a people that is already fully present in Wildi Merino, though it lacks a native language and takes visible form in the helpless immigrant, producing narratives that are necessarily broken, deterritorialised and incomplete; while Ochoa and Macchi discover how different apparatuses (those of the penal system and the cinema industry) are imposed on the people through authoritarian and antidemocratic models of repression-representation; and Alvarado reclaims issues of political obedience and positioning through artistic actions in the public space.

In the third and final part, Alÿs carries out operations that dilute the artistic object in its physical and social context (a block of ice that melts, the tin of paint that drips and empties itself), his ultimate goal being the transformation of work into play; Salcedo commemorates victims through the damaged object that is also a traumatic sign of their absence; Sierra, like a saboteur, creates friction within the regulating system of the city through physical obstructions and reveals the occulted and illegal methods by which the workforce is exploited and abused; Allora and Calzadilla make use of 'poor' materials (sticks of chalk, the soles of shoes) to reactivate a ground-level, contra-monumental freedom of expression; Téllez organises circus-style performances that overfly the demented frontiers imposed by the madness of reason; and Galindo directly confronts the authorities and uninhibitedly displays the blood that they have spilt in contexts of extreme violence and impunity.

These various strategies all serve a common disruptive practice. But this is not a practice that the artists included here invented and they are not alone in employing it. Over the course of the text, I have constantly referred to other traditions that they incorporate or revisit – from Constructivism to Situationism, from Surrealism to Minimalism. I have also mentioned a number of artists whose work in their own day elaborated a vision antagonistic to the established order, not only in the Latin American context (Oiticica, Clark, González-Torres, Rosenfeld, Porter, Jaar...) but internationally (Matta-Clark, de Maria, Christo, Serra, Hammons, Gerz...). In this book I have selected these twenty names but might equally have analysed the contra-discursive works of other Latin American artists of the same generation currently working in or from different points of the continent; artists such as Gabriel Acevedo Velarde, Gustavo Artigas, Tania Bruguera, Los Carpinteros, Abraham Cruzvillegas, Sebastián Díaz Morales,

Gabriel Kuri, Teresa Margolles, Damián Ortega, Alexander Apóstol and so on. This is not then an exclusive and reductive typology of art; it is shared, inclusive, in constant movement and rooted in a tradition that it renews with the most diverse materials and proposals.[12]

In fact, a rapid enumeration of these materials shows the extent to which the art of contraposition is at odds with the more traditional artistic media. We could cite lycra, lead, wax and confetti, buckets of water, glass bottles, olives and bananas, wooden spinning tops, plastic bags, altered vehicles, desiccated frogs, hanging chairs, blocks of ice and tins of paint, pieces of chalk, masks, bloodstained bowls and human cannonballs. The most interesting thing about this varied use of disparate materials is that they all serve to articulate the critique directed against the art object itself – which on occasion is extinguished or destroyed (wax that is consumed, bananas that rot, ice that melts) – and by extension against the very status of the artist, who no longer lives in an ivory tower observing the world but moves on foot through natural and urban landscapes like any other citizen or any other poetic and political subject.

The principal aim of this book has been to set out the claims for this kind of art practice so that in the future it can be incorporated in consistent form into the discourses of cultural centres not only in Latin America but internationally. As Patrick Frank has pointed out, even after several decades of post-modern deconstruction of the grand narratives and considerable effort to establish multicultural pluralism in the centres of contemporary art, the canon of art history 'is still heavily tilted toward the art of Europe and North America'.[13] It is time to study and familiarise ourselves with an art that poses uncomfortable questions for the status quo and does so with the ultimate objective of reinventing the continental project.[14] Only in this way can cultural institutions fulfil their true commitment: that of bringing artistic practices to their present and future audience without deactivating their political and social function.

The ultimate result of any kind of anti-democratic dynamic is depoliticisation. The art of contraposition by contrast offers not so much a political art as an *art that politicises*. The artists studied in this book are intent on understanding reality as historical and conflictual rather than natural or harmonious. Unlike religious or pseudo-political images, their works promise no redemption; they tend to promote dissidence in the public sphere through mechanisms of disillusionment and disenchantment. They reject the opiate function of conformist discourse but this does not prevent them proposing new possibilities of combat in the aesthetic sphere: living organisms that invade and subvert the order of the governmental space, tactics for giving a voice to those who do not have one, appeals to civil disobedience through actions that disrupt, if only for an instant, the disciplined flow of the city...

The art of contraposition does not dwell on individual cases if they do not somehow reflect the concerns of the community, nor does it criticise the world around it without proposing, in open or coded form, a possible, universal, emancipatory solution. Perhaps because, as Toni Negri once observed, 'in order to construct art, we have to construct liberation in its collective figure'.[15]

Notes

Introduction

1 For other significant indicators of socioeconomic inequality in Latin America, see [http://www.eclac.org/estadisticas/], viewed 12 November 2010.

2 A report published in the magazine *Forbes* on 10 March 2010 indicated that the Mexican Carlos Slim Helú is the richest man in the world and predicts that over the next few years he will be overtaken by Brazilian Eike Batista, currently the fourth richest man in the world (L. Kroll and M. Miller, 'Bill Gates No Longer World's Richest Man', [www.forbes.com/2010/03/09/worlds-richest-people-slim-gates-buffett-billionaires-2010-intro.html], viewed 14 November 2010).

3 I. Candela, 'Una conversación con David Harvey', *El País*, 8 September 2007, p.11.

4 As M. Sánchez Prieto has said, the post-utopian art of the continent confines itself to translating 'daily experiences which are characterised by an increase in privatisation, a change in people's ambitions, the lack of collective spirit, the primacy of hedonist values, and the consolidation of a lifestyle structured by seduction and apathy ... taking pleasure in the aesthetic contemplation of art as a strategic form of amnesia regarding postdictatorial power' (in 'Escape from Social Utopia. New Art in Argentina and Chile', *Third Text* 55, summer 2001, pp.75 and 77).

5 C. Medina writes in this context: 'Though the work of a number of the artists of the 1990s in Mexico is globally appreciated for its radical political preoccupations, it effectively lacks local articulation and takes no stance. [It is] a refusal to compound with the instrumental and demagogic terms of the prevailing politics' (in 'Notas para una estética del modernizado', *Eco. Arte contemporáneo mexicano*, exh. cat., Museo Nacional Centro de Arte Reina Sofía, Madrid, 2005, p.15).

6 In Adorno's words, 'Art, however, is social not only because of its mode of production, in which the dialectic of the forces and relations of production is concentrated, nor simply because of the social derivation of its thematic material. Much more importantly, art becomes social by its opposition to society, and it occupies this position only as autonomous art' (Theodor Adorno, *Aesthetic Theory*, tr. Robert Hullot-Kentor, Athlone Press, 1997 [reprinted Continuum, London, 2011], p.296).

7 Note that the definition of the 'autonomy' of the work of art as understood throughout this book is that given by J. Rancière: 'The aesthetic regime asserts the absolute singularity of art and, at the same time, destroys any pragmatic criterion for isolating this singularity. It simultaneously establishes the autonomy of art and the identity of its forms with the forms that life uses to shape itself' (*The Politics of Aesthetics*, tr. Gabriel Rockhill, Continuum, London, 2004, p.23).

8 P. Frank, 'The Cuban-Chinese Cook', *Readings in Latin American Modern Art*, Yale University Press, New Haven, 2004, p.xi.

9 M.C. Bernal, 'Transculturation: representing/reinventing Latin America', in *Transit*, exh. cat., University of Essex, Colchester, 2002, n. pag.

10 E. Armstrong and V. Zamudio-Taylor (eds), *Ultra-Baroque: Aspects of Post-Latin American Art*, Museum of Contemporary Art, San Diego, 2000. However, M.C. Ramírez has noted that 'Beyond the optimism conveyed by its euphemistic and one-way label of "post", our present is nothing but neocolonial' ('A highly topical utopia', in *Inverted Utopias. Avant-Garde in Latin America*, exh. cat., Yale University Press, New Haven, 2004, p.1).

11 R. Carvajal, 'Rutas: América Latina', in *XXIV Bienal de São Paulo. Vol. 2: Roteiros*, Fundação Bienal, São Paulo, 1998, p.76.

12 E. Valdés Figueroa, 'The Latin American and art. The politics of place in the era of the tsunami', in *The Hours. Visual Arts of Contemporary Latin America*, exh. cat., Daros-Latinamerica, Zurich, 2005, p.03:16.

13 G. Orozco, *Clinton Is Innocent*, exh. cat., Musée d'Art Moderne, Paris, 1998, p.87.

14 G. Mosquera, 'Against Latin American Art', *Contemporary Art in Latin America*, Black Dog Publishing, London, 2010, p.20. Mosquera moreover states that to define Latin American culture as hybrid is problematic if only 'because, in fact, there is no culture that is not hybrid' (ibid., p.15). See too B. Gennochio, 'The discourse of difference', *Third Text* 43, summer 1998, pp.9–11.

15 Z. Pick, *The New Latin American Cinema. A Continental Project*, University of Texas Press, Austin, 1993.

16 C. Tilly, *Democracy*, Cambridge University Press, Cambridge, 2007, p.xi.

17 T. Wood, 'Latin America Tamed?', *New Left Review* 58, July–August 2009, p.142. A very 'thin' middle class indeed, and which has been further thinned by the unemployment generated in the most recent financial crises; in the six months to March 2009, as Wood points out, 600,000 jobs were lost in Mexico, and in the final quarter of 2008, some 800,000 in Brazil.

18 E. Sader, 'The Weakest Link? Neoliberalism in Latin America', *New Left Review* 52, July–August 2008, p.7. To which Sader adds: 'the overthrow of one neoliberal government after another ... corresponded to a decline in the international preponderance of the US economy' (p.27).

19 T. Ali, *Pirates of the Caribbean. Axis of Hope*, Verso, London, 2006, p.ix. The challenge to the north American economy was reinforced in 2004 with the creation of the Andean-Caribbean 'Bolivarian Alliance for Peoples of our America' or *Alternativa Bolivariana para las Américas* (ALBA), which will attempt to introduce the SUCRE as a common Latin American currency and an alternative to the dollar.

20 T. Wood, 'Latin America Tamed?', *New Left Review* 58, July–August 2009, p.129.

21 None of the artists in this book has taken up radical practices such as those of the Argentine collective Tucumán Arde (1968) or the Colombian group Taller 4 Rojo (1972), with their strong revolutionary and anti-imperialist tendencies. Faced with those who advocate a fusion between aesthetics and politics, Suely Rolnik recently observed that the function of critical art today should not be identical with that of political activism, nor vice versa. This difference allows both artists and activists to take on different tasks and enables them to criticise and even 'monitor' each other in the political sense of the word (as she stated in 'Potencia política del arte y del activismo', lecture given at the 'Arte y revolución' seminar, La Casa Encendida, Madrid, 27 January 2007).

22 S. Goldman, *Dimensions of the Americas: Art and Social Change in Latin America and the United States*, The University of Chicago Press, Chicago, 1994, p.xviii. See also A. Amaral, *Arte para quê? A preocupação social na arte brasileira, 1930–1970*, Nobel, São Paulo, 1984.

23 J. Barnitz, *Twentieth-Century Art of Latin America*, University of Texas Press, Austin, 2001, pp.296–7.

24 For an analysis of the various artistic manifestations of this generation, see G. Brett, *Transcontinental. Nine Latin American Artists*, Verso, London, 1990; A. Giunta, *Vanguardia, internacionalismo y política. Arte argentino en los sesenta*, Paidós, Barcelona, 2001; C. Dunn, *Brutality Garden: Tropicália and the Emergence of a Brazilian Counterculture*, University of North Carolina Press, Chapel Hill, 2001; C. Frérot, *Art contemporain d'Amérique latine*, L'Harmattan, París, 2005; the last two chapters of E. Sullivan, *The Language of Objects in the Art of the Americas*, Yale University Press, New Haven, 2007; and L. Camnitzer, *On Art, Artists, Latin America and Other Utopias*, University of Texas Press, Austin, 2009, pp. 63–75.

25 M.C. Ramírez, 'A highly topical utopia. Some outstanding features of the avant-garde in Latin America', in *Inverted utopias. Avant-garde in Latin America*, Yale University Press, New Haven, 2004, p.5.

26 R. Storr, 'Gabriel Orozco: The power to transform', *Art Press* 225, June 1997, p.25.

27 S. Thorne, 'Signs of Life', *Frieze 122*, April 2009 [www.frieze.com/issue/article/signs_of_life/], consulted 5 August 2010.

28 On other hand, I should not like the reader to think that the inclusion of works in this book suggests that their creators have worked continuously within the aesthetic and political paradigms set out here. The subsequent trajectories of some of these artists have diverged and will continue to diverge from the *modus operandi* of 'contraposition'.

29 On the reductionist way in which the art of 'other geographies' is introduced in accordance with the expectations of the Western aesthetic canon, see J. Stallabrass, *Art Incorporated*, Oxford University Press, Oxford, 2004, pp.29–72.

30 I. Candela, *Sombras de ciudad. Arte y transformación urbana en Nueva York, 1970–1990*, Alianza Editorial, Madrid, 2007, and 'Introducción', *low key*, Fundación Botín, Santander, 2008, pp.11–21.

1 From sculpture to installation

1 Moacir dos Anjos has said that each of Neto's pieces 'enlarges the semantic power of an oeuvre that aspires to fluidity' (in *Ernesto Neto*, exh. cat., Museu de Arte Moderna Aloísio Magalhães, Recife, 2003, p.15).

2 In 'Hans-Michael Herzog in Conversation with Ernesto Neto', *Seduções. Valeska Soares, Cildo Meireles, Ernesto Neto*, exh. cat., Daros-Latinamerica, Zurich, 2006, p.131.

3 A. Pedrosa, 'Esculturas íntimas', in *Ernesto Neto. O corpo, nu tempo*, exh. cat., Centro Galego de Arte Contemporánea, Santiago de Compostela, 2002, p.66.

4 This first phase in Neto's work is analysed in C. Basualdo, *Ernesto Neto. Eighteightnineeight*, exh. cat., Galería Camargo Vilaça, São Paulo, 1998. Porosity is considered in P. Herkenhoff, 'Globiobabel nudelioname landmoonaia', in *Seduções*, op. cit., 2006, pp.158–65.

5 G. Brett, 'Life Strategies: Overview and Selection. Buenos Aires / London / Rio de Janeiro / Santiago de Chile, 1960–1980', in P. Schimmel (ed.), *Out of Actions: Between Performance and the Object 1949–1979*, exh. cat., MoCA, Los Angeles, 1998, p.198. See also G. Brett, *Brasil Experimental. Arte/vida: proposições e paradoxos*, Contra Capa Livraria, Rio de Janeiro, 2005.

6 In 'Hans-Michael Herzog in Conversation con Ernesto Neto', op. cit., pp.131, 133.

7 Ibid., p.131.

8 In E. Neto and C. Pereira, 'La fragilidad del mundo', *Ernesto Neto. O corpo, nu tempo*, op. cit., p.278.

9 In 'Hans-Michael Herzog in Conversation con Ernesto Neto', op. cit., p.133.

10 Ibid., p.133.

11 In 'La fragilidad del mundo', op. cit., p.276. Neto has criticised the way in which the Church uses the scission between body and soul today: 'I don't feel any connection with religion' (ibid., p.277).

12 E. Alliez, 'Body without Image: Ernesto Neto's Anti-Leviathan', in *Radical Philosophy* 156, July–August 2009, p.26. See also *Léviathan Thot. Ernesto Neto*, exh. cat., Éditions du Regards, Paris, 2006, and *A culpa civilizada. Ernesto Neto*, exh. cat., Musée des Beaux-Arts, Nantes, 2009.

13 In 'La fragilidad del mundo', op. cit., p.277.

14 J.A. Ramírez, 'Más fantasías: Königsberg y E. Neto', *Edificios-cuerpo*, Siruela, Madrid, 2003, p.81.

15 In 'La fragilidad del mundo', op. cit., p.277. Note how, in order to transform the object into experience (in a way not unlike the work of Orozco, however great the stylistic differences), Neto has to combine the artistic disciplines of sculpture, architecture and urbanism. In this respect, he has said: 'I am doing a kind of body/space/landscape' (in B. Arning, 'Ernesto Neto', *Bomb* 70, Winter 2000, p.82).

16 A. Pedrosa, op. cit., p.82.

17 For an interpretation of the installations of Lygia Clark and Hélio Oiticica from the paradigm of the phenomenology of perception and its extrapolation to Neto's recent installations, see C. Bishop, *Installation Art. A Critical History*, Tate, London, 2005, pp.64–5.

18 J.A. Ramírez, op. cit.,,. p.82.

19 O.M. Viso, 'Directions. Ernesto Neto', Hirschhorn Museum of Art, Washington, 2002, n. pag. Pedrosa has said that Neto's works afford 'comfort, shelter and intimacy to the spectator' (in op. cit., p.78), and Herkenhoff, that his sculpture 'gives pleasure' (op. cit., p.161).

20 Clark believed in the therapeutic possibilities of the interaction of her *Objetos Relacionales* with experiences in the patient's body-memory at a level that was neither verbal nor prelinguistic. Between 1976 and 1982 she treated many people with psychological problems. See S. Rolnik and C. Diserens (eds), *Lygia Clark, de l'oeuvre à l'événement: Nous sommes le moule, à vous de donner le souffle*, exh. cat., Musée de Beaux-Arts de Nantes, Nantes, 2005.

21 N. Bourriaud, *Relational Aesthetics*, Les presses du réel, Dijon, 2002, p.14.

22 P. Herkenhoff, op. cit., p.163.

23 In 'La fragilidad del mundo', op. cit., p.280.

24 F. Bonami, 'Gabriel Orozco: *La DS*', in *Flash Art* XXVII/175, March–April 1994, p.95.

25 M. Kwon, 'The fullness of empty containers', *Frieze* 24, September–October 1995, p.54. Revising the notion of progress through the reappropriation of the car is an idea also found in the Volkswagen deconstructed by Damián Ortega in *Cosmic Thing* (2002) or the carbonised Renault by Adel Abdessemed in *Practice Zero Tolerance* (2006), a work that refers to the riots in the Parisian *banlieus* of November 2005.

26 B. Buchloh has defined the work as 'the carcass of promise, between coffin and projectile', in 'Gabriel Orozco: The Sculpture of Everyday Life', in *Gabriel Orozco*, exh. cat., MoCA, Los Angeles, 2000, p.92.

27 B. Fer, 'Loco por Saturno: entrevista con Gabriel Orozco', in *Gabriel Orozco*, exh. cat., Consejo Nacional para la Cultura y las Artes, Ciudad de México, 2006, pp.109, 113.

28 'Gabriel Orozco en conversación con Guillermo Santamarina', in *Gabriel Orozco*, exh. cat., Museo Nacional Centro de Arte Reina Sofía, Madrid, 2005, p.36.

29 The geometries reconstructed by Orozco mean that both *Nature Recovered* and *La DS* give, as E.J. Garza puts it, 'a tangible sense of chaos and order, harmony and dissent, attraction and repulsion' (in 'The Poetry of Forms', *Literal*, Summer 2008, p.51).

30 G. Orozco, 'Lecture', in Y.A. Bois (ed.), *Gabriel Orozco*, The MIT Press, Cambridge, Mass., 2009, p.97.

31 Ibid., pp.94–5. To which he adds: 'It is important to understand ... how I try to give their intrinsic structure a new way of functioning, metaphoric on the one hand, but also utilitarian and in some way real' (pp.95–6).

32 J. Morgan, *Gabriel Orozco*, Tate, London, 2011, p.50.

33 In 'Teoria do não-objeto', his promotional manifesto for the Segunda Exposição Neo-concreta in 1960, Ferreira Gullar declared: 'The non-object is not an anti-object but rather a special object in which to synthesize both sensory and mental experiences' (reprinted in the book edited by A. Amaral, *Projecto construtivo brasileiro na arte, 1950–62*, Museu da Arte Moderna, Rio de Janeiro, 1977, pp.90–4).

34 S. Cosulich Canarututto, *Gabriel Orozco*, Electa, Milan, 2008, p.47.

35 G. Orozco, 'Lecture', op. cit., p.97. See how *Recaptured Nature* generates a similar process by converting an 'internal object' (the inner-tube of a tyre) into an 'external object' (a very noticeable rubber ball).

36 Orozco has said that 'even the cutting of the car was a very bodily-like experience'; see 'Gabriel Orozco in conversation with Benjamin H.D. Buchloh' in Y.A. Bois (ed.), *Gabriel Orozco*, op. cit., p.111.

37 In 'Gabriel Orozco en conversación con Guillermo Santamarina', op. cit., p.34.

38 In A. Temkin (ed.), *Gabriel Orozco*, exh. cat., MoMA, New York, 2009, p.92.

39 Adorno, *Aesthetic Theory*, op. cit., p.141. For a philosophical analysis of Orozco's works, which connects them with the notions of thinkers such as Leibniz and Deleuze, see M. González Virgen, *Of Games, the Infinite and Worlds: the Work of Gabriel Orozco*, Merz, Gante, 2003.

40 B. Fer, 'Loco por Saturno: entrevista con Gabriel Orozco', op. cit., pp. 61, 65.

41 B. Buchloh et al., 'A conversation with Gabriel Orozco', *October* 130, Autumn 2009, p.183.

42 B. Buchloh, 'Gabriel Orozco: la escultura como recolección', in *Gabriel Orozco*, exh. cat., Consejo Nacional para la Cultura, Ciudad de México, 2006, p.155. Orozco, who in 1998 entitled his exhibition at the Marian Goodman Gallery in New York *El mercado libre es antidemocrático* (*The Free Market is Antidemocratic*), observed: 'Many artists generate a system of production which reproduces the capitalist system of production. They thus establish a relationship with reality through production and through the use of other people's time to produce value. This is one of the more serious problems that we are currently witnessing.' (In 'Gabriel Orozco en conversación con Guillermo Santamarina', op. cit., p.32).

43 M. Minera, 'Conversación con Gabriel Orozco', *Letras libres*, December 2006, p.87.

44 P. Pobocha and A. Byrd, 'Chronology', in A. Temkin (ed.), *Gabriel Orozco*, op. cit., p.106.

45 At the same time, *Parking* requires the almost complete dismantling of the work as object, a process also developed by Orozco in two of his most polemical pieces: *Caja de zapatos vacía* 1993 (*Empty Shoe Box*) and *Tapas de yogur* 1994 (*Yoghurt Tops*), sculptures created exclusively from the modest objects from which they take their titles.

46 G. Brett, 'Between Work and World: Gabriel Orozco', in Y.A. Bois (ed.), *Gabriel Orozco*, op. cit., p.58.

47 B. Fer, 'Loco por Saturno: entrevista con Gabriel Orozco', op. cit., pp.109, 113.

48 G. Glueck, 'The Ruins, the Utopia', *The New York Times*, 16 February 2001, p.E39. See also *Carlos Garaicoa. La ruina; la utopía*, exh. cat., Biblioteca Luis Ángel Arango, Bogotá, 2000.

49 See his proposal 'Continuity of a Detached Architecture', in *Documenta 11_Platform 5: Exhibition*, exh. cat., Hatje Cantz, Ostfildern, 2002, p.561, and C. Garaicoa, *Continuidad de una arquitectura ajena*, Gli Ori, Prato, 2002.

50 In T. Loeb, 'Entrevista a Carlos Garaicoa', [www.puntocero.de/content/garaicoa.html], February 2006, viewed 20 March 2010. In conversation with Tanya Barson, Garaicoa stated: 'I don't want people to say that I am talking about Fidel [Castro] and politics every day. ... I think there are bigger problems in the world than just talking about Fidel. But people want to push you there; they want to put you in this situation, because [they] need to put you in a context which they understand' (in [www.tate.org.uk/research/tateresearch/majorprojects/garaicoa/work_1.htm], viewed 21 March 2010).

51 In H. Block, 'Carlos Garaicoa', *BOMB* 82, Winter 2002–3, p.28. See the data supplied by The United Nations Human Settlements Programme UN-HABITAT in [www.unhabitat.org], indicating that, as of today, 100 million people are homeless and 600 million live in precarious housing or accommodation likely to disappear (viewed 21 March 2010). At the same time, empty accommodation continues to increase; in the USA alone, the figure is rising towards 14 million.

52 In H. Block, 'Carlos Garaicoa', op. cit., p.29.

53 In T. Loeb, 'Entrevista a Carlos Garaicoa', op. cit., viewed 20 March 2010. Garaicoa continues: 'Something very important for me is the critical, anarchic spirit that should lie behind art. I think that artistic language should be slippery, versatile, constantly in contradiction with itself, and never be an act of complacency.'

54 M. Spiegler, 'City Lights', *ARTnews*, March 2005, pp.96–7.

55 In L. Fusi, 'A conversation with Carlos Garaicoa', in *Carlos Garaicoa. La misura di quasi tutte le cose*, exh. cat., Palazzo delle Papesse, Siena, 2004, p.29.

56 In H. Block, 'Carlos Garaicoa', op. cit., p.25. The gradual destruction of the cities (real and metaphorical) in the diptych *Now Let's Play to Disappear* acquired a more organic character in the later sculpture *Principios básicos para destruir* 2007 (*Basic Principles to Destroy*), for which Garaicoa constructed a city with lumps of sugar; encapsulated in a closed Plexiglas structure, it was eaten by hundreds of ants.

57 C. Ponce de León, 'Inventario de curiosidades', *María Fernanda Cardoso. Inventario 20 años*, exh. cat., Biblioteca Luis Ángel Arango, Bogotá, 2004, p.8.

58 In D. Garzón, 'Conversación con María Fernanda Cardoso', *Otras voces, otro arte. Diez conversaciones con artistas colombianos*, Editorial Planeta, Bogotá, 2005, p.157.

59 Ibid., p.157. Working with dead animals earned Cardoso the censure of ecological groups. She replied that she bought the desiccated animals from a US catalogue; she herself was not desiccating them but buying a commodity available on the market prior to her interest.

60 In H.-M. Herzog, 'María Fernanda Cardoso', *Cantos/cuentos colombianos. Contemporary Colombian Art*, Daros-Latinamerica, Zurich, 2004, p.269. Cardoso has said elsewhere that, for her, it is not enough for the animal to be dead; it must also 'look it' (in D. Garzón, 'Conversación con María Fernanda Cardoso', op. cit., p.162).

61 See in particular the chapter 'Concept of Enlightenment', in Th. W. Adorno and M. Horkheimer, *Dialectic of Enlightenment*, Verso, London, 1997, pp.3–42.

62 'María Fernanda Cardoso interviewed by Elizabeth Ann MacGregor', *Zoomorphia*, exh. cat., Museum of Contemporary Art, Sydney, 2003, p.43. Domination of the natural world in Cardoso's work reaches its culmination in *Cardoso Flea Circus* (1994–2000), a spectacle in which she directs an authentic flea circus. To do this, Cardoso not only constructed each of the pieces of circus equipment but had to become a professional 'flea trainer'. The work exhibits a total control over nature (the fleas) but on a ridiculously small scale (for a circus spectacle). See L.M. Herbert, 'The smallest show on earth', in *Cardoso Flea Circus*, exh. cat., Contemporary Art Museum, Houston, 2000, pp.5–12.

63 I. Arestizábal, 'Archipiélago de imágenes', *Archipiélago de imágenes: 50esima esposizone internazionale d'arte*, Instituto Italo-Latino Americano, Venice, 2003, pp.16–17; J. Roca, 'Biogeometrías', in *María Fernanda Cardoso. Inventario 20 años*, op. cit., pp.13–14.

64 In 'María Fernanda Cardoso', *Otras miradas*, exh. cat., Ministerio de Relaciones Exteriores, Bogotá, 2004, pp.72–3.

65 In 'María Fernanda Cardoso interviewed by Elizabeth Ann MacGregor', *Zoomorphia*, op. cit., p.43. In the work of Nadín Ospina, another Colombian artist of the same generation, we find a reconfiguration of Pre-Colombian imagery using the aesthetic strategies of Pop art.

66 In 'María Fernanda Cardoso', *Otras miradas*, op. cit., p.78.

67 C. Ponce de León, 'Inventario de curiosidades', in op. cit., p.10.

68 In 'María Fernanda Cardoso', *Otras miradas*, op. cit., p.71.

69 In D. Garzón, 'Conversación con María Fernanda Cardoso', op. cit., p.161. To which she adds: 'In all of my work there is a contradiction between the grotesque and the beautiful. ... How can I make the transition between something horrible like a corpse and turn it into a work of fine art?' (p.169).

70 R. Platt, 'Life Preserver', in *María Fernanda Cardoso*, exh. cat., MIT List Visual Center, Boston, 1994, p.8.

71 R. Leslie, 'Rivane Neuenschwander', *ArtNexus* 6/64, April–June 2007, p.136.

72 J. Hoffmann, 'Ethereal Materialism', *Flash Art* XXXIV/226, October 2002, p.92. Part of this complexity is treated in D. Birnbaum, 'Feast for the eyes: the art of Rivane Neuenschwander', *Artforum*, May 2003, pp.142–6, and in S. Thorne, 'Signs of Life', *Frieze* 122, op. cit., viewed 10 April 2010.

73 See B. Nunes, *A utopia antropofágica: a antropofagia ao alcance de todos*, Globo, São Paulo, 1990. Neuenschwander has spoken of her artistic influences – Oiticica, Clark, Tom Zé ... – in R. Marcoci, 'Rivane Neuenschwander', *Comic Abstraction: Image-Breaking, Image-Making*, MoMA, Nueva York, 2007, pp.96–101.

74 In C. Milliard, 'Ashes to ashes, dust to art ...', *Art Review* 26, October 2008, p.82. S. Hudson notes that Neuenschwander has reclaimed the legacy of *antropofagia*, but only in order to broaden it, avoiding 'the legacy of tropical clichés' (in 'Rivane Neuenschwander', *Artforum*, December 2006, p.304).

75 V. Cordeiro, 'Rivane Neuenschwander', *ArtNexus* 1/47, January–March 2003, p.101.

76 R. Martínez, 'From one to another', in D. Birnbaum et al., *Here Comes the Sun*, exh. cat., Stockholm, Magasin 3, 2005, p.53. Rain as metaphor reappears in *Suspension Point* (2008), an installation by Neuenschwander for South London Gallery, in which a soundtrack by the group O Grivo entitled *Lá fora está chovendo (It's Raining Out There)* recreated the sound of 'non-existent rain' (in B. Luke, 'Interview with Rivane Neuenschwander', *Art World* 10, April–May 2009, p.96).

77 L. Lagnado, '"Longing for the body", yesterday and today', in *Brazil: Body Nostalgia*, exh. cat., The National Museum of Modern Art, Tokyo, 2004, p.169.

78 M. dos Anjos, 'Olhar a poeira, por exemplo', in *Rivane Neuenschwander*, exh. cat., Museu de Arte Moderna Aloísio Magalhães, Recife, 2003, pp.4–5.

79 In B. Luke, 'Interview with Rivane Neuenschwander', op. cit., p.96. On the other hand, K.M. Jones has observed the relationship that Neuenschwander again establishes here with *antropofagia*, pointing out that 'the circles of paper that come through the holes in the ceiling suggest ingestion or digestion' (in 'Rivane Neuenschwander', *Frieze* 104, January–February 2007, [www.frieze.com/issue/review/rivane_neuenschwander], viewed 11 April 2010).

80 R. Martínez, 'From one to another', op. cit., p.53.

81 R. Neuenschwander, in C. Milliard, 'Ashes to ashes, dust to art ...', op. cit., p.85.

82 In B. Luke, 'Interview with Rivane Neuenschwander', op. cit., p.96. In this sense, Neuenschwander's work is in dialogue with that of Donna Conlon, which is analysed in the second part of this book.

83 R. Leslie, 'Rivane Neuenschwander', op. cit., p.137.

84 In B. Luke, 'Interview with Rivane Neuenschwander', op. cit., p.96. A first retrospective of Neuenschwander's work was organised shortly after the writing of this chapter at the New Museum of Contemporary Art in New York; see *Rivane Neuenschwander. Um dia como outro calquer = A Day Like Any Other*, New Museum, New York, 2010.

85 See the UN report on Banana Exporting Countries in 'The World Banana Economy, 1985–2002', [www.fao.org/docrep/007/y5102e/y5102e05.htm#TopOfPage], viewed 19 February 2012.

86 Cited in O. Flores Rodríguez, 'Delirios bananeros unen ricos y pobres', *Excelsior* (Comunidad), 30 October 2009, p.8. Note how another work made with bananas, *30.000 Bananas* (2000–4) by Doug Fishbone, acquired completely different overtones in the different places where it was installed, which included Ecuador, Poland, the UK and the USA.

87 For more information on the North American influence in Colombian history, see A. Molano's study, 'Colombia: un país violentado', in which he notes that 'Colombia now ranks third in U.S. military aid and has the highest number of U.S. embassy personnel worldwide: 3,000 employees' (in *Cantos/cuentos Colombianos*, op. cit., p.337).

88 In S. Araújo Castro, 'La Avenida Jiménez de arriba abajo', [www.elespectador.com/impreso/cultura/articuloimpreso166915-avenida-jimenez-de-arriba-abajo], 15 October 2009, viewed 24 April 2010.

89 In 'Delirios bananeros unen ricos y pobres', op. cit., p.8.

90 Ibid., p.8. Flores Rodríguez's article is to that extent badly titled, since Zamora's work does not so much 'unite rich and poor' as comment on their differences.

91 The term 'banana republic' was coined by W.S. Porter in his collection of stories *Cabbages and Kings*, published in 1904 under the pseudonym O. Henry.

92 A. Pedrosa, 'Héctor Zamora. Museo de Arte Carrillo Gil', *Artforum*, March 2005, p.245.

93 'Héctor Zamora. La calle como museo y el museo como zoológico', *Revista Bifurcaciones* 8, December 2008, p.3. For documentation of the complex legal formalities involved in realising the work and a series of interpretative texts, see *Paracaidista. Av. Revolución 1608 bis*, exh. cat., Museo de Arte Carrillo Gil, Mexico City, 2007.

94 See the article by J. Medeiros, 'Prefeitura veta obra no Lago do Ibirapuera', in [www.lsd.com.mx], viewed 24 April 2010.

95 C. Medina, 'Notas para una estética del modernizado', op. cit., p.13.

96 In 'Héctor Zamora. La calle como museo y el museo como zoológico', op. cit., pp.1–2.

97 Concerning *Enjambre de dirigibles*, E. Pyburn-Wilk has written: 'Even in the absence of any overtly political claim, the formal structure of Zamora's piece forces one to consider it a political action', in [www.lsd.com.mx/developed/biennale_venezia/bienal.pdf], viewed 25 April 2010.

2 Videographic practices

1 For a brief but particularly rich analysis of the difficult relationship between sculpture and moving image, see R. Hullot-Kentor, 'Film Performance Anthology', *Anthology Film Archives Film Program*, vol.36, no.4, October–December 2007, p.18.

2 The details of the production of *Here* in Tepoztlán, México, can be found in the documentary *Fuego amigo* 2006 (*Friendly Fire*); for more information about Ríos' work, see also the texts brought together in *Miguel Ángel Ríos*, exh. cat., Malba, Buenos Aires, 2009.

3 In the reportage 'Miguel Ángel Ríos op Vijversburg VI', made on the occasion of the projection of *Here* in the Friesmuseum (Leeuwarden), in [www.youtube.com/watch?v=-kuZN7kYb6g&feature=related], viewed 15 May 2010. On 'expanded cinema', see the classic study by G. Youngblood, *Expanded Cinema*, Studio Vista, London, 1970.

4 Amy Rosenblum Martín has related Ríos to other Latin American artists such as Oiticica and Pape in 'Miguel Ángel Ríos and Corporeal Intelligence', *Miguel Ángel Ríos: Aquí*, exh. cat., Blaffer Gallery, Houston, 2007, pp.17–23.

5 R. Rubinstein, 'The choreography of power', in *Miguel Ángel Ríos: Aquí*, op. cit., pp.12–13. He adds: 'In Ríos' works, however, the peace of this modernist geometry is shattered by violence, by warlike scenes in which the protagonists battle to the death' (p.13).

6 As he points out in *Fuego amigo*, where Ríos also cites his admiration for film directors such as S.M. Eisenstein, Fritz Lang, Luis Buñuel and Emilio Fernández.

7 Quoted in T. Sultan, 'Right here, right now', in *Miguel Ángel Ríos: Aquí*, op. cit., p.10.

8 M.A. Ríos, in 'Miguel Ángel Ríos op Vijversburg VI', op. cit., viewed 15 May 2010. Elsewhere, Ríos has said: 'What I would like to do is to make the viewer forget the game and concentrate on the violence of it. The tops spin like human beings. They cannot be guided easily. Their dance is a metaphor, an excuse to conceive violence, a violence that is pervasive today throughout the world' (in T. Sultan, 'Right here, right now', op. cit., p.7).

9 V. Verlichak, 'Miguel Ángel Ríos', *ArtNexus* vol.8, no.75, December 2009–February 2010, p.108.

10 R. Rubinstein, 'The choreography of power', op. cit., p.14.

11 Virginia Pérez-Ratton has pointed out that Conlon selected the shots of the 'ant demonstration' with reference to countries that had just taken part in a war and 'realised conflict was present in most nations' ('Donna Conlon', in *Turbulence. 3rd Auckland Triennial*, Auckland Art Gallery, Auckland, 2007, p.60).

12 The video *Miércoles de ceniza/Epílogo* ('Ash Wednesday/Epilogue', 2006) by Rivane Neuenschwander and Cao Guimarães takes up the idea of *Coexistence* and develops it in festive form; the ants here transport bits of coloured carnival confetti to the sound of a Brazilian samba played with matches on a table-top.

13 F. Guattari, *Three Ecologies*, tr. I. Pindar and P. Sutton (Athlone, New Brunswick, NJ, 2000). The three ecologies are environmental, social and mental, and none can, according to Guattari, exist without the other.

14 On this subject, M.E. Kupfer has stated: 'Conlon makes a social and ecological statement with humor and a sense of esthetics and, above all, with an alluring simplicity that enthralls the viewer' (in '4th Visual Art Biennial of the Central American Isthmus', *ArtNexus*, vol.3, no.56, April–June 2005, p.100).

15 Quoted on the artist's website, [www.donnaconlon.com/statement.php], viewed 5 June 2010. These pieces by Conlon share a preoccupation with *Proyecto Hábitat 1997–2007* (*Habitat Project*) by the Argentine artist Fabiana Barreda, which includes performances and small sculptures made from recyclable materials with a view to creating a social discourse favorable to ecological sustainability.

16 See Jaime Gil de Biedma, 'El juego de hacer versos' in *Volver*, Ediciones Cátedra, Madrid, 1993, pp.119–21: 'El juego de hacer versos— que no es un juego ...' ('The game of making verse—which is no game ...').

17 Quoted in [http://userpages.umbc.edu/~sbradley/projects/rtr_HTBA/project/artists/dconlon.html], viewed 5 June 2010. See also the interview with L. Darabi, 'Trashtastic Tuesday with Donna Conlon', in [http://everydaytrash.com/2008/04/15/trashtastic-tuesday-with-donna-conlon/], viewed 6 June 2010.

18 Ibid. A similar symbolic use of objects falling on the floor can be found in another video recently made in Latin America, *O Século 2011* (*The Century*) by Brazilian artists Cinthia Marcelle and Tiago Mata Machado.

19 G. Deleuze, *Cinema 2: The Time-Image*, Athlone Press, London, 1989, p.209.

20 Ibid., p.223.

21 In this respect, see Zink Yi's multi-channel video-installations *La Cumbia 1999* (*Cumbia*), *De adentro y afuera 2002* (*From Inside and Out*), *La Rumba 2004* (*Rumba*), *6 x Yta Moreno 2004* and *Dilusión facilitada 2009* (*Dilution Facilitated*).

22 On *Independence I*, a video-installation exhibited at the Ludwig Museum in Cologne in 2006, see B. Hess, 'David Zink Yi', *Flash Art*, XXXIX/251, November–December 2006, p.124.

23 A. Bazin, 'The Ontology of the Photographic Image', tr. Hugh Gray, in *Film Quarterly*, vol.13, no.4. (Summer 1960), pp.4–9.

24 D. Eichler, 'A different drum', *Frieze* 84 (June 2004), p.115. The presence of a singing, dancing individual in some of Zink Yi's videos is reminiscent of other practices that have similarly rejected the stereotypes of the body and sexuality imposed on the basis of Eurocentric premises; see in this respect R.C. Bleys, *Images of Ambiente. Homotextuality and Latin American art*, Continuum, London, 2000.

25 Quoted by D. Otero, 'Desconocido en el Perú, exitoso en Europa: Esculpiendo identidades', [http://arte-nuevo.blogspot.com/2006/12/la-obra-de-david-zink-yi.html], viewed 19 June 2010.

26 The strategy of *Huayno and Fugue Behind* is reminiscent of the 'Copernican revolution' effected in the experimental short *Zoo* (1962), in which the Dutch film-maker Bert Haanstra places the camera within the animals' cages to show, through the bars, the gestures of the human beings who gather to contemplate the animals. The animal becomes a man and the man an animal. In Zink Yi's piece, the Western spectator finds him or herself behind the strings, while the native becomes his or her distant observer.

27 E. Hobsbawm, *Globalisation, Democracy and Terrorism*, Abacus, London, 2008, p.23.

28 Quoted in D. Eichler, 'A different drum', *Frieze* 84 (June 2004), p.114.

29 P. Ursprung, 'Ours is a time of historical loss. The Video Essays of Ingrid Wildi', in *Shadows Collide with People*, exh. cat., Swiss Pavilion/51st Venice Biennale, editions fink, Zurich, 2005, p.70. The idea of absence and disappearance articulated by some of Wildi's pieces is also essential to the video *Proyecto para un monumento 2005* (*Project for a Monument*) by the Colombian Óscar Muñoz, in which the camera captures the artist as he sketches on stone with a brush soaked in water the faces of a number of 'disappeared' people, whose portraits immediately evaporate.

30 A. Valdés, 'El largo viaje', in *Ingrid Wildi. Historias breves*, exh. cat., Galería Gabriela Mistral, Santiago de Chile, 2007, p.8.

31 Ibid., p.6. Valdés has pointed out that the three women evoked in fact represent the artist's 'fantasy of her mother'.

32 Jacques Derrida and Safaa Fathy, *Tourner les mots. Au bord d'un film*, Paris: Éditions Galilée/Arte Editions, 2000, p.92.

33 Interview with Wildi made on the occasion of her exhibition *Historias breves* in Galería Gabriela Mistral, [www.youtube.com/watch?v=N_aYo-d7bWQ], viewed 10 July 2010.

34 H.R. Reust has noted: 'Her questions seek precision while also leaving room for digressions. [It] is as if filmic time could abandon its linear nature and forever change the borders running between real time, memory and fiction' (in 'Ingrid Wildi', *Artforum*, December 2004, pp.206–7).

35 The data on emigration in Latin America speaks for itself: ten million Mexican emigrants, three million Colombians, two million Brazilians, one and a half million Ecuadorians, one million Dominicans, 800,000 Chileans ...

36 Interview with Wildi on the occasion of *Historias breves*, op. cit. Ursprung has pointed out that Wildi's oeuvre, influenced by film-makers such as Claude Lanzmann and Abbas Kiarostami, is situated in polar opposition to television reality shows.

37 In [www.tomasochoa.com/works/5%20DOTS/5dots.html], viewed 24 July 2010.

38 This expression was coined by G. Deleuze in a conversation with Foucault in 1972. Foucault went on to say: 'In the most recent upheaval, the intellectual discovered that the masses no longer need him to gain knowledge: they know perfectly well, without illusion; they know far better than he and they are certainly capable of expressing themselves. But there exists a system of power which blocks, prohibits and invalidates this discourse and this knowledge, power not only found in the manifest authority of censorship, but one that profoundly and subtly penetrates an entire societal network' (in Michel Foucault, *Foucault Live. Collected Interviews, 1961–1984*, ed. S. Lotringer, tr. L. Hochroth and J. Johnston, Semiotext[e], New York, 1989, p.75).

39 In [www.tomasochoa.com/works/5%20DOTS/5dots.html], viewed 24 July 2010.

40 For more information on other native videos, see J.F. Salazar and A. Cordova, 'Imperfect Media and the Poetics of Indigenous Video in Latin America', in P. Wilson and M. Stewart (eds), *Global Indigenous Media: Cultures, Poetics, and Politics*, Duke University Press, Durham, 2008, pp.39–57.

41 I. Candela, 'Introducción', in *low key*, op. cit., p.19. Ochoa has said the resistance of the detainees 'isn't ideological but a resistance necessary if they are to survive' (in 'L'arte: una strategia di "memoria della ribellione" impossibile al sistema', in [www.luxflux.net/n2/interviste2.htm], viewed 24 July 2010). A similar objective seems to have motivated *Vídeo al nivel de la calle 1992–3* (*Street Level Video*) by Íñigo Manglano-Ovalle, made on the basis of a video-art workshop with gangs from the most underprivileged slums of Chicago.

42 'Latin America: Crisis behind bars', [http://news.bbc.co.uk/1/hi/world/americas/4404176.stm], viewed 24 July 2010.

43 M. Foucault, *Discipline and Punish: The Birth of the Prison*, tr. Alan Sheridan, Allen Lane, London, 1997, p.24.

44 C. Jiménez, 'Encuentros y desencuentros', *Tomás Ochoa*, exh. cat., Miki Wick Kim, Zurich, 2008, p.4.

45 In the Latin American context, critics of the mode of institutional representation tend to denounce US colonisation: in a recent study, Octavio Getino shows that the major Hollywood companies today account for between 75 and 80% of the attendances in Latin American cinemas. The percentage is almost identical for television programmes and video or DVD hire (O. Getino, *Cine iberoamericano. Los desafíos del nuevo siglo*, INCAA/Ediciones Ciccus, Buenos Aires, 2007, pp.106–7).

46 For an overall approach to Macchi's work, which includes installations, sculptures and drawings, see *Music Stands Still*, exh. cat., SMAK, Ghent, 2011; *Anatomía de la melancolía*, exh. cat., Bienal del Mercosur, Porto Alegre, 2007; and *Light Music*, exh. cat., University of Essex, Colchester, 2007.

47 In his paradox – the subject of a little essay by Borges, *Avatares de la tortuga* 1932 (*Avatars of the Tortoise*) – Zeno states that every arrow that moves from one point to another has to pass through many points. In its trajectory through each point, the arrow is where it is and is not where it is not. It follows that at every point it is stationary. How then can there be any movement that is stationary at every point? Zeno believed that movement could only be defined by stating that the arrow is and is not at the same time in the same place, which is contradictory and ultimately absurd. Faced with this fallacy, he announced the impossibility of movement.

48 In [www.boladenieve.org.ar/vision/41], viewed 16 August 2010.

49 J. Macchi, 'Poética de los residuos', in *El final del eclipse*, exh. cat., Museo de Arte Moderno, Ciudad de México, 2002, p.190.

50 In [www.jorgemacchi.com/cast/obra01.htm], viewed 16 August 2010.

51 As occurs in another Macchi video, *Diario íntimo* 2006 (*Intimate Diary*), made up of nothing but newspaper headlines. For another reappropriation of Dreyer's film, see *La Passion de Jeanne d'Arc (Rozelle Hospital)*, made in 2004 by Javier Téllez, in which the artist edits the original film with new intertitles written on a blackboard by patients in a psychiatric centre in Sydney, Australia.

52 Program notes, 'The Films of Standish Lawder', Anthology Film Archives, New York, December 2007, n. pag. The contrary procedure, that of extending rather than cutting the original, can be found in *24 Hour Psycho* 1993 by Douglas Gordon, which slows down Hitchcock's *Psycho* (1960) to two frames per second so that the film lasts twenty-four hours.

53 For a typology of strategies of reappropriation of film (from Joseph Cornell to Gianikian and Ricci Lucchi), see N. Brenez 'Cartographie du Found Footage', [http://archives.arte.tv/cinema/court_metrage/court-circuit/lemagfilms/010901_film3bis.html], viewed 16 August 2010.

54 The work was premiered at the Bienal del Mercosur 2007 by the Orquesta Sinfónica de Porto Alegre under the baton of Manfredo Schmiedt. In 2001, Macchi had made an earlier version entitled *La canción del final* (*The Song of the Finale*), in collaboration with the musician Alejandro González Novoa.

55 In [www.jorgemacchi.com/cast/obra27video.htm], viewed 17 August 2010.

56 The authors cite as one possible example the shooting of a film inspired by *Begleitmusik zu einer Lichtspielszene* (*Accompanying Music for a Film Scene*), op.34 by Arnold Schönberg (H. Eisler [and T.W. Adorno]: *Composing for the Films*, Oxford University Press, New York, 1947, p.37). In 1972, the film-makers Jean-Marie Straub and Danielle Huillet did indeed make a short based on that score.

57 On the Althusserian theory of the film apparatus, see J.L. Comolli and J. Narboni, 'Cinéma/idéologie/critique', *Cahiers du Cinéma* 216, October 1969, pp.11–5, and P. Rosen (ed.), *Narrative, Apparatus, Ideology: A Film Theory Reader*, Columbia University Press, New York, 1986.

58 Quoted in A. Sánchez, 'La música del azar. Entrevista a Jorge Macchi', in *Una tirada de dados: sobre el azar en el arte contemporáneo*, Consejería de Cultura, Madrid, 2008 (also at [www.jorgemacchi.com/cast/tex24.htm], viewed 16 August 2010).

59 J. Villacorta and J.C. Mariátegui, *Videografías invisibles. Una selección de videoarte latinoamericano 2000–2005*, exh. cat., Museo Patio Herreriano, Valladolid, 2005, p.36. C. Bayá Bolti notes that *Olive Green* 'throbs with irony and contradictions of social kind' (in 'Videoarte en Bolivia', *Brumaria 10*, Spring 2008, p.45).

60 Quoted in 'Narda Alvarado. Essen fassen als städtisches Ereignis', ACC Galerie de Weimar, [www.acc-weimar.de/ausstellungen/a2006/a168/alvarado.html], viewed 29 August 2010.

61 Rejected by the middle and working classes and having lost the support of the parties in his coalition government, Sánchez de Lozada was obliged to resign the presidency and immediately fled Bolivia, where he is currently considered a fugitive from justice for crimes against humanity. The ex-president currently lives in Washington under US state protection.

62 See article 'El mar llega en baldes, Narda Alvarado lo trae', *La razón*, 12 February 2003, [www.bolivia.com/noticias/autonoticias/DetalleNoticia11604.asp], viewed 29 August 2010.

3 Actions in the public space

1 In *Francis Alÿs. Seven Walks*, exh. cat., Artangel, London, 2005, p.30.

2 For more information about Alÿs's trajectory from the 1990s to today, see R. Fergusson, *Francis Alÿs. Politics of rehearsal*, exh. cat., Hammer Museum, Los Angeles, 2007, and M. Godfrey, 'Politics/Poetics: The Work of Francis Alÿs', in *Francis Alÿs. A Story of Deception*, exh. cat., Tate, London, 2010, pp.9–33.

3 See André Breton's letter to Jacques Doucet of 3 March 1921, in which he justifies the visit scheduled for 14 April by referring to the need to 'combat the ultra-aristocratic conception of art and intellectual life that exists today. Dada strives to abolish privilege and escape its ivory tower' (in *André Breton. La beauté convulsive*, exh. cat., Centre Pompidou, Paris, 1991, p.106).

4 H. Rosenberg, 'The American Action Painters', *Art News*, December 1952, p.22.

5 L. Andreotti mentions the intention to resist the reifying tendency towards spatialisation of the physical environment in 'Play-Tactics of the *Internationale Situationniste*', October 91, Summer 2000, p.45.

6 In *Francis Alÿs. Seven Walks*, op. cit., p.44.

7 In 'Russell Ferguson in conversation with Francis Alÿs', in C. Medina, R. Ferguson and J. Fisher (eds), *Francis Alÿs*, Phaidon, London, 2007, p.31.

8 Ibid., p.14.

9 Ibid., p.8.

10 Ibid., p.8.

11 The piece is reminiscent of Daniel Buren's *Les hommes sandwiches* 1968 (*The Sandwich Men*), an action in which two sandwich-board men are contracted to publicise his famously indecipherable striped surfaces in the streets of Paris.

12 In 'Russell Ferguson in conversation with Francis Alÿs', op. cit., p.15.

13 See G. Debord, 'Perspectives for Conscious Alterations in Everyday Life', in K. Knabb (ed.), *Situationist International Anthology*, Bureau of Public Secrets, Berkeley, 1989, p.69.

14 Ibid., p.75.

15 In 'Russell Ferguson in conversation with Francis Alÿs', op. cit., p.31.

16 Interview with Salcedo in E. Valdés Figueroa (ed.), *Guerra y pá. Symposium on the social, political and artistic situation of Colombia*, Daros-Latinamerica, Zurich, 2005, p.136.

17 H.-M. Herzog, 'Conversation with Doris Salcedo', in *Cantos/cuentos colombianos*, op. cit., pp.155, 158. Salcedo may be referring to Alfonso Plazas Vega, who was appointed Director Nacional de Estupefacientes in 2002 by then president Álvaro Uribe.

18 'Carlos Basualdo in conversation with Doris Salcedo', in N. Princenthal et al., *Doris Salcedo*, Phaidon, London, 2000, p.17.

19 C. Merewether, 'To Bear Witness', in *Doris Salcedo*, exh. cat., New Museum, Nueva York, 1998, p.21. For further information on *Unland*, see T. Barson, '*Unland*: The place of testimony', *Tate Papers*, [www.tate.org.uk/research/tateresearch/tatepapers/04spring/unland_paper.htm], Spring 2004, viewed 2 October 2010.

20 R. Mengham, '"Failing Better": Salcedo's Trajectory', in *Doris Salcedo. Neither*, exh. cat., White Cube, London, 2004, p.9. For an analysis of Salcedo's work during the 1990s, see N. Princenthal, 'Silence Seen', in N. Princenthal et al., *Doris Salcedo*, op. cit., pp.40–89.

21 Salcedo has said that 'the silence of the victim of the violence in Colombia, my silence as an artist, and the silence of the viewer come together during the precise moment of contemplation and only in the very space where that contemplation occurs' (Ch. Merewether, 'An interview with Doris Salcedo', in *Unland. Doris Salcedo*, exh. cat., San Francisco Museum of Modern Art, San Francisco, 1999, n. pag.).

22 E. Valdés Figueroa (ed.), *Guerra y pá*, op. cit., p. 150. The idea of an impossible or negative space is extended by Salcedo, still by use of the chair, in two other pieces about the seizure of the Palacio de Justicia: the installation *Tenebrae* (1999) and the series of chairs moulded in stainless steel *Thou-less* (2000–1).

23 Carlos Basualdo in conversation with Doris Salcedo', op. cit., p.12.

24 H.-M. Herzog, 'Conversation with Doris Salcedo', op. cit., p.159.

25 Ibid., p.155.

26 R. Mengham, '"Failing Better": Salcedo's Trajectory', op. cit., p.9.

27 'Carlos Basualdo in conversation with Doris Salcedo', op. cit., p.25.

28 Th. W. Adorno, *Aesthetic Theory*, op. cit., p.338.

29 In Ch. Merewether, 'To Bear Witness', op. cit., p.20.

30 E. Valdés Figueroa (ed.), *Guerra y pá*, op. cit., p.139. The accumulation of chairs also appears in her unrealised project for the Marsum cemetery in Groningen, Holland; see Salcedo's proposal, 'Topography of War', in *Doris Salcedo. Neither*, op. cit., p.27.

31 In the video 'Meet the artist', in [http://channel. tate.org.uk/media/28291797001], viewed 3 October 2010. On this work, see the essays in *Doris Salcedo. Shibboleth*, exh. cat., Tate Modern, London, 2007.

32 D. Salcedo, quoted in *Guerra y pá*, op. cit., p.138.

33 In H.-M. Herzog, 'Conversation with Doris Salcedo', op. cit., pp.130, 132.

34 I refer to the dictum 'because philosophy is good for nothing, it is not yet obsolete' (in Th. W. Adorno, 'Why Still Philosophy', *Critical Models: Interventions and Watchwords*, tr. H.W. Pickford, Columbia University Press, New York, 2005, p.11).

35 On antagonism in Sierra, see I. Candela, 'En los espacios heredados. Primeras propuestas contextuales de Muntadas, López-Cuenca y Sierra', *Revista de Arte Versiones* 1, 2007, pp.95–112.

36 As F. Cavalluci has shown, 'two simultaneous research directions, the aspiration to rigour and the pleasure of shapelessness' (in 'Deflagraciones mínimas', *Santiago Sierra*, exh. cat., Silvana Editoriale, Milan, 2005, p.19).

37 L. Psibiliskis, 'Es macht sie wirklich wütend ...', *Kunst-Bulletin* 10, October 2001, p.13.

38 D. Crimp, 'Redefining Site Specificity', *On the Museum's Ruins*, MIT Press, Cambridge, Mass., 1993, p.154.

39 The work moreover conceives of two kinds of spectators. On the one hand, there are the drivers who suffer a momentary obstruction caused by the lorry without having been warned that this is an artistic intervention. On the other, there are the spectators from the art world who know the work retrospectively only through its documentation. One kind of spectator is directly *in situ*; the other is an indirect spectator in the gallery space.

40 These works show the considerable influence exerted over Sierra by artists such as Smithson or Matta-Clark, who offered a critique of industrialisation on the basis of the decadence that industrialisation itself brought about, respectively in abandoned mine workings and abandoned neighbourhoods.

41 In *Santiago Sierra*, op. cit., p.97.

42 Benjamin in turn cites the Marxist analysis of the manipulation of bodies in factories: 'It is a common characteristic of all capitalist production ...', wrote Marx, 'that the worker does not make use of the working conditions. The working conditions make use of the worker' (in W. Benjamin, 'On some motifs in Baudelaire', *Illuminations*, Schocken Books, New York, 1985, p.175).

43 See on this subject I. Candela, *Sombras de ciudad*, op. cit., pp.114–20. In 2000, Sierra realised *Obstrucción de una vía con diversos objetos* (*Obstruction of a Road with Different Objects*), a road-block in Glentworth St., Limerick (Ireland), right in front of the city's police station.

44 K. García-Antón, 'Comprar el tiempo', in *Santiago Sierra*, exh. cat., Ikon Gallery, Birmingham, 2002, p.9.

45 Ibid., pp.7–9. Note how, in a different context (in Stockholm in 2009), Sierra reinvented the same piece by inverting the role of his 'protagonists': in *Persona obstruyendo una línea de containers* (*Person Obstructing a Line of Containers*), it is a citizen who blocks the way of the lorries, in an image surely intended to evoke the anonymous man who stopped the tanks of the Chinese army in Tiananmen Square in 1989.

46 In R. Martínez, *Santiago Sierra: Pabellón de España, 50ª Bienal de Venecia*, Turner, Madrid, 2003, p.116.

47 Cited in P. Echeverría, 'Minimum Wages', *Flash Art*, July–September 2002, p.103. Sierra has said that 'in Mexico or Guatemala you can easily find people who will perform hard labor for very low wages' (in 'Santiago Sierra talks about his work', *Artforum*, October 2002, p.131). For a critique of the way in which Sierra makes use of violence, see R. Gallo, *New Tendencies in Mexican Art*, Palgrave, New York, 2004, pp.115–16.

48 A. Pedrosa, 'Santiago Sierra', *Artforum*, January 2000, p.121.

49 'El arte es una sublimación de la política', in *Santiago Sierra*, exh. cat., Silvana Editoriale, Milán, 2005, p.75.

50 J. Allora told S. McKinlay: 'In our work participation and exchange begins with us. The will to communicate with another is the foundation for our collaborations and is what keeps it functioning – that ever-shifting space between two people. It is a very political space with an ever-present possibility for disagreement' (in *Common Wealth*, exh. cat., Tate Modern, London, 2003, p.88).

51 J. Allora, in Y. McKee, 'The monstrous dimension of art', *Flash Art*, January–February 2005, p.98.

52 G. Calzadilla, in C. Motta, 'Allora & Calzadilla', *Bomb* 109, Autumn 2009, p.71.

53 C. Motta, 'Allora & Calzadilla', op. cit., p.71.

54 For a study of the notion of the counter-monument, see I. Candela, 'Paz y prosperidad. Sobre la revisión crítica del monumento conmemorativo', in J.A. Ramírez and J. Carrillo (eds), *Tendencias del arte, arte de tendencias a principios del siglo XXI*, Cátedra, Madrid, 2004, pp.249–54.

55 J. Allora, in 'The monstrous dimension of art', op. cit, p.98.

56 J.J. Charlesworth, 'Power Plays', *Artreview* 15, October 2007, p.84.

57 Asked if they consider themselves activists, Calzadilla responds: 'What we are interested in as artists is putting into crisis this very terminology and what it means, by a necessary extending and complicating of its meaning, understanding, and use. [...] At that point it is up to each individual to decide if this self-questioning will play itself out at a political level, at a union level, at an aesthetic level, at a cultural or sexual level, and so on' (*Common Wealth*, op. cit., p.89).

58 H. Feldman has stated: 'Certainly, their work – no matter how disruptive its intent – has been and looks to continue to be well received. What this says about their politics or the political efficacy of their work is probably much less significant than what it suggests about the ease with which institutions mine and effectively re-territorialize such intentions' ('Sound Tracks', *Artforum*, May 2007, p.396).

59 M. Gronlund, 'Acting naturally: the face and the mask', *Afterall* 18, Summer 2008, p.55. For more information about Tellez's oeuvre, see *Javier Téllez. 4½*, exh. cat., Kunstverein, Braunschweig, 2010.

60 Concerning collaboration with the mentally ill, Téllez has stated: 'For me [this] participation is capital in the production of the work: the patients are the main actors, work on the scripts, choose the props, review the footage and comment on it' (in M. Faguet and C. Lehyt, 'Madness is the language of the excluded. An interview with Javier Téllez', *C Magazine* 92, Winter 2006, p.28).

61 Quoted in M. Faguet and C. Lehyt, 'Madness is the language of the excluded', op. cit., p.28.

62 Ibid., p.27.

63 T. Dalton, 'Javier Téllez', *Whitney Biennial 2008*, exh. cat., Whitney Museum, New York, 2008, p.238.

64 In the 1990s alone, more than three thousand people are thought to have died attempting to reach US territory from Mexico.

65 Cited in F. Suazo, 'Javier Téllez', *ArtNexus* vol.1, no.47, January–March 2003, p.119. Note the similarity to the way in which Zink Yi used the harp strings as bars for *Huayno and Fugue Behind* and altered the distinction within/without as this is imposed by a Eurocentric perspective.

66 T. Dalton, 'Javier Téllez', op. cit., p.238.

67 The nursery rhyme borrowed by Kesey in his novel – 'One flew East, one flew West/One flew over the cuckoo's nest' – was used in an article on Téllez written three years before the creation of his Mexican border work (see R. Zamudio, 'Institutionalized Aesthetics', *Flash Art* XXXIV/225, July–September 2002, p.96).

68 Quoted in M. Faguet and C. Lehyt, 'Madness is the language of the excluded', op. cit., p.27.

69 Ibid., p.27.

70 M. Faguet, 'El sueño de la razón produce monstruos. On the work of Javier Téllez', *Afterall* 18, Summer 2008, p.48.

71 M. Faguet and C. Lehyt, 'Madness is the language of the excluded', op. cit., p.26.

72 J. Tumlir, 'inSite 05', *Artforum*, November 2005, p.248.

73 Quoted in C. Ledesma, 'Javier Téllez. Metáforas sobre lo que la sociedad condena al olvido', *Arte al Día International* 125, November–December 2008, p.64.

74 See Herbert Marcuse, 'Aggressiveness in Advanced Industrial Society', in *Negations: Essays in Critical Theory*, tr. J.J. Shapiro, Boston, Beacon Press, 1968 (pp.246–68): 'Is not the individual who functions normally, adequately, healthily as a citizen of a sick society – is not such a person himself sick? And would not a sick society require an antagonistic concept of mental health, a meta-concept designating (and preserving) mental qualities which are tabooed, arrested and distorted by the "sanity" prevalent in the sick society?' (p.251).

75 T. Dalton, 'Javier Téllez', op. cit., p.238.

76 F. Goldman, 'Regina José Galindo', *Bomb* 94, Winter 2005–6, p.39. He adds: 'I have read (and contributed) plenty of words, a plethora of words, a surfeit of words, about violence and injustice in Guatemala. That trail of bloody footprints was the most powerful statement I'd encountered in ages' (p.39).

77 For more information see the various reports of the Comisión Internacional Contra la Impunidad in Guatemala (CICIG) of the United Nations, in [http://cicig.org], viewed 30 October 2010.

78 V. Pérez-Ratton, 'Central American women artists in a global age', in *Global Feminisms: New Directions in Contemporary Art*, Merrell Publishers, London, 2007, p.140. V. Adolphs, in turn, has observed that 'in Galindo's body language – a body that is for her subject, object and medium – walking is always a protest' (in *Gehen bleiben: Bewegung, Körper, Ort in der Kunst der Gegenwart*, exh. cat., Bonn: Kunstmuseum, 2007, p.194).

79 In F. Goldman, 'Regina José Galindo', op. cit., p.40.

80 P. Daniels, 'Pinochet escaped justice – we must ensure Ríos Montt does not', *The Guardian*, 14 December 2006, p.35. On the basis of murders per capita, Ríos Montt has been deemed the most violent dictator in the recent history of Latin America, thus placing in the shade such infamous figures as Augusto Pinochet, Jorge Rafael Videla, Alfredo Stroessner and Hugo Banzer.

81 'General to run in Guatemala', [http://news.bbc.co.uk/1/hi/world/americas/3111047.stm], 31 July 2003, viewed 30 October 2010. Nevertheless, in the elections of November 2003, Ríos Montt obtained only 17% of the vote and failed to reach the second round. He currently hopes to obtain parliamentary immunity from the accusations of genocide that he faces.

82 In F. Goldman, 'Regina José Galindo', op. cit., p.40.

83 Ibid., pp.40–1.

84 Data from [http://cicig.org], viewed 30 October 2010. The most surprising figure is that 1,500 of these cases could be resolved because the identity of the murderer is known. Trials do not occur because, given the corrupt judicial system, people are afraid even to bring charges.

85 R. Cazali, 'Regina José Galindo', in *Venice–Istanbul: A Selection from the 51st International Venice Biennale*, exh. cat., Istanbul Museum of Modern Art, Estambul, 2006, p.54.

86 R.J. Galindo, in [www.reginajosegalindo.com/es/index.htm], viewed 31 October 2010.

87 Quoted in E. Neira, 'El peso del dolor. Entrevista con Regina José Galindo', at [http://revista.escaner.cl/node/917], 31 July 2008, viewed 31 October 2010.

88 R. Cazali, 'Naked reality: On the work of Regina José Galindo', *ArtNexus* 8/75, December 2009–February 2010, p.81.

89 In F. Goldman, 'Regina José Galindo', op. cit., p.44.

90 E. Neira, 'El peso del dolor', op. cit., viewed 31 October 2010.

91 V. Pérez-Ratton, 'Regina José Galindo', in *Turbulence. 3rd Auckland Triennial*, Auckland Art Gallery, Auckland, 2007, p.68. Pérez-Ratton has also stated that 'Galindo addresses issues that concern women, but her statements are not specifically feminist in origin: her position stems from general politics, which obviously include feminism' (in 'Central American women artists in a global age', op. cit., p.140).

92 In R. Cazali, 'Naked reality', op. cit., p.83. On another occasion, she added: 'I don't perform redemptive acts in search of my own salvation; nothing could be further from the truth' (in E. Neira, 'El peso del dolor', op. cit., viewed 31 October 2010).

93 In R. Cazali, 'Naked reality', op. cit., p.84.

Conclusions

1 M. Sánchez Prieto, 'Escape from social utopia. New art in Argentina and Chile', op. cit., p.73.

2 S. Rolnik, 'Awaken from lethargy: art and public life in São Paulo at the century's turn', in *Parachute* 116, October–December 2004, p.15. A particular case of the instrumentalisation of combative art is studied in A. Longoni, 'Crossroads for activist art in Argentina', *Third Text* 22/5, September 2008, pp.575–87.

3 H. Olea, 'Los derechos de inversión', in H. Olea and M.C. Ramírez (eds), *Versions and inversions: perspectives on avant-garde art in Latin America*, Yale University Press, New Haven, 2006, p.18.

4 M. Foucault, 'Les confessions de Michel Foucault' (interview by Roger Pol-Droit), *Le Point*, 1 July 2004, " http://1libertaire.free.fr/Foucault40.html, viewed 28 June 2012.

5 Ibid., viewed 28 June 2012.

6 J. Rancière, *The Politics of Aesthetics*, op. cit., p.70.

7 Ibid., p.33.

8 Ibid., p.30.

9 T. Pitman, 'Latin American cyberprotest. Before and after the Zapatistas', in C. Taylor and T. Pitman (eds), *Latin American Cyberculture and Cyberliterature*, Liverpool University Press, Liverpool, 2007, p.86. Much of the documentation of actions and videos analysed in this book is available in whole or in part through various audiovisual websites.

10 C. Medina, 'Notas para una estética del modernizado', op. cit., p.17.

11 G. Orozco, in 'Gabriel Orozco en conversación con Guillermo Santamarina', op. cit., p.139.

12 Similarly, though my interpretations here are for the most part nourished by those of critics and curators specialised in Latin America (Brett, Carvajal, Medina, Mosquera, Rolnik, Pedrosa, Figueroa ...), I should again emphasise that many pieces described in this volume also have a stake in or have triggered aesthetic debates closely related to certain tendencies in European philosophy, including critical theory, Situationism, post-structuralism and Deconstruction (Benjamin, Adorno, Debord, Foucault, Deleuze, Derrida ...).

13 P. Frank, 'The Cuban-Chinese Cook', op. cit., p.ix. To which he adds: 'The basic problem that gives rise to the neglect of Latin American modern art is structural. The wealth and resources that support research and education about art are concentrated in Europe and the United States, but the human characteristics necessary for the creation of vital, compelling, and innovative art are much more widely dispersed' (ibid., p.ix).

14 Recently, G. Mosquera referred to Latin America as an 'invention' that 'we can reinvent' from the sphere of the arts: 'Rather than appropriating and critically re-functionalising the imposed international culture, transforming it in their own behalf, [Latin American] artists are actively making that metaculture firsthand, unfettered, from their own imagery and perspectives' (in 'Against Latin American Art', op. cit., p.16).

15 T. Negri, *Art & Multitude*, tr. E. Emery, Cambridge, Polity Press, 2011, p.51.

Bibliography

This list comprises books and exhibition catalogues; for articles and monographs, see the relevant notes.

Adams, Beverly; Ledezma, Juan; Ramírez, Mari Carmen (eds) *Constructing a Poetic Universe: The Diane and Bruce Halle Collection of Latin American Art*, exh. cat., Merrell, London/New York, 2007

Ades, Dawn, *Art in Latin America. The Modern Era, 1820–1980*, Yale University Press, New Haven, 1989

Adorno, Theodor W., *Aesthetic Theory*, Continuum, London, 2004

Amaral, Aracy, *Textos do Trópico de Capricórnio*, Editora 34, São Paulo, 2006

Armstrong, Elizabeth; Zamudio-Taylor, Victor, *Ultra-Baroque: Aspects of Post-Latin American Art*, Museum of Contemporary Art, San Diego, 2000

Baigorri, Laura (ed.), *Vídeo en Latinoamérica: una historia crítica*, Brumaria, Madrid, 2008

Barnitz, Jacqueline, *Twentieth-Century Art of Latin America*, University of Texas Press, Austin, 2001

Basilio, Mirian et al., *Latin American & Caribbean Art: MoMA at El Museo*, exh. cat., El Museo del Barrio/MoMA, New York, 2004

Benjamin, Walter, *Illuminations*, Schocken Books, New York, 1985

Bleys, Rudi C., *Images of Ambiente. Homotextuality and Latin American art, 1810–Today*, Continuum, London, 2000

Bois, Yves-Alain; Enriquez, Mary Scheider; Herkenhoff, Paulo, *Geometric Abstraction: Latin American Art from the Patricia Phelps de Cisneros Collection*, exh. cat., Harvard University Art Museums, Cambridge, Mass., 2001

Brett, Guy, *Transcontinental. Nine Latin American Artists*, Verso, London, 1990

——, *Carnival of Perception. Selected Writings on Art*, inIVA, London, 2004

——, *Brasil Experimental. Arte/vida: proposições e paradoxos*, Contra Capa Livraria, Rio de Janeiro, 2005

Camnitzer, Luis, *Conceptualism in Latin American art: Didactics of Liberation*, University of Texas Press, Austin, 2007

——, *On Art, Artists, Latin America, and Other Utopias*, University of Texas Press, Austin, 2009

Carvajal, Rina et al., *The Experimental Exercise of Freedom*, Museum of Contemporary Art, Los Angeles, 1999

Chaplik, Dorothy, *Defining Latin American Art*, McFarland, Jefferson, 2005

Contantino, Roselyn; Taylor, Diana (eds), *Holy Terrors: Latin American Women Perform*, Duke University Press, Durham, 2003

Contemporary Art in Latin America, Black Dog Publishing, London, 2010

Craven, David, *Art and Revolution in Latin America, 1920–1990*, Yale University Press, New Haven, 2002

Cullen, Deborah (ed.), *Arte [no es] vida: Actions by Artists of the Americas 1960–2000*, El Museo del Barrio, New York, 2008

Day, Holliday; Sturges, Hollister, *Art of the Fantastic: Latin America, 1920–1987*, exh. cat., Indianapolis Museum of Art, Indianapolis, 1987

Deleuze, Gilles, *Cinema 2: The Time-Image*, Continuum, London, 2005

Derrida, Jacques; Fathy, Safaa, *Tourner les mots. Au bord d'un film*, Éditions Galilée/ Arte Éditions, Paris, 2000

Devery, Jane (ed.), *Resonant Visions. Contemporary Video from Latin America*, exh. cat., National Gallery of Victoria, Melbourne, 2008

Dunn, Christopher, *Brutality Garden: Tropicália and the Emergence of a Brazilian Counterculture*, University of North Carolina Press, Chapel Hill, 2001

Eco: arte contemporáneo mexicano, exh. cat., Museo Nacional Centro de Arte Reina Sofía, Madrid, 2005

El final del eclipse: el arte de América Latina en la transición al siglo XXI, exh. cat., Museo de Arte Moderno/Fundación Telefónica, México DF/ Madrid, 2002

Entre líneas, exh. cat., La Casa Encendida, Madrid, 2002

Eztetyka del sueño. Versiones del sur, exh. cat., Museo Nacional Centro de Arte Reina Sofia, Madrid, 2001

Fernandes, Sujatha, *Cuba represent! Cuban Arts, State Power and the Making of New Revolutionary Cultures*, Duke University Press, Durham, 2006

Foucault, Michel, *Discipline and Punish. The Birth of the Prison*, Allen Lane, London, 1977

——, *Foucault Live. Collected Interviews, 1961–1984*, ed. Sylvère Lotringer, Semiotext(e), New York, 1989

Frank, Patrick (ed.), *Readings in Latin American Modern Art*, Yale University Press, New Haven, 2004

Frérot, Christine, *Art contemporain d'Amérique latine. Chroniques françaises 1990–2005*, L'Harmattan, Paris, 2005

F(r)icciones. Versiones del sur, exh. cat., Museo Nacional Centro de Arte Reina Sofia, Madrid, 2000

Gallo, Rubén, *New Tendencies in Mexican art: the 1990s*, Palgrave, New York, 2004

Garzón, Diego, *Otras voces, otro arte. Diez conversaciones con artistas colombianos*, Editorial Planeta, Bogotá, 2005

Giunta, Andrea, *Vanguardia, internacionalismo y política. Arte argentino en los sesenta*, Paidós, Barcelona, 2001

Giunta, Andrea; Katzenstein, I. (eds) *Listen, Here, Now! Argentine Art of the Sixties*, MoMA, New York, 2004

Golinski, H.G. (ed.), *Puntos de vista: zeitgenössische Kunst aus der Daros-Latinamerica collection*, exh. cat., Museum Bochum, Bochum, 2007

Goldman, Ana et al. (eds), *Arte latinoamericano siglo XX. Obras Malba – Colección Constantini*, Malba, Buenos Aires, 2004

Goldman, Shifra M., *Dimensions of the Americas: Art and Social Change in Latin America and the United States*, The University of Chicago Press, Chicago, 1994

González, Rita; Lerner, Jesse, *Cine MEXPERIMENTAL: 60 años de medios de vanguardia en México*, Fideicomiso para la Cultura México/EEUU, Ciudad de México, 1998

Guattari, Félix, *Three Ecologies*, Athlone Press, London, 2000

Guerra y pá: Symposium on the Social, Political and Artistic Situation of Colombia, Daros-Latinamerica, Zurich, 2006

Gutiérrez, Rodrigo, *Arte latinoamericano del siglo XX: otras historias de la historia*, Prensas Universitarias de Zaragoza, Zaragoza, 2005

Herzog, H.-M. (ed.), *Cantos/cuentos colombianos: Contemporary Colombian Art*, exh. cat., Daros Latinamerica, Zurich, 2004

——, *Seduções: Installations*, exh. cat., Daros Latinamerica, Zurich, 2006

——; López, Sebastián; Rausch, Felicita (eds), *The Hours: Visual Arts in Contemporary Latin America*, exh. cat., Daros Latinamerica, Zurich, 2006

Heterotopías: medio siglo sin-lugar, 1918–1968. Versiones del sur, exh. cat., Museo Nacional Centro de Arte Reina Sofia, Madrid, 2000

La Ferla, Jorge (ed.), *Historia crítica del vídeo argentino*, MALBA/Fundación Constantini/Fundación Telefónica, Buenos Aires, 2008

Ledezma, Juan (ed.), *The Sites of Latin American Abstraction*, Charta/CIFO, Miami, 2008

Longoni, Ana; Mestman, Mariano, *Del Di Tella a Tucumán Arde*, El cielo por asalto, Buenos Aires, 2000

Lucie-Smith, Edward, *Latin American Art of the 20th Century*, Thames & Hudson, London, 2004

Machado, Arlindo (ed.), *Made in Brasil. Três décadas do video brasileiro*, Iluminuras/Itaú Cultural, São Paulo, 2007

Marcuse, Herbert, *Negations: Essays in Critical Theory*, Beacon Press, Boston, 1968

Mariátegui, José Carlos; Villacorta, Jorge, *Videografías invisibles. Una selección de videoarte latinoamericano 2000/2005*, Museo Patio Herreriano, Valladolid, 2005

Marín Hernández, Elizabeth, *Multiculturalismo y crítica poscolonial: la diáspora artística latinoamericana (1990–2005)*, PhD thesis, Universidad de Barcelona, 2006

Medina, Cuauhtémoc; Debroise, Olivier, *La era de la discrepancia. Arte y cultura visual en México 1968–1997*, Museo Universitario de Ciencia y Arte UNAM, Ciudad de México, 2006

Mosquera, Gerardo (ed.), *Beyond the Fantastic: Contemporary Art Criticism from Latin America*, inIVA, London, 1995

——, *Copiar el Edén: Arte reciente en Chile*, Puro Chile, [Santiago de Chile], 2006

——, *Estados de intercambio: Artistas de Cuba*, exh. cat., Turner/A&R Press/inIVA, London, 2008

Negri, Toni, *Art and Multitude*, Polity, London, 2011

No es sólo lo que ves: pervirtiendo el minimalismo. Versiones del sur, exh. cat., Museo Nacional Centro de Arte Reina Sofia, Madrid, 2000

Nunes, Benedito, *A utopia antropofágica: a antropofagia ao alcance de todos*, Globo, São Paulo, 1990

Olea, Héctor; Ramírez, Mari Carmen (eds), *Inverted Utopias: Avant-Garde Art in Latin America*, Yale University Press, New Haven, 2004

——, *Versions and Inversions: Perspectives on Avant-garde Art in Latin America*, Museum of Fine Arts/Yale University Press, Houston/New Haven, 2006

Pérez-Barreiro, Gabriel (ed.), *Blanton Museum of Art: Latin American Collection*, exh. cat., Blanton Museum of Art/University of Texas, Austin, 2006

——, *The Geometry of Hope: Latin American Abstract Art from the Patricia Phelps de Cisneros Collection*, exh. cat., Blanton Museum of Art/University of Texas, Austin, 2007

Ponce de León, Carolina, *El efecto mariposa. Ensayos sobre arte en Colombia, 1985–2000*, Alcaldía Mayor, Bogotá, 2004

Power, Kevin (ed.), *Pensamiento crítico en el nuevo arte latinoamericano*, Fundación César Manrique, Lanzarote, 2006

Ramírez, Mari Carmen; Papanikolas, Theresa (eds), *Collecting Latin American Art for the 21st century*, Museum of Fine Arts, Houston, 2002

Rancière, Jacques, *The Politics of Aesthetics*, London, Continuum, 2004

Rasmussen, Waldo (ed.), *Latin American Artists of the Twentieth Century*, exh. cat., MoMA, New York, 1993

Rubiano Caballero, Germán, *Arte de América Latina 1981–2000*, Banco Interamericano de Desarrollo, Washington, 2001

Santana, Andrés Isaac (ed.), *Nosotros, los más infieles: Narraciones críticas sobre el arte cubano (1993–2005)*, Cendeac, Murcia, 2008

Sartor, Mario, *Arte latinoamericana contemporanea dal 1825 ai giorni nostri*, Ed. Jaca, Milan, 2003

Sullivan, Edward, *Latin American Art*, Phaidon, London, 2000

—— (ed.), *Brazil: Body and Soul*, exh. cat., Guggenheim Museum, New York, 2002

——, *The Language of Objects in the Art of the Americas*, Yale University Press, New Haven, 2007

Taylor, Claire; Pitman, Thea (eds), *Latin American Cyberculture and Cyberliterature*, Liverpool University Press, Liverpool, 2007

Vanderbroeck, Paul, *America, Bride of the Sun: 500 years of Latin America and the Low Countries*, exh. cat., Royal Museum of Fine Arts, Antwerp, 1992

Zegarra, Miguel, *Zona de desplazamientos. Videoarte peruano contemporáneo*, Museo de Arte Moderno de Buenos Aires, Buenos Aires, 2007

Acknowledgements

The advice and support of many individuals have been critical in the realisation of this project. First of all, I am grateful to the artists whose work I have studied in this book: Jennifer Allora and Guillermo Calzadilla, Narda Alvarado, Francis Alÿs, María Fernanda Cardoso, Donna Conlon, Regina José Galindo, Carlos Garaicoa, Jorge Macchi, Ernesto Neto, Rivane Neuenschwander, Tomás Ochoa, Gabriel Orozco, Miguel Ángel Ríos, Doris Salcedo, Santiago Sierra, Javier Téllez, Ingrid Wildi Merino, Héctor Zamora and David Zink Yi. They have facilitated this editorial undertaking while allowing the peculiarities of my own interpretation to emerge. I am also thankful for their generosity in suplying photographic material; for that purpose, the collaboration of their assistants and galleries have proved essential. I would also like to extend my gratitude to other artists, in particular Lara Almárcegui, Alexander Apóstol, Alejandro Cesarco, Anna Maria Maiolino, Cinthia Marcelle, Teresa Margolles, Cildo Meireles, Antoni Muntadas, Jesús Palomino, Lotty Rosenfeld and Tercerunquinto, who have shared with me their ideas and experiences of art making in Latin America.

During the writing of this book I had the opportunity to present versions of some chapters in the following academic conferences: 'Inconsistency', Manchester Metropolitan University (April 2009); 'Public Arts, Public Acts', Harvard University (April 2010); 'There is no such thing as nature!', Université Paris 1 Panthéon-Sorbonne (June 2010); and 'Antimonumentos', Espai d'Art Contemporani de Castelló (October 2011). I thank both the organisers of these events and the audience members who engaged in productive dialogue around my presentations, as did the public of the 2011 Chaco Art Fair conference series in Santiago de Chile.

It is a pleasure to thank many colleagues at Tate Modern for the supportive and intellectually stimulating environment they have provided me with over these past years: Tanya Barson, Juliet Bingham, Achim Borchardt-Hume, Ben Borthwick, Stuart Comer, Nicholas Cullinan, Chris Dercon, Amy Dickson, Elvira Dyangani Ose, Matthew Gale, Mark Godfrey, Kerryn Greenberg, Kyla McDonald, Jessica Morgan, Frances Morris, Kasia Redzisz, Helen Sainsbury and Nicholas Serota. I have enormously benefited from the knowledge and expertise of such an outstanding group of colleagues. Being a member of Tate's Latin American Acquisitions Committee has also been an enriching endeavour: I am grateful to Virginia Cowles-Schroth, Ann Gallagher, Julieta González, Richard Hamilton, Mauro Herlitzka, Catherine Petitgas, José Roca and Juan Carlos Verme, among others, for sharing their passion on the art of the region. Heartfelt thanks are due to Guy Brett, John Rajchman, Sheena Wagstaff and Vicente Todolí, for their steady support and sound advice during these last years.

I am delighted to be working again with Tate Publishing, where I am indebted to Roger Thorp for his continued trust. Thanks are also due to Giulia Ariete for the picture research, and to Alice Chasey and Beth Thomas, for their patience in editing this book. My gratitude also to Chris Miller, who skilfully translated the text making important suggestions along the way, and Cristina Castrillo of Alianza Editorial in Madrid, who made possible the Spanish publication of the text. I would also like to thank many art professionals with whom I discussed various matters concerning current artistic practice in Latin America, among them, Rodrigo Alonso, Caroline Bachmann and Stefan Banz, Federico Braun, Gladys Fabre, Guillermo Goldschmidt, Carmen Julia, José Carlos Mariátegui, Kiki Mazzuccheli, Miriam Metliss, Gerardo Mosquera, Pablo León de la Barra, Maria Inés Rodríguez, Alma Ruiz and Edward Sullivan.

My friends and family are a constant source of understanding and affection for which I remain truly grateful. Lastly, a special acknowledgement is due to Breixo Viejo, my most valuable interlocutor. He has provided guidance on numerous intellectual matters and carefully revised the final manuscript. This book is dedicated to him *con amor*.

Copyright and photographic credits

All work copyright the artist unless otherwise stated.

Index